Cultivating Demand for the Arts

Arts Learning,
Arts Engagement, and
State Arts Policy

Laura Zakaras
Julia F. Lowell

Commissioned by

Supporting ideas.
Sharing solutions.
Expanding opportunities.

RESEARCH IN THE ARTS

The research in this report was produced within RAND Education, a unit of the RAND Corporation. The research was commissioned by The Wallace Foundation as part of its State Arts Partnerships for Cultural Participation (START) initiative.

Library of Congress Cataloging-in-Publication Data

Zakaras, Laura.
 Cultivating demand for the arts : arts learning, arts engagement, and state arts policy / Laura Zakaras, Julia F Lowell.
 p. cm.
 Includes bibliographical references.
 ISBN 978-0-8330-4184-5 (pbk. : alk. paper)
 1. Arts—Economic aspects—United States. 2. Consumption (Economics)—United States. 3. U.S. states—Cultural policy. 4. Arts—Study and teaching—United States. 5. Art appreciation—Study and teaching—United States. I. Lowell, Julia, 1961– II. Title.

NX705.5.U6Z35 2008
700.1'030973—dc22

 2008009770

The RAND Corporation is a nonprofit research organization providing objective analysis and effective solutions that address the challenges facing the public and private sectors around the world. RAND's publications do not necessarily reflect the opinions of its research clients and sponsors.

RAND® is a registered trademark.

Cover design by Eileen Delson La Russo

Published 2008 by the RAND Corporation
1776 Main Street, P.O. Box 2138, Santa Monica, CA 90407-2138
1200 South Hayes Street, Arlington, VA 22202-5050
4570 Fifth Avenue, Suite 600, Pittsburgh, PA 15213-2665
RAND URL: http://www.rand.org/
To order RAND documents or to obtain additional information, contact
Distribution Services: Telephone: (310) 451-7002;
Fax: (310) 451-6915; Email: order@rand.org

Preface

Recent reports and commentaries point to a growing gap between the quantity of artworks produced by American artists and arts organizations and the desire and ability of many Americans to experience those artworks. This report offers a framework for thinking about supply and demand in the arts and suggests that too little attention has been paid to cultivating demand. It identifies the roles of different factors, particularly arts learning, in stimulating interest in the arts and enriching individuals' experiences of artworks. It also describes the institutional infrastructure that provides arts learning for Americans of all ages.

This is the third in a series of documents describing a multiyear study of the changing roles and missions of state arts agencies (SAAs). The two earlier RAND reports—Julia F. Lowell, *State Arts Agencies 1965–2003: Whose Interests to Serve?* MG-121-WF, 2004; and Julia F. Lowell and Elizabeth H. Ondaatje, *The Arts and State Governments: At Arm's Length or Arm in Arm?* MG-359-WF, 2006—document shifts in thinking about, respectively, the purposes of public funding for the arts and how closely SAAs should be working with elected officials and other state agencies. This third report is intended to help SAAs better understand how to cultivate long-term involvement in the arts and policies that will best support that objective in their states. Besides SAAs, our intended audience is a broad range of policymakers in both the arts and education, as well as arts professionals, arts educators, community leaders, and members of the public who care about increasing the number of Americans who engage with the arts.

This report was produced within RAND Education, a research unit within the RAND Corporation. The research was commissioned by The Wallace Foundation as part of its State Arts Partnerships for Cultural Participation (START) initiative, a program designed to help SAAs develop more-effective strategies for increasing arts participation in their states. The Wallace Foundation supports the development of knowledge from multiple sources and differing perspectives.

Other RAND Books on the Arts

Revitalizing Arts Education Through Community-Wide Coordination (2008)
Susan J. Bodilly, Catherine H. Augustine

Arts and Culture in the Metropolis: Strategies for Sustainability (2007)
Kevin F. McCarthy, Elizabeth Heneghan Ondaatje,
Jennifer L. Novak

The Arts and State Governments: At Arm's Length or Arm in Arm? (2006)
Julia F. Lowell, Elizabeth Heneghan Ondaatje

A Portrait of the Visual Arts: Meeting the Challenges of a New Era (2005)
Kevin F. McCarthy, Elizabeth Heneghan Ondaatje,
Arthur Brooks, Andras Szanto

Gifts of the Muse: Reframing the Debate About the Benefits of the Arts (2004)
Kevin F. McCarthy, Elizabeth Heneghan Ondaatje,
Laura Zakaras, Arthur Brooks

*Arts Education Partnerships: Lessons Learned from One School District's
Experience* (2004)
Melissa K. Rowe, Laura Werber Castaneda,
Tessa Kaganoff, Abby Robyn

State Arts Agencies, 1965–2003: Whose Interests to Serve? (2004)
Julia Lowell

From Celluloid to Cyberspace: The Media Arts and the Changing Arts World (2002)
Kevin F. McCarthy, Elizabeth H. Ondaatje

The Performing Arts in a New Era (2001)
Kevin F. McCarthy, Arthur Brooks,
Julia Lowell, Laura Zakaras

A New Framework for Building Participation in the Arts (2001)
Kevin F. McCarthy, Kimberly Jinnett

Contents

Figures

Tables

Summary

Despite decades of effort to make high-quality works of art accessible to all Americans, demand for the arts has not kept pace with supply. Those who participate in the arts remain overwhelmingly white, educated, and affluent. Moreover, audiences for the arts are growing older: Each year, fewer young Americans visit art museums, listen to classical music, or attend jazz concerts or ballet performances.

Optimism about the future of the arts was widespread in the 1960s and 1970s, when the number of artists and arts organizations expanded rapidly, and demand surged with increases in supply. Museums, performing arts centers, symphonies, opera companies, theaters, and dance companies proliferated and spread outside the major cities where they had been concentrated. Public funding through the newly created National Endowment for the Arts (NEA) and state arts agencies (SAAs), coupled with financial support from major foundations and individual contributors, helped accelerate and sustain the growth of arts-producing organizations.

Support for arts education saw no similar increase, however. While artists and arts organizations benefited from an influx of funds, public funding for arts education stagnated and even declined. In the 1970s and, again, in the early 1990s, school districts across the country reduced their education spending, often by cutting arts specialist positions. Many of these positions have never been restored. In more recent years, general education reforms have shifted class time toward reading and mathematics, which are subject to high-stakes testing, further eroding arts education.

These trends raise questions about public policy on the arts. To put it simply: Will the current priorities and practices of policymakers and major funders meet the challenges created by the diminishing demand? If not, what kinds of adjustments might reverse the decline? The findings in this report are intended to shed light on what it means to cultivate demand for the arts, why it is necessary and important to cultivate this demand, and what SAAs and other arts and education policymakers can do to help.

Study Purpose and Approach

The research we describe here is part of a multiyear study of the evolution of SAAs—their missions, budgets, and funding priorities. Two previous reports produced by this study focused on SAAs' responses to changes in their economic and political environments. The focus here is on the role SAAs have played—and can still play—in increasing demand for the arts.

The research considered only the benchmark arts central to public policy: ballet, classical music, jazz, musical theater, opera, theater, and the visual arts. It specifically addressed four questions:

1. What role does demand play in the creation of a vibrant nonprofit cultural sector?
2. What role does arts learning play in the cultivation of demand?
3. What does the current support infrastructure for demand look like, and does it develop in individuals the skills needed to stimulate their engagement with the arts?
4. How and to what extent have SAAs supported demand in the past, and how can they improve their effectiveness in this role?

To address these issues, we reviewed the relevant literature, analyzed national data on SAA grantmaking over the past 20 years, and conducted interviews and roundtable discussions with arts education experts and arts policymakers at the state and federal levels. Our analysis produced evidence that national and state policies relating to the arts are out of balance: They support the creation and display/performance (supply) of a wealth of artworks but pay scant attention to developing adults who can understand and appreciate artworks (demand). At the same time, education policymakers leave little room in the public school curriculum for the study of the arts. It is our view that the best way to bring large numbers of Americans to lifelong involvement in the arts is to offer more arts education, to encourage the comprehensive approach to teaching called for in the arts standards, and for SAAs to become more active in advocating for such steps and building bridges among policy communities to work toward that goal.

Framework for Understanding Supply and Demand

Our understanding of the role of supply and demand in the arts is based on the concept that works of art are instruments of potential communication. Much has been written about the ways in which the communication that can occur between the artist and the people who encounter the artist's work enhances those people's lives, fosters personal growth, and contributes positively to the public sphere. These benefits depend for their existence on a particular kind of experience, which we call the *aesthetic*

experience, that actively involves the spectator's senses, emotions, and intellect. For an aesthetic experience to take place, three components are necessary: a work of art (supply), an opportunity to encounter it (access), and an individual with the capacity to have such a response to it (demand).

Figure S.1 illustrates the relationship between supply, access, and demand as they relate to the arts. At the center of the diagram is the individual experience of a work of art, which is made possible by the institutions and individuals that contribute to supply on the one hand and demand on the other. Supporting the supply of art is a vast infrastructure of artists, universities that train them, performing groups, presenters, record companies, libraries, publishers, and many others that contribute to the creation, conservation, display, and dissemination of artworks. Supporting demand, on the other hand, are the individuals and institutions that help draw people into engagement with the arts and teach them what to notice and value in the encounter. The main actors here are teachers in the kindergarten through grade 12 (K–12) school system, private instructors and teaching artists, journalists and critics, and the parents, relatives, and friends who serve as mentors in the arts they love. With this framework, "cultivating demand" is not primarily about marketing campaigns and public outreach; it is about giving people the skills and knowledge they need to have encounters with works of art that are rich enough to keep them coming back for more.

Many agents that operate primarily on one side of the framework also play some role on the other (for example, many artists also teach the arts; many teachers also

Figure S.1
Concept of Supply, Access, and Demand in the Arts

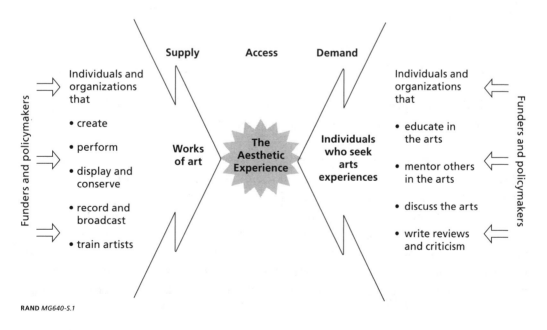

RAND *MG640-S.1*

create art). And agents on both sides of the framework promote opportunities for broader access to the arts. Finally, as the figure shows, all parts of the system are influenced by funders and policymakers.

It follows, then, that public organizations dedicated to the country's cultural well-being should consider three objectives in pursuing their missions: expand supply by increasing the production of high-quality works of art, expand access by creating more opportunities for people to encounter such works, and expand demand by cultivating the capacity of individuals to have aesthetic experiences with works of arts. The third of these, which has received the least attention from arts policymakers, was the focus of our research.

Cultivating Demand

We explored the research literature to discover whether arts education is associated with the capacity for aesthetic experiences that lead to future involvement and, if so, whether the type of arts instruction matters. On the first issue, empirical studies show that level of education in general, and arts education in particular, is strongly associated with adult involvement in the arts. On the second issue, a rich body of conceptual research examines the kind of arts learning most likely to enable that involvement. Many arts education scholars writing in the last half of the 20th century have identified skills and knowledge that enable learners to enter into such experiences. We synthesize such learning into four types:

1. the capacity for aesthetic perception, or the ability to see, hear, and feel what works of art have to offer
2. the ability to create artistically in an art form
3. historical and cultural knowledge that enriches the understanding of works of art
4. the ability to interpret works of art, discern what is valuable in them, and draw meaning from them through reflection and discussion with others.

These skills and knowledge are the content of what we call *comprehensive arts education*, through which individuals learn not only to create, but also to appreciate and understand works of art. This approach is closely aligned with principles articulated more recently in the national and state arts content standards. Although there are still many schools of thought about how the arts should be taught, the standards represent broad consensus among practitioners and policymakers and define common ground between supporters of arts-based instruction (which focuses on studio art or performance) and supporters of humanities-based instruction (which focuses on apprecia-

tion). These standards were forged from a long tradition of theory and practice in arts education that confirms the value of a broad-based approach to teaching the arts.

Institutional Support for Arts Learning

To what extent are Americans given the opportunity for what we refer to as comprehensive arts education? Although the data on arts learning in any setting are limited, rendering any portrait of this landscape largely incomplete, we reviewed what is known about all forms of arts instruction, both formal and informal, for people of all ages. What the evidence shows is that institutional support for any type of arts education is weak. The young are not provided enough instructional time to develop the skills and knowledge associated with long-term arts engagement, college students have many more opportunities to do so, and adults seldom participate in arts learning opportunities of any kind.

For school-age Americans, four components make up the arts learning infrastructure:

1. *The K–12 public school system*, which is the primary source of arts learning for the young. No other system has so much access to the young, the resources with which to teach them, and the responsibility for ensuring they have equal opportunity to become knowledgeable about the arts. Recent surveys suggest, however, that a significant proportion of schools around the country offer minimal arts education.
2. *Higher education*, which plays several critical supporting roles in the delivery of arts learning to the young, the most important of which is training and offering ongoing professional development to classroom teachers and arts specialists who work in the K–12 system. Many colleges and universities also house museums, performing arts centers, and community schools of the arts, all of which offer educational programs. Some also host or contribute to after-school programs in the arts.
3. *Public after-school programs*, which are a source of arts learning that draws on a multitude of arts providers in the communities around schools. Most of these teach casual art-making or emphasize child-development outcomes.
4. *Arts learning in the community*, which is offered to school-age children by arts organizations, community service organizations, and community schools of the arts both after school and on weekends. Most of these programs focus on art-making and performance.

Arts learning for adults consists of three components:

1. *Higher education institutions*, which are by far the most important sources of broad-based arts education for adults. This is in addition to their primary focus on preparing professional artists, arts specialists, general classroom teachers, and scholars.

2. *Arts learning in the community*, which is offered to adults through arts organizations and, to a lesser extent, community schools of the arts and community service organizations. Museums are seriously committed to their education mission, the goal of which is to enrich people's experiences of works of art in their collections. Performing arts organizations are offering considerably more educational programming than they did even ten years ago, but programs for adult audiences of arts organizations are still limited in scope and reach.

3. *Arts journalism*, which has played a critical role in developing informed audiences for the arts but has been losing ground in newspapers across the country. Experienced journalists, including film, theater, dance, and visual arts critics, are being squeezed out. Unless such discourse fully migrates to the Internet, and this medium can support career development and stability for arts critics, the breakdown in the traditional transmission of arts news and criticism is likely to weaken demand for the arts.

State Funding of the Arts

Has arts policy supported the kind of comprehensive arts learning that best cultivates demand? To answer this question, we analyzed 20 years of data on grants awarded by SAAs to assess the relative proportion of funding devoted to the three policy objectives introduced earlier: expanding the quantity of high-quality artworks, creating more opportunities for people to encounter such works, and cultivating individuals' capacity to have aesthetic experiences.

We found that between 60 and 70 percent of the value of grants awarded from 1987 to 2004 went to institutional support, mostly for arts organizations, and to the creation, exhibition, and preservation of art. Less than 10 percent was specifically devoted to arts learning. And although roughly one-quarter of the value of SAA grants went in part to support activities that grantees considered educational, the little we know about those activities suggests that many if not most of them are designed to expand access rather than to develop the skills and knowledge associated with long-term arts engagement.

Recently, however, a number of SAAs moved beyond grantmaking to work with state education departments, arts educators, and arts organizations to improve arts education policy at the state level. Two of these SAAs, the Rhode Island State Council on the Arts and the New Jersey State Council on the Arts, have had particular success leveraging their position at the nexus of state government and the arts com-

munity to strengthen youth arts education. By promoting collaborations among arts educators, arts advocates, arts policymakers, and artists and arts organizations, they have achieved far more than they could have by relying exclusively on their own limited grantmaking budgets. Specifically, they have helped arts educators develop state arts content standards and curricular frameworks for K–12 education, determine the amount and reach of arts education around their states, raise the visibility of arts education with both the public and elected officials, and develop tools for assessing student proficiency in the arts.

Policy Implications

Our analysis implies that in line with their mandate to support and encourage public interest in the arts, SAAs should consider giving more priority to cultivating demand for the arts. This does not necessarily mean they should replace grants designed to expand supply and access with grants designed to cultivate demand; there may be other tools available that will serve. In fact, some SAAs have already demonstrated that the use of such tools as convening and advocacy can be very effective in promoting arts education in the public schools and the broader arts community—perhaps more effective than grants. Nevertheless, placing greater emphasis on demand will require SAAs to reallocate some resources from individuals and organizations operating on the supply and access portions of the arts infrastructure to those operating on the demand side.

To evaluate their options, SAAs should consider several questions:

- *What is the status of youth arts learning in the state?* Before an SAA can begin to help remediate problems in youth arts learning, it must have a good understanding of the overall environment. A handful of states, with the help of their SAAs, have conducted assessments, and state policymakers are using the survey data to identify gaps and inequities and to develop strategies for addressing them.
- *What can an SAA do to raise public awareness of the need for comprehensive arts learning within and beyond the schools?* Time and money will not be made available for arts education unless state residents and their political leaders are convinced that arts education should be a basic part of K–12 education. SAAs are uniquely positioned within state government to advocate for the benefits of aesthetic engagement and the necessity of promoting such engagement through education.
- *How can an SAA best contribute to policy changes that will strengthen arts education in the public school system?* No single group of stakeholders has the resources or clout essential for bringing about change in general education policy at the state level. SAAs are likely to be more effective in this area as influencers and conve-

ners of the disparate stakeholders in support of standards-based arts education in schools.

- *How can an SAA best contribute to policy changes that will strengthen arts learning in the community?* An SAA can focus its education grantmaking on organizations that contribute to comprehensive arts learning. If SAAs look at the arts learning infrastructure as a whole, they may also be able to advise artists, arts organizations, and other arts learning providers on where the gaps are—and fund individuals and institutions that can fill those gaps.

- *How can an SAA identify and promote programs likely to lead to adult involvement in the arts?* SAAs can work with other organizations to bring recognition to exemplary programs in their states—educational programs, professional development programs, teacher preparation programs, and local collaborative networks in support of arts learning. In this way, they can influence practitioners to offer standards-based arts instruction and develop public support for such programs at the same time.

For other policymakers and funders, the key implication of our work is that greater attention should be directed to drawing more Americans into lifelong involvement in the arts. Of the many potentially effective strategies for achieving this objective, we make three recommendations:

- *Support research to inform policy.* More research is needed to illuminate the relationship between comprehensive arts learning and long-term arts participation. For example, studies are needed to test what the conceptual literature (and personal observation) supports: that developing the skills of aesthetic perception and interpretation, for example, can increase the satisfaction people get from their encounters with the arts, and the higher their satisfaction, the more they demand such experiences.

- *Support collaborative programs that increase the amount and breadth of arts learning.* We have offered a broad view of the support infrastructure for arts learning so that policymakers can determine where and how they might have the most leverage in spurring improvements. For the young, for example, we have highlighted critical gaps in arts learning opportunities. Many of these can only be addressed by changes in state education policy. But policymakers should identify and support promising programs offered by arts organizations, higher education institutions, and local collaborative networks to strengthen school-based arts education.

- *Advocate for change in state education policy to bring arts education to all students.* Increased time for arts instruction is needed at all grade levels in the public schools, a need that cannot be met without significant changes in state education policy. Arts content standards now exist in nearly every state, but K–12 children will not be provided with more and better arts education until states follow through with

an accountability system and ask districts to report on arts instruction provided and learning achieved. Unless state boards of education require such results, their arts standards and mandates will be ignored.

To bring about reform in state education policy, however, communities that have often worked at cross-purposes will have to reach out to one another and forge a common agenda. Those that will play the key roles are the arts policy community (which includes the NEA and SAAs), leaders in the arts community (such as directors of major arts organizations and the business leaders on their boards), and the professional associations that represent the thousands of arts educators across the country. Only by working together can these communities persuade the general education community—and the public—of the importance of arts learning in drawing more Americans into engagement with the culture around them.

Acknowledgments

We are indebted to many people who supported this work. First, we are grateful to The Wallace Foundation for sponsoring this study and to Ann Stone and Pam Mendels in particular for their encouragement and helpful comments on earlier drafts of this report. Second, we benefited from the thoughtful reviews of Samuel Hope of the National Office for Arts Accreditation and David Steiner of Hunter College, who helped us achieve greater clarity in our thinking and our writing.

We also extend our thanks to many others who provided comments on early drafts, including Kevin McCarthy, Susan Bodilly, and Catherine Augustine of RAND, Ralph Smith of the University of Illinois at Urbana-Champaign, Richard Deasy of the Arts Education Partnership, Mark Slavkin of the Music Center of Los Angeles, Michael Faison of the Idaho Commission on the Arts, David Marshall of the Massachusetts Cultural Council, Sherilyn Brown of the Rhode Island State Council on the Arts, Marty Skomal of the Nebraska Arts Council, Steve Runk and Robin Middleman of the New Jersey State Council on the Arts, and Philip Horn and Heather Doughty of the Pennsylvania Council on the Arts.

We also thank numerous others—education directors from other state arts agencies and the National Endowment for the Arts, officials from national associations of performing arts organizations and the National Assembly of State Arts Agencies, state education policymakers, and arts journalists and educators—who provided data or took part in interviews, focus groups, or email exchanges during the course of this study. There are too many to name here, so we have listed them in Appendix A of this report and thank them collectively for taking the time to describe their organizations and activities and to bring us up to date on developments not yet documented. We also thank Elizabeth Ondaatje and Jennifer Novak of RAND, who helped conduct interviews and gather data for this report.

Finally, we are grateful to Jeri O'Donnell, our expert editor, who found many ways to improve our style, clarity, and consistency.

We want to emphasize, however, that the findings and recommendations in this report reflect our views as the authors and are not necessarily the views of those who contributed to our research, The Wallace Foundation, or the RAND Corporation itself.

Introduction

Spurred in part by a large influx of both philanthropic and government funding, the number of artists and nonprofit arts organizations in the United States has multiplied since the founding of the National Endowment for the Arts (NEA) and most state arts agencies (SAAs) in the mid-1960s. Demand for their output has not kept pace, however, as evidenced by declining rates of arts participation for Americans, particularly those age 30 and under.[1] Despite more than four decades of public support, the financial health of the U.S. arts sector has seen little to no improvement (McCarthy et al., 2001).

One explanation for these declining rates of arts participation is a lack of education: Many Americans have never acquired the knowledge and skills needed to understand and appreciate what the arts have to offer. According to this view, education policymakers have made little room for the arts in the public school curriculum, and policymakers in the arts have focused on increasing the availability of high-quality art (Fowler, 1996; Gioia, 2007). For various reasons, policies for cultivating demand for the arts—that is, for stimulating most Americans' broad interest in and knowledge of the arts—have been either ineffective or nonexistent.

Our research explored the relationship between arts learning, arts engagement, and arts policy at the state level. The findings presented in this report are intended to shed light on what it means to cultivate demand for the arts, why this cultivation is necessary and important, and what SAAs and other arts and education policymakers can do to help. We focus on SAAs not because they are major funders of education or the arts—in budget terms, they are very small—but because they are in a position to influence arts learning,[2] both by leveraging other public and private resources and by participating in policymaking decisions.

[1] For this report, "the arts" are the seven benchmark art forms surveyed by the NEA—ballet, classical music, jazz, musical theater, opera, theater, and the visual arts—most of which are produced in the nonprofit sector. However, many of the basic skills and much of the knowledge needed to appreciate the benchmark arts are also needed to appreciate the wide range of art forms produced in the commercial and volunteer sectors.

[2] Although many use the terms *arts education* and *arts learning* as synonyms, we use the term *arts education* to mean formal instruction in a school setting and the term *arts learning* to mean the many ways in which arts

This is the third in a series of reports on the roles and missions of SAAs. In 2002, RAND was asked to study the results of a multiyear Wallace Foundation initiative encouraging SAAs to explore new ways to increase public participation in the arts.[3] As reported by Lowell (2004), the initiative caused many SAAs to rethink how they might best serve the citizens of their states through grantmaking and other means.

Background

According to data collected by the U.S. Department of Labor's Bureau of Labor Statistics, the population of professional artists in the United States increased by 127 percent between 1970 and 1990 while the population of "all professionals" increased by 89 percent, and the labor force as a whole increased by 55 percent (Ellis and Beresford, 1994).[4] During the 1990s, this growth in the number of professional artists slowed somewhat; but for the visual arts, theater, music, and literature, there remains "keen competition for both salaried jobs and freelance work [as] the number of qualified workers exceeds the number of available openings" (U.S. Department of Labor, Bureau of Labor Statistics, 2008).

Growth in the number of nonprofit arts organizations has been nearly as dramatic. Schwarz and Peters (1983) estimate that during the decade of the 1970s, the number of opera companies increased by 150 percent, the number of art museums increased by 150 percent, and the number of nonprofit literary organizations doubled.[5] Between 1982 and 2002, the number of nonprofit performing arts establishments grew by approximately 9 percent per year, significantly outdoing manufacturing establishments, which grew in number by less than 0.05 percent per year (U.S. Department of Commerce, Bureau of the Census, 1984, 2005b).

The growth and spread of artists and nonprofit arts organizations generated a corresponding surge in arts participation among members of the baby boomer generation in the 1970s and 1980s. More recent trends, however, show that demand is not keeping

knowledge and skills can be gained in less formal settings. We also use *arts learning*, as in the sentence above, as the more inclusive term to mean both formal and informal instruction.

[3] The State Arts Partnerships for Cultural Participation (START) initiative was launched in 2001. Through START, The Wallace Foundation gave 13 SAAs multiyear grants in support of innovative programs, research, and outreach efforts aimed at increasing arts participation in their states. Most of the grants concluded in 2005–2006.

[4] In this study, artists self-identified. The artist occupations listed were actors and directors; announcers; architects; authors; dancers; designers; musicians and composers; painters, sculptors, and craft artists; photographers; and teachers of the arts in higher education.

[5] The time spans measured were 1970 to 1980 for opera companies, 1966 to 1978 for art museums, and 1974 to 1980 for nonprofit literary publishers. This report is one of the few sources of data on nonprofit arts organizations for the period. The U.S. Census Bureau did not begin its Economic Census, which counts for-profit and nonprofit arts establishments, until 1977.

up with supply. Data from the NEA's Survey of Public Participation in the Arts (SPPA) for 1982, 1992, and 2002 offer evidence of "ongoing attrition in the audience for many of the arts" (DiMaggio and Mukhtar, 2004, p. 169). When growth in population and growth in education levels are held constant, the participation rate (the number of participants as a percentage of the adult population) can be seen to decline in all seven of the benchmark art forms surveyed by the NEA (McCarthy et al., 2001). This decline holds true for all age and education groups.

Perhaps the most worrying trend is that fewer young adults (persons age 18 to 24) than ever are visiting art museums, going to the ballet, and attending classical or jazz concerts. Except in the case of opera, the share of young adult audience members for nonprofit performing arts has declined across the board; accordingly, the median age of the performing arts audience is rising faster than the median age of the general population (Peterson, Hull, and Kern, 2002; Nichols, 2003). And not only the performing arts have been affected. Of all the arts tracked by the NEA, the literary arts have suffered the largest decline in young adult participation. In 1982, young adults had the highest reading rate across all age categories; 20 years later, they had the lowest rate of all adults under 65.

Part of this broad-based decline in adult, particularly young adult, rates of participation can be explained by the huge expansion of home-entertainment options, including greater access to music and film via computers and other electronic devices.[6] Many observers see mass-entertainment marketing that targets the young as the main culprit. Others point to new forms of cultural participation among those under 30: a surge in creative practices made possible by new technologies, such as composing and editing music, making digital films, and creating video games (Tepper and Ivey, 2008). Hands-on participation rates in the benchmark arts, however, have not been rising among the young, and media participation (that is, listening to recordings or watching broadcasts) in those art forms has declined since 1982 (NEA, 2004).

What's at Stake

There are several reasons to be concerned about declining demand for the arts and the growing imbalance between artistic supply and demand. First, if demand for the arts—and therefore the earned income of arts organizations—keeps declining, it is unlikely that government support and arts philanthropy will be able to take up the slack: Public and private funders alike are finding it increasingly difficult to justify support for the arts in the face of competing social and environmental claims (Americans

[6] We define *entertainment* as cultural activity whose full appreciation requires little in the way of intellectual/ aesthetic skill or historical/cultural knowledge.

for the Arts, 2007).[7] Eventually, some arts organizations will go out of business. This, of course, happens frequently in the for-profit world, and there may be organizations that deserve to fail. But there are also institutions that are highly valued by a relatively small number of Americans now but could be highly valued by much larger numbers of Americans in the future—and these, too, may be forced to close their doors.[8]

Second, declining demand leads to a loss of the public and private benefits derived from the arts. Beyond the artist's creative act and the work of art that he or she produces, there are the people who are "arts appreciators," that is, who appreciate the arts and seek repeated arts encounters. The quality of those encounters—the level of emotional and mental engagement people experience with works of art—is critical to the creation of a range of benefits that enhance personal lives and contribute to the public welfare in ways that go beyond economics. People who experience high levels of engagement with works of art move imaginatively and emotionally into different worlds; broaden their field of reference beyond the confines of their own lives; exercise their capacity for empathy; develop faculties of perception, interpretation, and judgment; and form bonds with others who find in some works of art the expression of what whole communities of people have experienced (McCarthy et al., 2004). If the number of arts appreciators shrinks with succeeding generations, the cultivation of these humanizing effects will decline as well.

Third, declining demand is likely to be associated with increasing inequity in how the arts-derived benefits are distributed. Research suggests that early arts experiences, arts education, and the valuing of the arts by family members and peers dispose one toward arts participation (see Chapter Three for an overview of this research). Children who are provided with little or no experience or study of the arts are less likely to become arts participants as adults. Thus, if the public schools do not commit to providing arts education, the arts and the intrinsic benefits they offer will not be equally available to America's children.

Fourth, a number of educators and others argue that by deemphasizing the education of children in the arts and humanities, American public schools are no longer adequately preparing their students to participate in the rich cultural life that is one of civilization's greatest achievements. Finn and Ravitch (2007, p. 1) warn that a liberal education, which includes the arts, is "critical to young people because it prepares them for 'public life'—not just politics and government, but the civic life in which we should all partake." Ferrero (2007, p. 37) refers to the "nascent hunger for schools to do more than help children read and compute and obtain a credential that will land

[7] Also see "Is Giving to Universities and Arts Groups Under Attack?" (*Chronicle of Philanthropy*, 2007).

[8] Heilbrun and Gray (1993, p. 205) describe this as the "legacy to future generations" argument: "The argument is that both those who enjoy the arts and those who do not would be willing to pay something today to ensure that the arts are preserved for the benefit of future generations." The legacy argument is also used as a justification for public subsidy of historic preservation.

them a lucrative job." And von Zastrow and Janc (2004) state that because the liberal arts "span the domains of human experience," they foster "an understanding of what it means to be human." In this view, the narrowing of the K–12 curriculum to mathematics, science, and reading does a disservice to American children.

Research Questions

This report seeks to clarify what it means to cultivate demand for the arts, how well American institutions are cultivating this demand, and whether it is in the public interest for policymakers to make cultivation of this demand a greater priority. Specifically, we address four research questions:

1. What role does demand play in the creation of a vibrant nonprofit cultural sector?
2. What role does arts learning play in the cultivation of demand?
3. What does the current support infrastructure for demand look like, and does it develop in individuals the skills needed to stimulate their engagement with the arts?
4. How and to what extent have SAAs supported demand for the arts in the past, and how can they improve their effectiveness in this role?

Although we single out SAAs for special attention, we recognize that many other policymakers—such as leaders of arts organizations and their education departments, arts educators and their professional associations, the foundation community and other funders of the arts and arts education, and education leaders committed to the value of the arts—face similar issues in their strategic planning. Our ultimate objective is to shed light on what it takes to cultivate demand, particularly the role of arts learning in this cultivation, and to encourage all these stakeholders to develop a shared commitment to improving policy and practice in this area.

Research Approach

Our analysis took three main avenues. First, we read widely in several areas: (1) theoretical literature on arts education, arts education policy, and the philosophy of art; (2) empirical research on arts education in the public schools, including historical perspectives on policies that have influenced the arts curriculum, teaching practices, teacher education, and assessment; (3) research on youth arts learning beyond the school day, including studies of after-school programs and community-based arts learning for children; and (4) studies of arts learning opportunities for adults, including college arts programs and community-based programs for lifelong learning in the

arts. This body of work helped us draw a picture of the main institutional supports for arts learning. We also discovered large uncharted areas in which data and research simply do not exist.

Second, we analyzed national data on the value of SAA grants by type of recipient, type of activity, and education orientation of the activity funded. These data have been compiled by the National Assembly of State Arts Agencies every year since 1986. Although they represent an imperfect measure of SAA priorities, they indicate where the bulk of SAA money and attention has been directed over the past 20 years. (Chapter Six describes the dataset in detail.)

Finally, we conducted structured and informal interviews and roundtables with arts education experts, arts journalists, arts education advocates, staff members of state departments of education, and current and past NEA and SAA staff to find out about recent approaches—most of which have not yet been well documented—used to cultivate demand for the arts at the federal and state levels. The interviews were designed to provide qualitative insights into a range of issues, including the state of arts education in public schools and ways to encourage lifelong learning in the arts.

Report Organization

Chapter Two begins with an overview of the process of artistic creation and arts appreciation, describing how the communicative cycle of art creates unique benefits for the individual and the broader public, and arguing that both the artist and the arts appreciator are needed to create these benefits. With that understanding in place, we then set out a framework that illustrates the importance of both supply and demand for a healthy cultural system, and describe the institutional supports for supply and for demand. We then discuss why we think policy objectives will have to address three critical areas—supply, access, and demand—if they are to create the most value for the public through the arts.

Chapter Three looks at how to develop an individual's capacity to engage with the arts, a capacity we argue is critical to spurring ongoing demand for arts experiences. We draw on a number of studies offering evidence that arts learning stimulates arts participation later in life. We also synthesize a body of conceptual research that identifies the skills and knowledge individuals need to be taught if they are to be able to fully engage with works of art—or partake in aesthetic experiences. Many of these studies broadened the understanding of arts education's purpose in the 1970s and 1980s and helped create the foundation for the national and state arts content standards adopted in the 1990s and 2000s. We also point to the need for further research to test our hypothesis that the decline in school-based arts education has contributed to the decline in arts participation.

The next two chapters then examine the institutional infrastructure that promotes individual demand for arts experiences. Chapter Four concentrates on youth arts learning; Chapter Five, on adult arts learning. Our purpose in describing this complex landscape of organizations is to improve the general understanding of it, since it is within this environment that public and private policies will have to be targeted to stimulate demand for the arts.

Chapter Six examines SAA grantmaking over the past 20 years, revealing that state arts funding has typically emphasized support for the production and performance or exhibition of works of art, with minimal attention to arts learning. We describe initiatives in two states that are designed to strengthen youth arts learning. These initiatives show how SAAs, despite their modest resources, can have a notable effect on arts learning in their states if they use their position as state government agencies to facilitate collaborations among stakeholders.

Chapter Seven, our concluding chapter, summarizes the main insights from our analysis and highlights our overall purpose, which is to stimulate discussion about the appropriate balance of policy objectives for the arts and to shed light on policy options.

A Framework for Understanding Supply, Access, and Demand

This chapter addresses our first research question: What role does demand play in a vibrant nonprofit cultural sector? We begin by describing the interaction between those who create works of art and those who respond to them as a communicative cycle that creates benefits for those engaged in the cycle and for the public at large. We then describe the different individual and institutional actors that sustain both the demand and the supply components of the cycle. Finally, we identify the conditions that need to be met for the cycle to function effectively and propose that cultural policy focus on meeting these conditions.

Art as Communicative Experience

To understand the role of supply and demand in the arts, it is important to establish that a work of art can be seen as a form of communication, designed to be experienced and interpreted by persons other than its creator. The process, illustrated in Figure 2.1, begins with artistic creation, an act in which the artist draws on two highly developed gifts: a capacity for vivid perceptions of the world, including his or her inner world, and an ability—imaginative, intellectual, and technical—to communicate ideas and feelings through a particular art form, thereby bringing them from the private to the public realm where they can be experienced, reflected on, and shared by others. Eisner (1991, p. 2) describes the public contributions of the arts in this way: "The arts and the humanities have provided a long tradition of ways of describing, interpreting, and appraising the world: history, art, literature, dance, drama, poetry, and music are among the most important forms through which humans have represented and shaped their experience."

As the figure illustrates, the communicative cycle requires more than just the artist and work of art. The communicative potential of the created artwork is realized only when individuals experience the work in a way that engages their emotions, stimulates their senses, and challenges their minds to a process of discovery—the kind of

Figure 2.1
The Communicative Cycle of the Arts

SOURCE: Adapted from McCarthy et al., 2004.
RAND *MG640-2.1*

occurrence traditionally referred to as an aesthetic experience.[1] Unlike other forms of communication, which are delivered in terms of concepts and propositions grasped largely by the intellect, art engages the artist's full range of human faculties during the creative process and has the power to arouse that same range in individuals who encounter the art (Dewey, [1934] 1980).[2] Much has been written about the ways in which such experiences enhance individual lives, foster personal growth, and contribute to the public sphere.[3] For our purposes, the important point is that these benefits depend on the existence of works of art, opportunities to encounter them, and individuals capable of being caught up and moved by works of art so that they develop the inclination to seek more such experiences.

The final component of the communicative process shown in Figure 2.1 is the critical response to art, which refers to the public discourse stimulated by the arts. Greene (2001, p. 50) writes that the arts "create a public space in which meanings are shared and perspectives expressed and clarified." In other words, the communi-

[1] As we suggest in the next chapter, the concept of an aesthetic experience is particularly important to arts educators, whose work involves enabling students to have such experiences—that is, cultivating in students ways of perceiving and responding to works of art that enrich their lives. See Eaton and Moore, 2002, for an account of this concept, including modern philosophical debates about its validity.

[2] Dewey states on p. 84: "Science states meanings; art expresses them."

[3] See McCarthy et al., 2004, for a synthesis of the research on both instrumental and intrinsic benefits of arts experiences.

cative cycle encompasses more than just the communication between the artist and any single beholder. When one looks at a painting or sees a film, for example, even if alone, one is part of a community of viewers and can draw on others' experiences for help in understanding and deepening one's own experience. Such discourse takes place in many forms, from informal discussions among friends to the published work of reviewers and critics. Oakeshott and Fuller (1989) call this "the Great Conversation"; it includes artists, critics, teachers, and members of the public who have been talking and listening to one another, engaged in reconstructing the meaning of great works of art, sometimes for generations.

The critical response to art influences both the artistic experience of creating and the aesthetic experience of perceiving: It helps shape the cultural environment in which new art is made, and it helps members of the public reflect on and evaluate their own responses in light of the observations of others. Dewey ([1934] 1980) states that this link in the communicative cycle of art (see Figure 2.1) is critical to a vibrant culture in that it increases the value gained from any individual arts experience. Ciment and Kardish (2003), writing about the world of film and the discourse it inspires, agree: "Films alone do not make a culture resonant, but thinking, arguing, and writing about them, their makers, and their context do" (p. 6).

We propose, based on our study, that a vibrant culture results from the full functioning of this communicative cycle. The weakening of any links along the chain—the closing of organizations or the departure of individuals that provide high-quality art to the public, a decrease in the number and/or the capacity of individual appreciators of art, a lessening of opportunities to encounter works of art, a decrease in outlets for public discourse, or a decline in the quality of that discourse—will weaken the cultural sector and diminish its benefits to the public.

This communicative concept of works of art is helpful in understanding the role of demand because it highlights the individual encounter with a work of art, the aesthetic experience, as the critical nexus of supply and demand. "Cultivating demand," according to this concept, is not primarily about creating better marketing campaigns and public outreach; but, rather, about providing individuals with the tools they need to have rich experiences with art—experiences so engaging that they will desire more of them.

Framework for Understanding Supply, Access, and Demand

Figure 2.2 illustrates the individual and institutional actors that make it possible for people to experience art in its many forms. At the center is where the individual who is seeking an arts experience (demand) encounters a work of art (supply). The work of art is made available through the efforts of a vast infrastructure of support for artistic production in the nonprofit, for-profit, public, and volunteer sectors (left side of the

Figure 2.2
Concept of Supply, Access, and Demand in the Arts

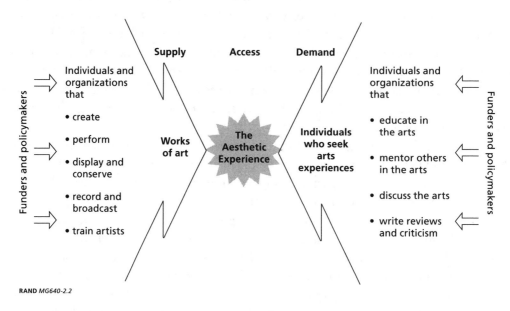

figure). This support infrastructure for supply includes the artists who create and perform works of art and the academies and university departments dedicated to increasing the number and quality of artists and artworks. It also includes a great range of other individuals and institutions that contribute to the supply of art and create the conditions under which artworks can be enjoyed: museums and galleries, ballet companies, recording studios, radio stations, theater groups, libraries and bookstores, arts service organizations, publishers, and consulting firms that serve arts organizations and government agencies.[4] All of these belong to what Danto (1964, 1981) calls the "artworld."

The support infrastructure for demand (right side of the figure) consists of the individuals and institutions that help draw people into engagement with the arts and teach them what to notice and value in arts encounters. The main actors in this realm are the K–12 public school system and the teachers who deliver education in music, the visual arts, dance, theater, literature, and film. Beyond these, there are instructors and teaching artists who operate outside the K–12 system and offer private lessons in the arts, and family members and friends who serve as mentors in the art forms they love. Also critical in cultivating demand are the colleges and universities that train arts specialists, teaching artists, general classroom teachers, and arts journalists, and those that offer basic arts education courses to general students and more-advanced courses to arts majors.

[4] Beardsley (1982, p. 120) calls these individuals and organizations "aesthetic auxiliaries."

Funders and policymakers, including the NEA, private-sector foundations, and state and local arts agencies, use their financial and other assets to stimulate both sides of this framework. They support the supply infrastructure by offering grants to the various types of organizations and artists operating within that infrastructure in order to increase the quality and quantity of works of art. And they support the demand infrastructure through grants as well, primarily by funding artist residencies in schools and encouraging partnerships between schools and cultural institutions, but also, more recently, through programs to build the capacity of institutions and individuals (such as teachers and journalists) within the demand infrastructure. In addition to grantmaking, funders and policymakers use convenings, research, advocacy, and other policy tools to achieve their objectives.

One of the major objectives of both the NEA and state and local arts agencies is to improve access to the arts. As Figure 2.2 shows, individuals must have access to works of art in order to respond to them. Partly in response to public policies aimed at increasing and diversifying audiences for the arts, individuals and organizations on both sides of the framework, but particularly on the supply side, have instituted strategies to increase participation by improving access to the arts. A theater company touring a rural part of the state, a modern dance company offering subsidized tickets to college students, an art museum opening an adjunct gallery in a distant suburb, performing arts groups offering concerts and plays in schools and community venues—all of these are strategies aimed at removing practical barriers to accessing the arts.[5]

It is important to recognize, however, as McCarthy and Jinnett (2001) point out, that there are two kinds of barriers to arts involvement: practical barriers and perceptual barriers. Practical barriers—high cost, inconvenient location, lack of information, scheduling conflicts, etc.—diminish participation by people who are inclined to participate. Perceptual barriers—inexperience with and ignorance about the arts, social norms that stigmatize the arts, etc.—inhibit interest in and create resistance to participation. Marketing campaigns are typically designed to promote access to arts events by mitigating the practical barriers that prevent individuals who are inclined to participate from doing so. But such campaigns are typically ineffective at increasing the participation of people with little interest in or knowledge about the arts (McCarthy and Jinnett, 2001).

One final point about the framework for supply and demand is that various individuals and institutions play a role in both support infrastructures. Many artists also teach the arts; many teachers also create art. Many arts organizations whose mission is

[5] It should be noted that these strategies are often described as audience development. For example, Hager and Pollak (2002, p. 6) write: "Presenting organizations of all sizes are involved with a variety of audience development strategies, such as free performances, programs aimed at school-aged youth, and the dissemination of program notes. The use of audience development strategies increases with budget size, but even the presenters with the smallest budgets display a range of audience development efforts." Our concept of cultivating demand should not be confused with audience development of this kind.

primarily to provide the arts to the public also offer educational programs. And almost all museums have a strong educational function that coexists with their mission to acquire, preserve, and display works of art. But despite such overlaps, the majority of individuals and organizations have missions that place them primarily on one side or the other. Higher education is the exception in that it plays a crucial role on both sides: on the supply side, increasing the number and quality of artists and often serving as the central provider of performing arts in communities across the country; on the demand side, training arts specialists and offering arts education courses for general students.

Implications for Cultural Policy

The framework described above and shown in Figure 2.2 implies that the focus of cultural policy should be on maximizing the interactions between supply and demand—in other words, increasing the number and quality of aesthetic experiences—rather than on simply maximizing the number and quality of works of art. Beardsley (1982) proposes three conditions that must be met for an aesthetic experience to occur:

1. The work of art needs to provide the potential for an engaging experience.
2. The individual beholder must have the opportunity to encounter such works of art. That is, the quantity and dispersion of works of art judged to be of high quality must be sufficient to provide the public with reasonable access to them.
3. The individual beholder must have the capacity to be moved by the expressive and intellectual qualities of a work of art, a capacity that typically comes from familiarity with an artistic form, such as dance, poetry, or painting.

If these three conditions are required to promote the spread of aesthetic experiences, cultural policies then need to have corresponding goals:

- *Increase the number of works of art that have the potential to provide an engaging arts experience.* This goal calls for an increase in the supply of high-quality works of art, which has been a mandate of public funding at all levels of government since the late 1960s.
- *Promote the opportunity for citizens to encounter such works of art.* This goal, which aims to improve the public's access to works of art, calls for strategies affecting both arts providers and arts consumers. Increasing the geographic spread of high-quality artworks has also been the most important justification for passing funds from the NEA to the SAAs.
- *Cultivate the capacity of individuals to have engaging experiences with works of art.* This goal calls for strategies designed specifically to produce general interest and

engagement in the arts and to enrich the actual experience for individual participants, rather than to simply increase the audiences for arts events or museum collections.

The third objective, which is largely ignored in arts policy research, is the focus of this study.

Enabling Individual Engagement with Works of Art

This chapter examines how individuals develop the capacity for aesthetic experiences, which we define as responses to works of art marked by heightened awareness and emotional and cognitive engagement. To examine this issue, we drew on a range of sources: studies based on small-scale surveys of participants in various arts activities, statistical analyses of the relationship between youth arts learning and adult arts participation, behavioral models of arts participation, and, most relevant to the question at hand, a body of theoretical works by arts education scholars. The research supports the view that early positive experiences with the arts in the home, community, and school build a child's interest in the arts and a propensity to seek more such experiences as an adult. It also suggests that a broad-based approach to arts education, which we define below, is more likely to stimulate long-term involvement in the arts than is an approach focused solely on arts production.

It seems self-evident that people are more likely to be interested in a field or activity if they have had exposure to it and acquired some knowledge of it in their youth.[1] This is certainly true of career choices, and it appears to be true of leisure activities as well. In fact, studies have found that the more one knows about any leisure activity, the greater one's capacity for engagement in and enjoyment of the experience (Kelly, 1987; Kelly and Freysinger, 2000).

Research on the Influence of Arts Learning in Cultivating Participation

In the case of the arts, it seems reasonable to assume that the influence of arts learning on participation is especially important. If, as we suggested earlier, the arts serve as a form of communication, one that is often subtle and complex, arts learning provides the dictionary, or decoder, for understanding and responding to the language of the particular art form. Stigler and Becker (1977) argue that knowledge, previous artis-

[1] We acknowledge that people can develop new interests at any stage of life and sometimes through a single catalyzing experience. But the more common pattern is for the interest to arise from having been introduced to a certain field or activity and having gained certain knowledge and skills while young.

tic experience, education, and family background are key determinants of arts consumption because they increase the individual's capacity to derive pleasure and value from arts experiences. This effect, of increased capacity, helps explain why participation levels vary so sharply. At one extreme are individuals whose capacity is low or nil and who thus rarely or never seek arts experiences; at the other extreme are those whose knowledge and experience give them a capacity high enough that their desire for arts experiences becomes a kind of addiction (Stigler and Becker, 1977).[2]

Survey data and empirical research offer evidence that education level in general and arts learning in particular are in fact strongly correlated with arts involvement as adults. First, data from the NEA's SPPA in 1982, 1992, and 2002 show that education level is by far the most important individual characteristic in predicting arts participation—stronger than income, occupation, age, gender, or ethnicity. And it is most strongly correlated with the kind of involvement we are discussing: the consumption of art through direct encounters, as compared with media consumption or hands-on participation (NEA, 1998; Robinson et al., 1985; Robinson 1993; Schuster, 1991).[3] Education level is also associated with differences in attitudes toward the arts. On average, the more education one has, the more one values the arts, supports government funding for arts institutions, supports school arts programs, and engages in a wide variety of creative activities (DiMaggio and Useem, 1980).

Second, survey data and analysis reveal that *arts* learning in particular and early exposure to the arts in childhood are strong predictors of adult involvement. In a detailed analysis of the NEA's 1982 SPPA, Orend (1988, p. 40) found that "activities that socialize young people to become consumers of art" (lessons, appreciation classes, and being taken to a performance or exhibition by relatives or friends) "are good predictors of later participation as audience."[4] A 1998 survey conducted by The Urban Institute found similar results (Walker and Scott-Melnyk, 2002).

A handful of studies analyzed the independent contribution of arts-related learning to a person's involvement in the arts later in life. Orend and Keegan (1996), for example, found that music lessons, art lessons, music appreciation classes, and art appreciation classes taken prior to age 25 are all highly correlated with adult participation—and that arts learning occurring after age 12 has a stronger effect than arts learning

[2] Ostrower (2005a,b) describes a national survey's findings that frequent attendees at various arts events express much higher levels of benefits from their arts experiences than do infrequent attendees. They were more likely than infrequent attendees to strongly agree that the art was of high quality (69 percent versus 36 percent), that they learned something, that the experience was emotionally rewarding and socially enjoyable, and that they would go again. Also see her essay in Tepper and Ivey's *Engaging Art* (Ostrower, 2008).

[3] A good summary of the research on determinants of arts participation can be found in DiMaggio and Useem, 1980; and McCarthy, Ondaatje, and Zakaras, 2001.

[4] Orend (1988, p. 136) also found that such learning experiences have a stronger effect on adult participation when they take place later in one's schooling than grade school.

in earlier childhood.[5] They also found that socialization through arts education and exposure to the arts was the key distinguishing factor correlated with higher participation rates among less well-educated persons (p. 105). These results are supported by Bergonzi and Smith's finding (1996, p. 3) that the link between arts learning and adult attendance at arts performances is "about four times stronger than any other factor considered." This holds true whether the learning is school based or community based. Kracman (1996) found that arts instruction provided through the schools is more strongly associated with adult cultural consumption than is community-based arts instruction—or no instruction at all. Two Dutch studies of the relationship between arts education in secondary school and cultural participation 10 to 20 years later also show a positive, though weaker, correlation (Nagel and Ganzeboom, 2002; Nagel et al., 1997). None of these studies, however, completely controls for other possible influences on adult participation—in particular, for family-related factors that may influence decisions to participate in arts learning as a child and in the arts as an adult.[6] Clearly, more definitive research in this area is needed.

Knowledge and Skills That Enable Engagement

If we accept, as the evidence suggests, that arts learning increases the likelihood that a person will engage in the arts later in life, we must then ask whether there is any significance to the *kind* of arts learning. Here, we have no statistical analyses to look to for answers. However, a body of arts education research, based on theory and observation in the visual arts and music, has explicitly addressed this question. The scholars who produced these studies, most of whom were active from the 1960s to the 1980s, share the belief that the primary purpose of arts education is to draw more people into engagement with works of art. Some of these scholars refer to their enterprise as *aesthetic education* because of its focus on developing the individual's capacity for aesthetic experience of artworks. Arguing that the prevailing practice of arts education was too narrowly focused on art-making, they helped articulate a rich tradition of making and analyzing art based on knowledge of its history and aesthetic effects. Their studies helped form the intellectual foundation for the model of visual arts education promoted in the 1980s by the Getty Center for Education in the Arts. That model, which came to be called *discipline-based arts education* (DBAE), influenced the com-

[5] Note, however, that the explanatory power of Orend and Keegan's arts learning variables is not very strong: Variability in arts learning cannot explain most of the variability in current participation (Orend and Keegan, 1996, p. 135).

[6] The probability that an individual will be offered (and accept) the opportunity to experience or study the arts depends on individual factors (such as personal tastes, talents, aptitudes, personality); family factors (such as parental education, resources, presence of the arts in the home); and community factors (such as attitudes of peers, opportunities for study and practice available in schools and the local area) (McCarthy et al., 2004).

prehensive approach to arts education that is now established in the national and state arts content standards described below.[7]

Before we summarize the insights from this literature, however, we must acknowledge that there has been and continues to be a vigorous debate about the overall purpose of arts education. We draw from the aesthetic education tradition (or what some call the humanities-based approach) because these writers address the purpose that interests us in this study. But there are diverse schools of thought on this subject. Those who take a purely arts-based approach (or what some call the studio or performance-based approach) hold that the aim of arts education is to teach students how to create in the art form. Those concerned with youth development argue it can help young people develop such qualities as self-esteem and a greater sense of responsibility to the community. Some educators believe that arts education in schools should be used primarily as a tool for teaching other subject matter.

Given the focus of this study, we turned to those thinkers who advocate the kind of arts education that leads to understanding, appreciation, and aesthetic engagement, an approach that is likely to create future audiences for the arts. These scholars describe certain skills and knowledge that can be taught to all students, regardless of their artistic talent, to enable them to have more satisfying encounters with works of art, now and in the future. We synthesize these learning objectives into four categories—aesthetic perception, artistic creation, historical and cultural context, and interpretation and judgment—all of which can be learned separately but, according to most of these writers, are the most effective when learned in combination.

Aesthetic Perception

As we have suggested, works of art often do not automatically reveal themselves; the aesthetic qualities of a work of art require perceivers who are able to single them out for a particular kind of attention (Greene, 2001, p. 14). Referring to the visual arts, Eisner (1991) describes this skill as "seeing, rather than mere looking," as requiring what he calls an enlightened eye: "We learn to see, hear and feel. This process depends upon perceptual differentiation, and, in educational matter as in other forms of content, the ability to see what is subtle but significant is crucial" (p. 1, 21). Elaborating on such active engagement on the part of the beholder, Greene (2001, p. 13) writes:

> Perceiving a dance, a painting, a quartet means taking it in and going out to it. The action required is at the furthest remove from the passive gaze that is the hallmark of our time: the blank receptivity induced by the television set, the "laid-back"

[7] We draw primarily on the work of Elliot Eisner, Ralph Smith, Harry Broudy, Michael Parsons, Harold Osborne, Bennett Reimer, and Maxine Greene. For an overview of research on aesthetic education and the issues it raises and a description of seminal work on the topic, see Smith, 2004. We do not mean to imply that all of these sources are associated with a single school of thought or that there are no important distinctions among them. But they all offer insights on how to build receptivity to and engagement in the arts.

posture of which the young are so proud. Perceiving is an active probing of wholes as they become visible. It involves, as it goes on, a sense of something still to be seen, of thus far undisclosed possibility. It requires a mental and imaginative participation (even when the mind does not "hold sway"), a consciousness of a work as something there to be achieved, depending for its full emergence on the way it is attended to and grasped.

With good facilitation from the teacher, learners are encouraged to draw on their own powers of observation to describe what they actually see, hear, and feel in response to a work of art. With exercise and guidance, and with instruction on the elements and vocabulary of the art form, learners can increase their awareness of details in the work of art (Parsons, 1987). At the first exposure to symphonic music, for example, it takes a learner's full attention to follow the melodic line from one set of instruments to the other while listening to the orchestra; but with practice, that listener can follow the lines and accompaniments simultaneously. Through repeated experience, "our perception span expands to apprehend larger and larger clusters of sensory stimuli" (Broudy, 1972, p. 68).[8] It is often pointed out that the experience of the same work of art changes as the individual's awareness grows: the individual is able to see more in it, and greater subtlety of perception enriches the experience (Osborne, 1970, p. 171).[9]

It is generally agreed that these perceptual skills are best learned in encounters with masterpieces, exemplary works of art that reward close attention and bring the entire range of aesthetic skills into play. Ideally these works represent a variety of historical periods, regions of the world, and genres of the art form, including folk, popular, classical, and ethnic cultures (Smith, 1995; Reimer, 1992).[10]

Artistic Creation

The knowledge and skills learned through hands-on creative participation in an art form may be the most effective way to teach children how to respond to works of art. Each art form uses a different language for communicating the human experience, and by learning that language, Eisner writes, "children gain access to the kinds of experience that the forms make possible" (1988, p. 5). Part of what is gained in the act of artistic creation is a heightened perception of the world. One of the great ben-

[8] Parsons (1987, p. 13) describes five stages of aesthetic development, or "levels of increasing ability to interpret the expressiveness of works."

[9] In *Enlightened Cherishing: An Essay on Aesthetic Education*, Broudy (1972) writes about how to teach students to be more perceptive of the qualities and expressiveness of artworks in a chapter titled "Aesthetic Education as Perception."

[10] Some of the critics in the humanities community who have turned against quality distinctions in art reject the notion of exemplary works of art, or masterpieces. Yet there needs to be a way to refer to works of art that have had a powerful influence in their fields over the centuries and still exercise their influence now. It can be argued that this kind of influence is detrimental, but until the weight of critical opinion supports this conclusion, *masterpiece* remains a useful term. Smith (1995) offers a thoughtful discussion of how to define excellence in art.

efits of drawing or photography, according to Eisner, is that the child is invited to look more carefully at the world: Through art, the child discovers the visual richness of the world we inhabit (1988, p. 7). The act of shaping those perceptions into a work of art requires a complex synergy of imagination, intellect, craft, and sensitivity that can be known only by interacting with the materials of the art form. It is through the creative act itself that the learner comes to understand the kinds of choices that artists make and the ways in which those choices determine what the work becomes and does not become (Reimer, 1992). Such creative activity deepens the understanding of achievement in any art form.

When taught in combination with the other elements we are describing, learning to create or perform in any art form builds the skills of engagement.[11] In music, for example, learning to perform a challenging work of art requires the kind of attention to the work's components that often develops aesthetic perception and appreciation.[12] There is evidence, however, that strictly hands-on practice in an art form is not sufficient for developing aesthetic perception and response. In studying the effects of a high school visual arts course that focused on artistic creation, Short (1998) concluded that "studio experiences alone do not enhance students' ability to understand or appreciate well-known historical artworks" (p. 46). She argues that transferring understanding from one context to the other requires curricula on the high school level that includes "the critical activities of talking and writing about works of art" (p. 62).

The balance between creating art and appreciating art should shift according to the learners' developmental stage: The mix for students in elementary school will differ from the mix for students in high school, college, or beyond. The very young are strongly motivated to create and perform art, and it is through this direct engagement that other aspects of arts study can be introduced. As students get older, however, it becomes more difficult for them to develop a high level of creative proficiency: "[T]heir ability to develop aesthetic perception and response is far greater than their ability to create in the arts, even if they have chosen to specialize in a program of study that focuses on performance or creation" (Reimer, 1992, p. 46).

Historical and Cultural Context

Relevant factual knowledge is essential to understanding and appreciating art forms and specific works of art. Music, for example, is a universe of different musical worlds,

[11] Some, such as researchers at Harvard University's Project Zero, argue that artistic creation must be the key component of learning in the visual arts. Others, such as many writers in the DBAE tradition, consider the making of art to be one of the components of arts education but not its cornerstone. Both schools of thinking, however, support an arts education approach that integrates multiple perspectives rather than focusing primarily or exclusively on art-making. See Hetland et al., 2007, for a detailed description of the aims and outcomes of a broad-based studio framework for visual arts education.

[12] It is no surprise that many of those who attend classical music concerts learned to play an instrument in their youth (John S. and James L. Knight Foundation, 2002).

such as jazz, blues, choral, folk, and classical, each rooted in a particular context and governed by standards and skills that are constantly practiced, discussed, and modified within the communities of those who make, listen to, and critique music (Elliott, 1991, p. 156). It is often necessary to acquire some knowledge of the historical evolution of artistic practice in order to understand the full dimensions of an individual piece. But such knowledge must be assimilated: "If assimilated, it can transform seeing, hearing, and aesthetic understanding" (Reid, 1971, p. 169). As experts in aesthetic education emphasize, the function of historical and cultural knowledge is to provide individuals with new and more-sensitive points of contact with works of art.[13]

In an extended account of musical literacy—or "the ability to understand the majority of musical utterances in a given tradition"—Levinson (1991) writes about that assimilation. Contextual knowledge, as he calls it, allows us access to musical works, but real growth in our capacity to respond to them comes from accumulated listening experiences (p. 19). As an illustration, Levinson asks us to consider a first-time listener being confronted with the first movement of Bruckner's Fourth Symphony. What is minimally needed, he asks, particularly in terms of contextual knowledge, for that listener to hear and respond to what Bruckner is "saying" in this piece of music? Levinson lists ten competencies, which include familiarity with tonal music, understanding of the symphonic form, some sense of the style of Romantic music, and some expectation of the music's flow or progression. There are a number of ways to acquire this familiarity, including taking courses in music and reading about music.[14] But Levinson emphasizes that ultimately this knowledge is refined by cumulative listening experiences that relate what is being heard to what the listener knows about patterns, norms, and facts lying outside the music itself: "Comprehending listening is a process of constant, largely unconscious correlation, and a listener without a 'past' will be incapable of having it proceed in him in the right way" (p. 27). It is through the gradual acquisition of such a past, through learning and recurrent listening experiences, that individuals develop the musical literacy needed to achieve increasing levels of pleasure and appreciation from the art form. It seems likely that a combination of knowledge and perceptual skills achieved through successive arts experiences is what brings many individuals into lifelong engagement with classical music.

Interpretation and Evaluation

Finally, learners are encouraged to develop the skills of analyzing, critiquing, and drawing meaning from works of art. There are multiple names for these skills, such as appre-

[13] For an interesting discussion of the kind of knowledge required to be relatively literate in different art forms, see Smith, 1991. The chapters of particular relevance to this discussion are Sparshott's "Contexts of Dance," Gillespie's "Theater Education," Hirsch's "Contextualism: How Do We Get There, and Do We Want To Go?" and Levinson's "Musical Literacy."

[14] Musicians who read this may well argue that music theory provides the most profound insights into what is going on in Bruckner's Fourth Symphony, at least into what is going on musically.

ciation, aesthetic valuing, interpretation, criticism, and judgment. But they all draw on reflection and conversation, which develop the learner's skills in a several ways. First, as already mentioned, discussion offers learners the opportunity to test their perceptions against those of others and recognize what they may have missed. Once learners become aware that their perceptions have limitations, discussion—whether direct or through books, journals, and other media—can enlarge their view of the work, draw their attention to details they overlooked, and generally invite them to look again and reconsider (Reid, 1971). This is the activity we described earlier, in Chapter Two, as the critical response to a work of art (see Figure 2.1) that plays such a key role in the communicative cycle stimulated by the arts.

Second, discussions of shared works of art offer an opportunity to discover what those works mean to individual perceivers. Making an aesthetic judgment is essentially a personal step—that is, there is no final arbiter of interpretation, no substitute for sensitive experience. However, through conversation and debate (both live and mediated through reading and study), aesthetic awareness grows in ways that can enlarge the individual's experience of a work of art. Because meanings in works of art are typically implicit rather than explicit, these reflections and discussions also invite the individual to embark on what Bruner (1986, p. 25) calls "a search for meanings among a spectrum of possible meanings." Addressing this point, Beardsley (1982, p. 292) writes that one of the most important aspects of the aesthetic encounter is "the experience of discovery, of insight into connections and organizations—the elation that comes from the apparent opening up of intelligibility." He calls this aspect "active discovery" to suggest the cognitive challenge of making sense of something previously unknown, a process that can reshape the individual's understanding of the world. Conner (2008) describes the pleasures of active discovery in educational programs for audiences of theater performances and advises against programs in which experts lecture from a position of authority. What the audience really wants from an arts event, she argues, "is the opportunity to coauthor the arts experience. They don't want to be told what the art means. They want the opportunity to participate—in an intelligent and responsible way—in telling its meaning" (p. 14). Taylor (2006, p. 5) makes this point in a slightly different way:

> Consider any powerful, transformative moment you've had with an act or artifact of creative expression. That moment required at least TWO lifetimes to form its value—your lifetime to that moment and the artist's. There was a resonance between your experiences or emotions and the expressive voice. The moment required them both. The value was co-constructed.

Third, the act of discussing observations with others engages the individual with a community of beholders and a world of shared reality, an engagement we mentioned earlier as one of the critical functions of the arts. According to Parsons (1992), a characteristic of later stages of aesthetic development is the movement from expression of

what is experienced in terms of mere personal preferences, or subjective likes and dislikes, to a closer understanding of the work of art itself, and sometimes of themselves and others. As Bruner (1986, p. 63) puts it, "Joint and mutual use of language gives us a huge step in the direction of understanding other minds. . . . Achieving joint reference is achieving a kind of solidarity with somebody."[15]

Policy Endorsement of a Comprehensive Approach

When many of the studies we have drawn on were written, national and state standards and traditions that shaped arts education were different in structure and approach for the various disciplines, and they focused most on knowledge and skills for performance. But from then until now, there has been a constant evolution toward greater breadth. There are still divisive battles among arts educators over the appropriate aims and content for instruction, but a remarkable consensus has been achieved, in policy if not in practice, with the creation of arts content standards. Based on a long tradition of practice and research in both the arts-based and the humanities-based approaches, the standards endorse the intrinsic purposes of arts education and call for a comprehensive approach to teaching art that develops both performance and appreciation skills.

The national standards were developed in 1994 within the context of a general education reform calling for content standards throughout the K–12 curriculum.[16] In brief, these standards for arts content (National Association for Music Education, n.d.) set forth "what students should know and be able to do . . . by the time they have completed secondary school":

- They should be able to communicate at a basic level in the four arts disciplines: dance, music, theatre, and the visual arts. This includes knowledge and skills in the use of basic vocabularies, materials, tools, techniques, and intellectual methods of each arts discipline.
- They should be able to communicate proficiently in at least one art form, including the ability to define and solve artistic problems with insight, reason, and technical proficiency.
- They should be able to develop and present basic analyses of works of art from structural, historical, and cultural perspectives, and from combinations of these

[15] For an interesting discussion of the effects of collaborative work in the arts—both performance and discussion—see Stevenson and Deasy, 2005. The concept of "third space" that they introduce refers to the public space within which relationships are forged between artists, students, and teachers, creating a strong sense of community within which students are encouraged to become more actively engaged in their own learning.

[16] They came about through the leadership of the four major national teachers' associations for specialists in art, music, dance, and theater. Written by task forces of professional arts educators from elementary, secondary, and higher education, the standards are a formulation of the objectives that these professionals identified as the primary elements of their discipline.

perspectives. This includes the ability to understand and evaluate work in the various arts disciplines.

- They should have an informed acquaintance with exemplary works of art from a variety of cultures and historical periods, and a basic understanding of historical development in the arts disciplines, across the arts as a whole, and within cultures.
- They should be able to relate various types of arts knowledge and skills within and across the arts disciplines. This includes mixing and matching competencies and understandings in art-making, history and culture, and analysis in any arts-related project.

By the late 1990s, 47 states had endorsed the national standards or developed some version of them. Although these state standards differ from each other in terminology and sometimes in content, they all call for a comprehensive approach to arts education that emphasizes performance, aesthetic response, and historical knowledge. In this way, they transcend methodological debates and define common ground. Although the standards have not been broadly implemented within states or school districts—and will not be unless there is an enormous influx of funds and many more arts specialists are trained—they are influencing teaching practice, as described in the next chapter.

The Support Infrastructure for Youth Arts Learning

In the last chapter, we described the knowledge and skills that enable individuals to experience deeper engagement with works of art. In this chapter and the next, we examine the extent to which children and adults have access to the kind of instruction that develops that capacity. Although we focus on schools and colleges, where most of the instruction and resources exist, we describe the entire institutional infrastructure for arts learning.[1] Data shortcomings are always the key limitation in such analyses. We used whatever data were available and relatively current to describe the amount of instruction delivered, populations reached, and general content of the learning provided in different parts of the system. The result is necessarily sketchy, but we believe such a broad systems perspective, which is rarely attempted, will help arts and education policymakers assess how well American institutions are functioning, make better decisions about which parts of the system can most benefit from intervention, and identify strategies that are the most likely to improve outcomes of interest.

We classify institutional supports for youth arts learning into four main components, as illustrated in Figure 4.1:

1. *The K–12 public school system,* which is the primary source of arts education for the young. No other system has the access, resources, and responsibility for ensuring that young people have equal opportunity to become knowledgeable about the arts.
2. *Publicly supported after-school programs based in schools,* which constitute an arts learning source that draws on a multitude of arts providers in the communities around schools.
3. *Arts learning in the community,* which consists of the learning opportunities offered by arts organizations, community service organizations, and community schools of the arts.
4. *Higher education,* which plays several critical supporting roles within the support infrastructure, the most important of which is training teachers who work in

[1] We focus on the institutional level rather than specific programs or individuals. We do not describe arts learning provided in the home or by individual private instructors, for which we have no data.

Figure 4.1
Support Infrastructure for Youth Arts Learning

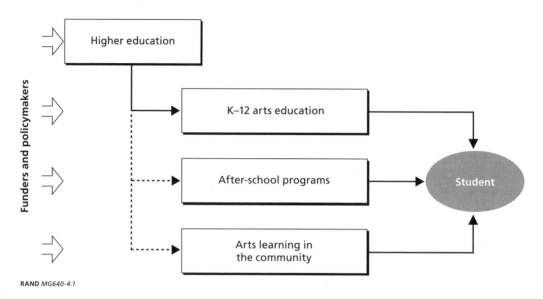

RAND *MG640-4.1*

the K–12 system and offering ongoing professional development. Many colleges and universities also house museums, performing arts centers, and community schools of the arts, all of which offer educational programs. Some also contribute to after-school programs in the arts.

Beyond these four main delivery systems are multiple supporting organizations—including philanthropic funders, government agencies, professional associations, parent groups, and many others that advocate reforms and influence policy—all of which we show as funders and policymakers in Figure 4.1.[2]

In the following discussion, we describe the system characteristics of each component of the support infrastructure, including recent trends that have shaped them. To the extent the data allow, we describe the amount of instruction and the nature of its content, defining content in terms of the national arts content standards. In particular, we are looking for signs that instruction includes developing learners' aesthetic skills and imparting the historical and cultural context that enriches responses to works of art. We acknowledge, however, that comprehensive arts instruction takes more time and more resources than narrowly focused instruction does, and that time and funding are serious constraints in the public school system.

We emphasize the schools in our overview, and the education policies that sustain them, because public education has the broadest responsibility and the most resources

[2] One component of this funding and policy support structure for arts learning, the SAA, is discussed in Chapter Six.

for providing equitable access to arts learning. Community-based programs cannot be expected to be as comprehensive, sequential, or far reaching as school instruction, but they can complement school instruction in significant ways. One of the most positive developments we describe is the trend toward greater integration of community-based and school-based programs to provide more comprehensive arts learning to students. A single high-quality program with a limited purpose can be effective in getting young people engaged with an art form; for example, a mentoring program that pays for theater enthusiasts to take a few high school students from low-income families to a play and spend 90 minutes discussing the experience with them afterward (the Open Doors program supported by the Theater Development Fund in New York), or a museum tour for children that invites them to look at paintings in a specific way. Such one-time programs can play an important part in creating interest in the arts and are particularly effective when combined with comprehensive school-based arts programs that build greater skills over a longer period of time.

K–12 Arts Education

Structural Characteristics

Formal arts education is delivered within the vast U.S. public school system, which consists of approximately 92,000 schools and 15,000 school districts. Development of this system was highly decentralized, decisionmaking taking place mainly at the district and school levels. Trends in governance over the past few decades, however, have led to greater centralization of decisionmaking at state levels and even the federal level. States now control about half of the funding that goes to education, and there are spending restrictions on an increasing percentage of the funds they allocate to districts (U.S. Department of Education, National Center for Education Statistics, 2006). Besides their control of funding, state departments of education determine which subjects must be tested and how, stipulate the proficiency standards that must be met, select instructional materials, and mandate core curriculum. In sum, even though local school boards still administer the education provided in the schools—making most decisions about individual school finances, hiring and firing, and sometimes the textbooks and curricula that are adopted—their discretion has become increasingly constrained since the 1990s. They have fewer flexible dollars for their districts to allocate as they see fit and less freedom to pursue local reforms (Howell, 2005; Augustine, Epstein, and Vuolo, 2006; EdSource, 1996–2008).

Discretion with regard to arts education, as opposed to general education, rests much more firmly with districts and individual schools, however. Although almost every state now mandates standards-based arts education, states have not provided the resources, incentives, or accountability mechanisms needed to carry out that mandate. As a result, arts instruction exists only to the extent that school districts and individual

schools decide to offer it. Thus, for example, a school will not have a music program unless the school board decides that music study is important enough to provide the supporting resources for it, including a qualified teacher, a sequential curriculum, and sufficient time in the school day. This decentralized authority means that the arts are only included and sustained in the school day if they are continually justified at the local level by arts specialists, parents, and community activists.

Pressures for accountability in non-arts subject areas and decreases in districts' discretionary budgets have created hostile conditions for sustained arts education. Many principals report that exemplary arts programs exist because of a single arts education champion, often an arts specialist but sometimes a principal or superintendent. They also report that when that catalyst moves on or retires, the programs may lapse.[3]

Three national reform movements in general education over the past 15 years have considerably affected arts education:

1. the push for content standards in every academic discipline
2. educational test-based accountability focused on language and mathematics
3. reforms in teacher licensure and certification programs (Sabol, 2004).

The first of these galvanized the arts education, arts policy, education, and arts communities to join together in an unprecedented collaborative effort to articulate national standards in each of the arts disciplines. The second imposed accountability measures, such as standardized testing, to determine whether students were meeting achievement goals, especially in language and mathematics and exclusive of the arts. As a result, a few state departments of education developed and implemented assessments of learning in the arts, and once the fine arts had been added to the national education goals, they were included in the National Assessment of Education Progress (NAEP) (U.S. Department of Education, 1994). These assessments were not, however, funded at the same levels as assessment for other subjects; nor were they made subject to test-based accountability, which imposes sanctions if students fail to learn the subject matter. The third reform, concerning certification, was stimulated by the standards movement and the assessments that followed, which raised questions about why schools were not following content standards and brought renewed calls for more-rigorous teacher licensing in all subjects, including the arts (Council of Chief State School Officers, 1992; National Art Education Association, 1999; NEA, 1988). This call for reform at the federal policy level initiated reforms of state certification policies and helped spread the use of improved models for teacher preparation and certification in the arts.

These developments call attention to the peculiar predicament of arts education today. On the one hand, the creation of both national and state content standards in music, theater, dance, and visual arts represents a great advance in the field. The stan-

[3] See, for example, Washington State Arts Commission, n.d.

dards express the uniqueness and value of each arts discipline, especially theater and dance, for which content guidelines had seldom been developed in the past. They also represent a consensus that never existed before about the key aspects of arts study. On the other hand, content standards do not necessarily translate into improved arts learning in the classroom. In today's climate, some argue that in the absence of standardized testing and assessment, arts standards are not likely to be budgeted.[4] And if they are not budgeted, they will not be implemented, and school districts will be unable to find the human and material resources needed to teach to them.[5] Yet assessment in the arts does not lend itself to standardized testing in the way that fact-based disciplines do. The skills and knowledge called for by proponents of comprehensive arts education might be more appropriately assessed through open-ended responses and possible portfolio assessments.

Of course, schools, like all organizations, have always had to contend with budget constraints. But because the arts have always been considered peripheral to the main educational enterprise, they are particularly vulnerable to elimination from the curriculum when budgets get tight. In the 1970s and 1980s, thousands of arts specialists in urban school districts lost their jobs because of budget cuts, and entire arts education programs were dismantled in some areas (Caterall and Brizendine, 1984; Jackson, 2007). The NEA, SAAs, and private foundations responded by providing grants designed to help schools keep at least some form of their arts education programs going (Bumgarner 1994a,b). Today, many schools rely on these grants, which in some cases represent the only available funding for arts education.

Amount and Reach of Instruction

How much arts education is the public school system delivering, and how many children does it reach? Because authority for arts education largely resides with individual schools and school districts, it is difficult to answer these questions. Even within school districts, good data on arts education are difficult to come by, and state-level data are seldom collected. Several states, however, have recently conducted surveys of the arts education programs offered in their public schools, and the U.S. Department of Education conducted national surveys in 1984–1985, 1994–1995, and 1999–2000 (Carey et al., 2002). These provide a glimpse of the general landscape.[6] Other data come from

[4] As of this writing, only one state, Kentucky, has a state-level arts assessment. Eight states require district-level arts assessments (Education Commission of the States, 2005).

[5] In a recent national survey of elementary and secondary principals, the overwhelming majority cited insufficient funding as the most intractable problem in providing arts education, a challenge that is even more acute for low-income and high-minority schools (von Zastrow and Janc, 2004).

[6] The surveyed states are Illinois, Kentucky, Washington, California, New Jersey, and West Virginia. See Illinois Arts Alliance, 2006; Collaborative for Teaching and Learning, 2005; Washington State Arts Commission, 2006; Woodworth et al., 2007; New Jersey Arts Education Census Project, 2007b; and Appalachian Education Initiative, 2006.

a survey of public school principals in Illinois, Maryland, New Mexico, and New York to determine trends in resource allocation to arts education in the schools since the federal No Child Left Behind Act (NCLB) was implemented (von Zastrow and Janc, 2004).

Elementary School. According to the 1999–2000 national survey, almost all elementary students receive some arts instruction in music and visual arts, but few get instruction in theater or dance (14 percent of elementary schools responding offered theater, and 20 percent offered dance). The survey indicates that elementary students get an average of just over 60 minutes per week of music instruction and a few minutes less per week of visual art instruction (Carey et al., 2002). State surveys are somewhat more pessimistic: According to principals in Illinois, for example, elementary students receive only 40 minutes of arts instruction per week, almost exclusively in music and the visual arts. In Washington and New Jersey, instructional time for music and the visual arts is closer to 45 minutes per week, but again, only in music and the visual arts. In contrast, a recent U.S. Department of Education survey indicates that elementary students receive each week approximately 11.6 hours of instruction in language arts, 5.4 hours in mathematics, 2.5 hours in social studies, and 2.3 hours in science.[7]

Two states—Illinois and Washington—report that a significant proportion of elementary students are receiving no instruction in the arts at all. In Washington, for example, 18 percent of students receive no music, 34 percent receive no visual arts, 73 percent receive no drama, and 81 percent receive no dance, leaving some students with no arts instruction in any of these disciplines (Washington State Arts Commission, 2006). In Illinois, about one-third of students in any elementary grade receive no instruction in any of the arts (Illinois Arts Alliance, 2006).

There is also evidence that arts education at the elementary level is declining. In Illinois, Maryland, New Mexico, and New York, one-quarter of public school principals reported cutbacks in the arts, and 36 percent of principals in low-income schools reported such cutbacks over the past five years (von Zastrow and Janc, 2004). According to a report on music in California public schools, more than 1,000 music specialists lost their jobs between 1999 and 2004, representing a loss of more than one-quarter of all music specialists in the state, and the number of students taking music classes declined by 50 percent (Music for All Foundation, 2004). A representative survey of 349 school districts across the country found that most elementary schools have increased instructional time in tested subjects (by 46 percent in English and 37 percent in mathematics) in the five years since NCLB took effect. In 44 percent of school districts, the increases in instruction for these tested subjects came at the expense of instruction in social studies (reduced by 36 percent), science (reduced by 28 percent), and art and music (reduced by 16 percent) (Center on Education Policy, 2007, p. 7).

[7] These are our calculations using data on students in grades 1 through 4 from Morton and Dalton (2007) but based on the 40-week school year assumed by Carey et al. (2002).

Although the class time allocated for arts education has been slipping, the teachers at the front of the classroom tend to be arts specialists. National data show that in 92 percent of elementary schools, music instruction is provided by a full- or part-time arts specialist. In visual arts, the proportion is 72 percent. The state data show similar patterns: In New Jersey, over 95 percent of instruction in music and the visual arts in both elementary and high schools is provided by certified arts specialists (New Jersey Arts Education Census Project, 2007b). In Kentucky, 90 percent of music instruction and 67 percent of visual arts instruction are offered by certified specialists (Collaborative for Teaching and Learning, 2005). In West Virginia, the majority of music instruction at all grade levels is offered by music specialists, a percentage that increases from grade 1 through grade 8. The figure is lower for the visual arts in the early grades but shows the same trend, increasing in percentage with each grade level. A very high percentage of music and art students in grades 7 and 8 receive instruction from arts specialists (Appalachian Education Initiative, 2006). In California, by contrast, only 25 percent of elementary schools have one or more full-time-equivalent arts specialists (Woodworth et al., 2007).

State data also reveal substantial socioeconomic disparities in access to arts education. In California, for example, students in low-income schools receive about one-half the amount of arts education that students in affluent schools do.[8] Even schools described as "medium poverty" get substantially more arts education than very low-income schools. Inequities are also created by "shadow" funding mechanisms. Most of the funding for arts education is provided by parent groups in 59 percent of public schools in affluent areas, compared with 11 percent of public schools in low-income areas (Woodworth et al., 2007, p. 15). Other private funds, such as business and foundation grants, provide most of the funding in 17 percent of affluent schools, compared with 7 percent of low-income schools. In New Jersey, an average of 43 percent of funding for arts education, excluding salaries and one-time capital expenditures, is provided by sources external to the school district. This percentage is higher in affluent than in low-income school districts.[9]

Middle and High School. The majority of students in U.S. middle and high schools are no longer required to take arts courses. Few states (12, as we wrote this document) require any form of arts education for graduation from middle school; for high school graduation, 21 states require at least one arts course, and 15 require students to choose between an arts course and a course in another subject, such as the practical arts or

[8] Only 25 percent of students in California's low-income schools receive music instruction, compared with 45 percent in the state's affluent schools. The comparable numbers for the visual arts are 29 versus 49 percent; for theater, 8 versus 17 percent; for dance, 7 versus 17 percent (Woodworth et al., 2007, p. 13).

[9] However, the New Jersey survey found no connection between schools' arts education offerings and the surrounding community's income levels.

physical education (Arts Education Partnership, "Arts Requirement for High School Graduation," n.d.).

Because arts classes are typically electives after grade 6, participation in arts education classes drops off in middle school and is minimal by the time students reach high school.[10] Chapman (1982a, p. 74) called high school students the "neglected majority" 25 years ago, and little has changed since then. In California high schools, for example, just 25 percent of students take visual arts in any given year, and only 14 percent take music, 8 percent enroll in theater courses, and 4 percent take dance (Woodworth et al., 2007). In New Jersey in 2005–2006, 39 percent of high school students enrolled in a visual arts class, 39 percent in music, 6 percent in theater, and 5 percent in dance (New Jersey Arts Education Census Project, 2007b). There is also evidence that few high school students enroll in more than a single introductory course in any of the artistic disciplines. The Kentucky survey, for example, shows a steady decline in the proportion of high schools that offer more than one year of music study: 65 percent offer one year of music, 50 percent offer two years, 41 percent offer three years, and so forth (Collaborative for Teaching and Learning, 2005). In Illinois, most high schools offer fewer than four visual arts courses and only one or two music courses, one theater course, and no dance courses each year (Illinois Arts Alliance, 2006).

These findings show that as students mature, they are less likely to pursue courses in the arts. Of all the age groups, teenagers are the least likely to receive arts education that could foster their interest in future participation in the arts. We also found little evidence of high school arts courses for students not interested in making or performing works of art. As we point out in the next chapter, college campuses offer a full range of such courses, many of which would be appropriate for high school students.

Content of Instruction

Few recent studies have been conducted on the content of arts education, but studies whose results have been published in the past 25 years suggest that the scant arts education offered is rarely broad or rigorous and is often narrow and casual. The NEA's *Toward Civilization* report (1988) found that arts education in American schools focused on teaching the skills of creating and performing, not on imparting historical or analytic knowledge about the arts. Studies on education in specific arts disciplines tend to confirm that assessment. Chapman (1982a), for example, found that the prevailing educational practice in visual arts education focused narrowly on creative art activities—not to be confused with rigorous studio instruction—"without a corresponding emphasis on teaching for appreciation" (p. 11). Chapman found that because early education in the visual arts was so scant and nonsequential, 75 percent of the high school teachers she surveyed taught drawing, design, painting, sculpture, and ceramics

[10] The West Virginia survey, however, shows that a high proportion of middle school students take both music and visual arts.

in the same way teachers taught them in elementary and middle school (p. 75). Since we have no evidence that any state public school systems have implemented sequential arts education, it is likely that this practice is still prevalent.

Gillespie (1991) makes a similar point about theater education: "[I]t is fragmented and discontinuous; that is, the college curriculum assumes nothing from high school, nor the high school from the elementary school. . . . It pays relatively little explicit attention to aesthetic issues at any level" (p. 38). Theater education in elementary school, according to Gillespie, focuses on the personal and social development of students through the performance of dramatic skits. Plays are typically either improvised or written for the specific age group; children are seldom introduced to standard plays, even versions rewritten for an age group (pp. 35–36). In high school, students receive more-rigorous instruction in production and performance, especially acting and technical theater, but aesthetic and historical learning is still neglected. Students do not even develop familiarity with substantive works of drama through performance. Since World War II, not one play by a recognized master of Western drama has been among the 20 most frequently produced high school plays. The criteria in these selections are recreation and entertainment rather than cultural enrichment (p. 36). Only in college can students find theater courses that include history, criticism, and theory of drama, courses in which the classics of Western drama make up an important part of public performances (p. 36).

The music curriculum in many high schools also concentrates on teaching the knowledge and skills associated with performance, in this case through such instrumental ensembles as band, orchestra, and choir. Classes typically have a rehearsal/concert format (Schwadron, 1988). The proliferation of competitions among school bands and ensembles reinforces the pressure to achieve excellence in performance at the cost of other arts educational goals (Reimer, 2003; Fowler, 1988, 1996; Kirchhoff, 1988; Detels, 1999). According to Fowler (1996, p. 33), many U.S. high school arts programs "confine their educational focus to what is essentially vocational training."

Since state standards for arts learning were established, however, the content of instruction has been evolving to reflect them. Given that there have been no increases in the time or resources devoted to the arts—in fact, there is some evidence of decreases in both—this can only mean that some small portion of existing instruction has been redirected to align with the content described in the standards. This alignment is a far cry from implementation of the standards, but it does reflect greater agreement that the objective of arts education is not totally reducible to making art. The 1999–2000 national survey indicated that about 75 percent of elementary school curricula and 80 percent of high school arts curricula were "aligned" with state standards. In a recent survey of high school visual arts instructors, 90 percent of respondents reported that their curricula were aligned with the national standards (National Art Education Association, 2001).

The few state surveys that asked about alignment found less observance. In California, for example, survey results showed that most K–12 schools (60 percent) had aligned their instruction with the standards in one or more disciplines. In Washington, however, the survey found that just 40 percent of music teachers and 24 percent of visual arts teachers had aligned their curricula with state standards in elementary school, and fewer than 20 percent of all other classroom teachers and arts specialists in the various disciplines and at all grade levels had aligned their instruction with the standards.

Professional Development

Professional development (also called *in-service training*) of practicing teachers, another critical part of the support infrastructure for K–12 arts learning, has grown in importance over the past 10 years with the push toward standards-based arts curricula. Because most general classroom teachers have had little or no training in the arts, they need rigorous professional development in order to be responsible for arts instruction in their classrooms. And even then, it is unlikely that the full range of knowledge and skills needed to teach to the standards can be developed in teachers who do not already have a strong arts background. Yet many types of institutions—colleges and universities, arts education associations, community-based arts education organizations, arts organizations, etc.—have stepped up to this task, as we describe in a later section. These institutions have received support from state departments of education, but also from the NEA, which has a tradition of offering professional development to general classroom teachers, arts specialists, and teaching artists. State and local arts agencies have also played important roles in this area. Professional training takes a number of forms, including in-school seminars or conferences, workshops with artists or arts groups, and programs on college campuses.

As in other parts of the arts teacher education system, there are few public data on these programs. The state surveys mentioned earlier provide some statistics on the proportion of districts offering professional development opportunities to general classroom teachers and arts specialists, but little is known about the number of programs, their quality, and the proportion of arts teachers who take advantage of them.

After-School Programs

A growing proportion of youth arts learning in the United States is occurring in the vast and expanding arena of after-school programs.[11] Participation in these programs is

[11] These are often referred to in the field as out-of-school-time (OST) programs. In this report, the term *after-school programs* means all school-based programs that take place before and after school and on weekends. Our definition does not include after-school activities not organized with the help of schools or government agencies and not receiving public or private charitable funding (for example, private piano lessons).

voluntary, however, so with the exception of some subsidized programs in low-income areas, families are responsible for finding and paying for their children's participation. As with arts education in the public schools, after-school arts programs, as we describe below, have been shaped by a number of factors having nothing to do with the arts.

Structural Characteristics

The after-school sector is a huge, decentralized collection of heterogeneous providers largely disconnected from one another. Over the past 50 years, this sector has developed rapidly in response to various economic and social changes, including the movement of large numbers of women into the workforce and the increasing number of single-parent and other nontraditional families. Over time, pressure has mounted from families and others to improve this sector's quality and expand its scope; as a result, many people now see after-school programs as a means for addressing social problems. For example, the federal government now spends $1 billion annually on after-school programs, primarily for at-risk youth. National and local charitable foundations, which were the first major funders of after-school programs, are still extremely active in helping communities improve and coordinate after-school care (Bodilly and Beckett, 2005).[12] Taken together, these trends have helped shape an alternative delivery system for arts learning that previously did not exist.

At the local level, after-school arts programs are often housed within a large network of providers—some massive and districtwide, and some smaller and focused on specific populations. Two examples in Los Angeles help illustrate this range.

Beyond the Bell, a branch of the Los Angeles Unified School District, serves the district's 700,000 students.[13] It is an umbrella organization for about 25 separate programs, some of which reach as many as 500 schools. These programs have different content, intended age groups, and objectives. The arts-based programs, which represent 40 percent of Beyond the Bell's "enrichment" offerings (which it distinguishes from its learning and tutoring programs), primarily focus on achieving various youth-development outcomes through artistic creation and performance.

The other example is LA's Best, which falls loosely under the umbrella of Beyond the Bell but operates independently from offices in Los Angeles's city hall.[14] This model after-school program is a partnership between the city of Los Angeles, the Los Angeles Unified School District, and philanthropic business leaders. It targets the neediest children—a requirement for eligibility for federal funds—and its programs are offered at no cost to participants. Starting in 1988 with 10 schools, LA's Best now reaches 28,000 students in 189 schools. All students in the program get daily home-

[12] Bodilly and Beckett (2005) provide an informative description of the evolution of OST programs over the past 30 years.

[13] See Beyond the Bell, n.d.

[14] See LA's Best, n.d.

work assistance plus instruction in mathematics and science, and in the past four years have been given a choice of sports or the arts as an elective.

The extensive network of programs created by LA's Best provided an opportunity for the creation of the After-School Arts Program (ASAP) in 2003. This program offers 10-week arts classes that meet once a week for two hours and culminate in a performance or public exhibit.[15] All teachers in this program, who are either teaching artists from the community or graduate students in fine arts from the University of California, Los Angeles (UCLA), are required to create a standards-based curriculum. Some of the most important cultural institutions in Los Angeles (the Music Center and the Los Angeles County Museum of Art, for example) are partners in ASAP. This program's outcomes have been evaluated, and ASAP is emerging as a model for other after-school arts programs across the country.

Amount and Reach of Instruction

We have no data on the amount of instruction or the number of K–12 children reached by after-school arts programs nationwide or statewide. Data from the U.S. Census Bureau show that nationally, in 2000, 59 percent of all children from 6 to 17 years old (or 28.4 million children) participated in one or more extracurricular programs, classified as sports, clubs, or lessons (Lugaila, 2003). It is impossible to tell what proportion of these 28.4 million children engage in arts programs. A few cities—notably Boston and New York—are committing substantial resources to mapping their after-school programming, identifying who is offering what to whom, providing more oversight for program development, and introducing standards for providers.[16] But overall, after-school programming is so decentralized and lacking in data and research that it is difficult to characterize or evaluate (Bodilly and Beckett, 2005).

The Kentucky survey of arts education offers a rare glimpse of the reach of after-school arts programs in one state. As shown in Table 4.1, after-school music programs are available in 43 percent of all elementary schools in the state, and that proportion increases in the middle schools and high schools. Drama programs also become much more common at higher grades.[17]

[15] Although each program consists of only 20 hours of instruction, it is frequently the only instruction in the arts that these children receive. For children who receive arts instruction in school, this 10-week program nearly doubles the average number of hours of arts instruction they get for the year.

[16] Boston, for example, has been recognized as leading the nation in serving the after-school needs of children 6 to 12 years of age. Boston's After-School for All partnership, a public-private initiative of 15 philanthropic, educational, and business organizations and government agencies, has committed more than $26 million over five years to expand and improve the after-school sector (Boston After School and Beyond, n.d.; Bodilly and Augustine, 2008).

[17] Kentucky's after-school arts activities are taught by certified or licensed arts teachers (36 percent), noncertified teachers (16 percent), artists (19 percent), and volunteers (33 percent).

Table 4.1
After-School Programs in the Arts in Kentucky Schools

Type of school	Percentage of Schools with After-School Program in:			
	Music	Visual Arts	Dance	Drama/Theater
Elementary	43	33	16	24
Middle	60	27	19	41
High	66	31	21	55

SOURCE: Collaborative for Teaching and Learning, 2005.

Content of Instruction

Again, there are few data on the content of after-school arts programs. We know of some programs, such as Los Angeles's ASAP, that are incorporating instruction that responds to each of the arts standards. By so doing, ASAP is more likely to serve broader aims, including the development of individuals with the skills to appreciate the arts. Most after-school arts programs have not been formally evaluated with respect to outcomes, however.[18] And they probably will not lend themselves to evaluation, since they were not designed as proper objectives-based instructional programs. That is, they are not, according to Colwell (2005, p. 22), "coherent, sequential programs that, if well executed, will lead to valuable and expected outcomes."

The scope and quality of instruction in after-school arts programs should improve as the after-school sector addresses a number of challenges. According to Wynn (2000, p. 4), these challenges include "the absence of a clear mandate regarding their primary function; the lack of program standards and substantial variation in program quality; a host of operations impediments related to facilities, staffing, administrative supports, and financing; and the need for identified outcomes and an attention to accountability for achieving them." A growing body of research is highlighting the need for standards, evaluations, and the development of effective practices in this largely unregulated terrain (Pittman, Irby, and Ferber, 2000; Connell, Gambone, and Smith, 2000; Walker and Scott-Melnyk, 2002). Given these challenges, and the focus on youth-development outcomes, most arts-focused programs in the after-school sector are unlikely to build the knowledge and skills associated with long-term engagement in the arts.

Arts Learning in the Community

The other major institutional players in arts education are arts organizations, community service organizations, and community schools of the arts. Besides offering their own

[18] We base this statement on our survey of the literature and conversations with arts and education policymakers.

learning opportunities, many of these institutions also contribute to the K–12 public school system and after-school organizations. Unfortunately, the data and research on community-based arts learning are scant. The few studies done on this area tend to be case studies of exceptional programs. We discuss some of these to give an idea of how institutions other than schools are helping to develop individual capacity for aesthetic experiences with works of art. Note, however, that the nature of our sources biases our account in favor of individual programs that appear to be most effective. It also prevents us from providing an overview as we did in describing arts education in the K–12 system. We do not know, for example, how many such programs exist or how many children they are reaching. We can only estimate that the number of children is vastly smaller than the number reached through school-based arts education.

Arts Organizations

Arts organizations have been offering special programs to students for decades, in the schools, in the community, and in their own spaces. In the 1970s, when a large number of urban public schools lost a high proportion of their qualified arts teachers, many of their communities turned to resources offered by non-school organizations to help stem the disintegration of arts education. National foundations and federal arts policy encouraged this development—*Coming to Our Senses: The Significance of the Arts for American Education*, a 1977 report by the Arts, Education, and Americans Panel, led by David Rockefeller, proposed a national arts education policy founded on such collaborations—and initiated a flow of federal, state, and local funding to support it. Public and private funders established grant programs that created financial incentives for schools to form partnerships with arts organizations in their communities and to engage local artists in residencies. As funding from these sources expanded, more and more schools drew on these programs, and today's arts organizations have an established place in the arts education landscape.

The best data on these programs are collected by the national service organizations for performing arts institutions. According to an annual survey conducted by the American Symphony Orchestra League (2006),[19] for example, the great majority of educational performances in 2005 were offered to elementary school children: The combined programs of the 109 symphonies surveyed reached 400 elementary schools, 130 middle schools, and 66 high schools. The large to midsize orchestras have staffs of two to four in education and community relations, which are usually housed in one department. Theater companies, in contrast, aimed their education efforts primarily at adolescent audiences. Theatre Communications Group's education survey for 2005 found that 55 percent of their members' educational programs were geared to ages 12 to 18 years, 25 percent were geared to ages 5 to 11, and the rest were geared to adults of

[19] The league changed its name to the League of American Orchestras in fall 2007.

various ages. Student matinees were their most prevalent type of program, along with workshops and classes offered at the school, and residency programs (Renner, 2006).

Arts organizations are also involved in after-school and community programs based on sequential learning. Many symphony orchestras support youth orchestras. Many museums hold weekend workshops that instruct the young in creative activities in the visual arts. Theater companies may offer children's classes, teen classes, summer programs and camps, and workshops and classes at community centers, as well as conservatory and professional training programs. Some dance ensembles work with community service organizations such as Boys and Girls Clubs to offer workshops for students of various ages in order to develop basic dance vocabulary, self-confidence, and tolerance of diversity.

For many years, the established model for arts partnerships with schools was a service model: Schools contracted with an individual artist or arts organization for certain services, such as a performance or an artist residency, through a simple transaction (Rowe et al., 2004; Remer, 1996). In most schools, this is probably still the predominant model. Nearly every SAA provides an online roster of artists and ensembles available to help teachers and school administrators provide appropriate arts experiences for students during the school day. In the state of Washington, for example, 54 percent of public schools draw on external resources for their arts instruction, which typically consists of field trips or such in-school programs as artist residencies and assemblies provided by touring artists and cultural institutions. Of these external supports, 67 percent were characterized as "low-intensity arts episodes without teacher or curricular coordination" (Washington State Arts Commission, 2005, p. 21).

But in at least a few places, this model is changing. Some believe that field trips and in-school performances have a greater effect when students have the skills and knowledge needed to draw value from their experience. Some school districts around the country have been revamping their partnerships with artists and arts organizations so that the offerings are more integrated with existing curriculum. Instead of going with the traditional concert series offered by the local symphony, for example, district representatives may enter into discussions with the symphony and the museum to plan programs that are relevant to students at different grade levels and speak to issues raised by the curriculum. In many of these cases, districts purchase texts and teaching materials on instrumental music or the visual arts from arts organizations, which offer teachers workshops, often during summer, on how to use these materials to best effect (Dana Foundation, 2003).[20]

Some arts organizations contribute to arts learning by offering professional development to practicing teachers and to artists who work collaboratively with teachers. Sometimes they offer programs that help prepare teachers for certification, but more

[20] For an account of the evolution of arts partnerships and the challenges they face in not only surviving but thriving over time, see Seidel, Eppel, and Martiniello, 2001.

often they offer in-service training for teachers already in the classroom. For example, 68 percent of the 107 theater companies responding to the 2005 education survey conducted by the Theater Communications Group offer professional development programs for classroom teachers and teaching artists, and 79 percent offer both student assessment and program evaluation tools. However, survey respondents represent a small minority of theaters across the country, and their programs cannot be expected to reach many theater teachers.[21]

Performing Arts Centers. The trend toward greater integration of the arts experience with arts instruction is reflected in the growing number of performing arts centers that are offering K–12 students a range of arts study programs tied to their own presenting series. These centers' educational mission often includes cultivating appreciation of the performing arts and making the arts an integral part of school and community life. A 2003 report by the Dana Foundation contains case studies of eight of these centers, along with profiles of 74 others, and describes the unique role of these centers in the arts education ecology. Some of the centers have been part of their communities for generations, but half of those profiled in the report—37 in all—were established after 1990, and another 17 were created between 1983 and 1990.

Although such centers cannot be expected to perform the same function as public schools, they are uniquely positioned to help young learners develop the knowledge and skills likely to enrich their experience of the performing arts. Part of the mission of performing arts centers is to develop a local citizenry that values the arts. They do this by offering classes on art-making that recognize different entry points for the young at many levels of experience, from the curious to the proficient. Many centers also provide performance space for school performances and student exhibits.

The Flynn Center for the Performing Arts, in Burlington, Vermont, provides a good example of what these centers can do. In 2001–2002, the Flynn Center served 45,000 largely rural K–12 students with programs that went well beyond attendance at a single performance:

- Workshops in the classroom before and after attendance at matinees "to help students prepare for, reflect on, and extend the performance experience" (Dana Foundation, 2003, p. 24). The workshops included study guides with background materials and relevant learning activities linked to Vermont's arts content standards.
- After-school workshops for teachers in specific art forms and in integrating arts into other subjects.
- Several three-credit college courses per year for classroom teachers and arts specialists on such topics as "aesthetic education" and "bringing history, literature,

[21] Only 107 of 460 members of the Theater Communications Group responded to the survey, and there were approximately 1,490 nonprofit theaters in the United States in 2005 (as reported by the Theater Communications Group from Internal Revenue Service data).

and arts to life." The courses used performances at the Flynn Center as texts and sometimes included interaction with performers.

- Year-round classes in theater, dance, and music for people of all ages and levels of ability. These focused on topics related to the performing series, such as "jazz combo" and "singing solo jazz."

Many performing arts centers and other arts organizations also develop artist residencies in partnership with school administrators and teachers to supplement the schools' arts programs.[22] According to the Dana Foundation, these residencies have been evolving away from the traditional model, in which the resident artist provides instruction or a performance independent of the classroom teacher, toward a more "symbiotic relationship" between the artist and classroom teacher. Resident artists are encouraged to "build teachers' capacity to teach in, through, and about the arts" so that teachers will continue to make the arts part of their teaching once the residency is over (Dana Foundation, 2003, p. 12).[23]

Museums. Among arts organizations, museums have the longest history of commitment to education. But education became a more explicit part of the mission of art as well as non-art museums in the 1990s with the publication of *Excellence and Equity: Education and the Public Dimension of Museums* (Hirzy, 1992), an influential report issued by the American Association of Museums. The report proposed that museums embrace an ongoing education mission in order to develop audiences and draw more Americans from diverse backgrounds into engagement with museum exhibits. During the same period, public funders and private foundations used grants to encourage museums to offer educational programs and teacher training—and they required museums to report on visitor numbers and diversity as measures of the effectiveness of their strategies. As museums increased their commitment to education, they focused more on children, creating new positions for museum educators in areas such as development and oversight of educational programming, docent training, and education-related fundraising.

Art museums have supported the creation of learning tools and curricula to develop "critical viewers"—in other words, to help school children discover what is special about the works of art they encounter in the museums. Drawing on research documenting stages of aesthetic development from novice to expert (such as Parsons, 1987), museums have created educational strategies to encourage children, including

[22] According to a national survey, 38 percent of public elementary schools hosted at least one short-term artist residency program during the 1998–1999 school year, and 22 percent hosted at least one longer residency. For public secondary schools, these figures, at 34 percent and 22 percent, respectively, were slightly lower (Carey et al., 2002, pp. 5, 37). SAAs are important funders of artist residencies.

[23] Note that most artist residencies consist of contracts between independent artists and schools, with no connection to performing arts centers or other arts organizations. See Chapter Six for more on artist residency programs.

very young children, to look closely at selected works of art and share their perceptions about those works with each other. Davis (2005, p. 141) describes one such learning tool, which entails asking viewers two questions: What's going on in this picture? (to invite viewers' sustained and focused attention to the work of art) and What do you see that makes you say that? (to encourage viewers to defend their perceptions in terms of the work's elements).[24] This learner- and inquiry-based approach is in contrast to the typical way that classroom teachers use museums, which is to draw connections between works of art and a topic (such as the American Revolution or the history of Rome) being studied in the classroom.

Community Centers

Community centers that offer arts education programs are another source of arts learning for the young. Often rooted in low-income and minority neighborhoods, these centers first emerged at the turn of the 20th century when grassroots activists sought to provide places where community residents could organize themselves and provide for each other's needs (Davis et al., 1993). Although simple observation makes it clear that many community centers include arts programs along with literacy programs, social services, and health clinics, no national data are available on their numbers, their geographic dispersion, and the number of children participating in their programs.

We do know that at least some community centers focus exclusively on the arts. A 1993 study (Davis et al.) reviewed hundreds of centers around the country, choosing six exemplary programs as case studies. Most of the community centers in the broad sample were founded by artists, some well known—for example, dancer Katherine Dunham founded more than 60 dance schools in urban centers around the country, and jazz saxophonist Jackie McLean started a community arts center in North Hartford, Connecticut, to help combat the substance abuse plaguing the neighborhood (Missouri Historical Society, 2006; Davis et al., 1993). Most such centers are very small operations sustained by highly committed artist-directors and community volunteers, many of whom are parents. The objective for most of the programs is not to provide comprehensive arts learning but to offer a path to engagement with the world to low-income and minority children who are not succeeding in traditional schooling and are vulnerable to drug addiction and violence.[25]

[24] This approach was created by Phillip Yenawine, director of education at The Museum of Modern Art, and Abigail Housen, a researcher in aesthetics, who instituted new museum programs to appeal to both teachers and students having very little experience looking at art. The museum's traditional educational programs, by contrast, were designed for museum visitors having considerable viewing experience (Housen and Duke, 1998). Yenawine and Housen's work has evolved into an elementary school curriculum (see Visual Understanding in Education, 2001).

[25] Survey findings reported by Davis et al. (1993) reveal that these programs have five types of objectives, ranging in priority from highest to lowest as follows: personal and interpersonal goals, such as "a sense of mattering," and respect for others; cognitive goals, such as learning how to learn; multicultural/culture-specific goals, such as increasing awareness of heritage art forms from African American, Latino, and Chinese communities;

Community Schools of the Arts

Community schools of the arts are nonprofit organizations whose mission, in part, is to improve access to instruction in the arts for members of the community, including many underserved groups. This component of the infrastructure for youth arts learning appears to be flourishing. Partially in response to cutbacks in arts education in the public schools, these community schools have proliferated in the past 25 years. According to the National Guild of Community Schools of the Arts, professional faculty in thousands of these schools are now instructing community members interested in learning more about the arts.[26] About 370 of the schools are members of the Guild, serving more than 500,000 students with regular weekly instruction. These schools do not grant degrees and take one of two forms: Roughly 60 percent are independent institutions with complete control over their own operations; the other 40 percent are affiliated with other institutions.

We found that with a few exceptions—such as special magnet schools for the arts, private schools and conservatories that specialize in the arts, and a small group of general high schools—community schools of the arts offer the only rigorous, sequential curriculum in any arts discipline for the young (and the old). They all offer open access to instruction by professional faculty, who are predominantly professional performers or artists; and most of them offer courses in more than one discipline. A survey of Guild members in 2004–2005 found that 78 percent of these schools collaborate with public schools.

Community education in music is playing an increasingly important role as a pipeline that prepares talented youth for advanced undergraduate music programs (National Association of Schools of Music, 1991, p. 3): "Community education in music . . . has provided an institutional framework for young people with high musical aspirations; it has identified and developed talent, often without regard to the student's financial resources; it has introduced hundreds of thousands to the joys and rewards of serious music study. One result has been tremendous benefits to music in higher education."

Access to and Amount of Arts Learning in the Community

The only data we found on the amount of instruction and number of people served by community organizations come from professional associations in the performing and visual arts and from the National Guild for Community Schools of the Arts. We

community goals, such as cultivating a strong community within the center and improving the community outside the center; and professional goals, such as teaching artistic and entrepreneurial skills relevant to a career in the arts (summarized in Davis, 2005).

[26] Much of the material for this section was provided by Jonathan Herman, executive director of the National Guild of Community Schools of the Arts. For information related to our discussion here, see National Guild of Community Schools of the Arts, n.d. For a history of the movement behind the community schools of the arts and the Guild in particular, see Evans and Klein, 1992.

have no way of estimating the size of other parts of the system, such as arts learning in community centers. What we do know is that the number of youth served by all these institutions appears to be small compared with the number reached by arts education in the public schools across the country. However, intensity of instruction and the opportunity for sequential arts instruction appear greater in community schools of the arts than in public schools. According to our data, the programs offered by community organizations are not typically designed to be comprehensive but, rather, to serve specific ends, primarily performance.

Content of Arts Learning in the Community

Arts learning opportunities in the community reflect all the major purposes of arts education that we mentioned earlier, in Chapter Three:

- Historically, performing arts organizations focused on bringing high-quality performances to school-age children, a strategy more appropriately described as broadening access than as cultivating individual skills. However, that focus is shifting toward more educational content for students. Explicit learning objectives are being defined in collaboration with classroom teachers and school officials. Many of these programs are also designed to build the general classroom teacher's capacity. Museums have paid special attention to the aesthetic development of the young by creating learning tools that help the young discover what is worth noticing in specific works of art.
- Community service organizations often focus on non-arts outcomes, such as the healthy development of young people from disadvantaged backgrounds. Secondary goals for students may include learning about the cultural heritage of ethnic communities and developing proficiency as a creative artist.
- Community schools of the arts focus on developing increasingly solid artistic skills through rigorous, sequential instruction primarily in creation and performance. These schools broaden access to such instruction for those who cannot afford private instruction or tuition payments, and they take pride in placing students in prestigious post-secondary programs in the arts.

Higher Education

The fourth key component of the support infrastructure for K–12 arts learning comprises colleges and universities, which serve a number of support functions, the most important being the professional education of those who teach the arts to K–12 students: arts specialists, performers who become private instructors, creators and performers who become teaching artists, and general classroom teachers. Like arts education within the K–12 public schools, the teacher pipeline for the arts exists within a

vast, decentralized system and is subject to the same problems and reform efforts as the larger system. We describe that system, which provides for certification of all full-time teachers in public school, very broadly here. We also provide observations about how well the system prepares teachers to offer the kind of learning most effective in stimulating long-term involvement in the arts.

Structural Characteristics

There are approximately 1,200 programs in the United States that prepare K–12 teachers in all subject areas (Doyle, 1990). State requirements for teacher certification and licensure vary widely. Specific control over program content typically resides within the institution—with the art department, the college of education, the arts education program, or some combination of these—although it is usually limited to a significant degree by state departments of education through licensure requirements.[27] The variations from one institution to another and from one state to another create a substantial range in program quality. In 2004, only about one-half of all teacher education programs in the country had documented that they meet the professional standards advocated by the National Council for Accreditation of Teacher Education (Kirby et al., 2006).[28] And except in the case of music programs, even fewer had documented that they meet the arts specialist teacher preparation requirements of the arts accrediting associations.[29]

The teacher education "system" is so decentralized and idiosyncratic that it has been relatively intractable to reform despite a long history of initiatives, many of which were supported by substantial external resources from businesses and national foundations.[30] Lee Shulman, president of the Carnegie Foundation for the Advancement of Teaching, states the problem clearly: "There is so much variation among all programs in visions of good teaching, standards for admission, rigor of subject matter preparation, what is taught and what is learned, character of supervised clinical experience, and quality of evaluation that, compared to any other academic profession, the sense of chaos is inescapable" (Shulman, 2005).

[27] Certification is earned when a candidate meets all the course requirements of his or her teacher education program. Licensure is issued by the state after a teacher candidate completes certification, state teacher examinations, and probationary periods of teaching. For a detailed review of the wide disparity in certification and licensure policies for arts education across states, see DiBlasio, 1997.

[28] In 2004, that number was 588 institutions. Also see the National Council for Accreditation of Teacher Education's 2004 report *NCATE at 50: Continuous Growth, Renewal, and Reform*.

[29] Correspondence with Samuel Hope, executive director of the National Office for Arts Accreditation.

[30] For a useful summary of the seven most important reforms of the past 20 years (most of which fall within the past 10 years), see Kirby et al., 2006, particularly Chapter Two.

Preparation for General Classroom Teachers Versus Arts Specialists

Candidates for elementary education credentials typically major in education as undergraduates, sometimes with a teaching major in an academic discipline or two teaching minors. According to a 2002 report, however, over 58 percent of elementary teachers had studied only education, with no specialization in any academic subject area. Another 18 percent were education majors with subject area specializations (Seastrom et al., 2002). There is some evidence that those studying to become general classroom elementary teachers may not be required to take even a single course in the arts (Chapman, 1982a).[31] Some institutions cover arts education in the general methods courses required for elementary education majors (Champlin, 1997).

Given the limits of this preparation, it is unrealistic to expect general classroom teachers to be the primary providers of standards-based arts instruction in all four arts disciplines (Woodworth et al., 2007; Carey et al., 1995). Chapman argues (1982a, p. 151) that a student is more likely to be misinformed rather than gain solid knowledge about art through teachers who are responsible for teaching art to the young but have not studied art. And she writes (Chapman, 2005, p. 133): "The majority of classroom teachers are not prepared to offer standards-based instruction and not receiving professional development activities that inform them (even minimally) of expectations for learning in art."[32] The problem is exacerbated by the fact that there are few published curricula and standards-based texts in the arts compared with other subject areas. Classroom teachers are often expected to single-handedly create their own arts curricula while teaching full time (Chapman, 1982a; Kowalchuk and Stone, 2000).

People who become arts specialists, on the other hand, complete an extensive curriculum in their artistic discipline. As in all subject areas, programs vary from one institution to another. Some institutions offer five-year, integrated bachelor of arts/master of teaching programs that provide teaching certification as well; others offer a one- or two-year certification program post-baccalaureate. Candidates for secondary education credentials usually complete a major in one of the arts disciplines.

Additionally, most colleges have developed what are called *alternative certification programs* in the arts, which prepare mid-career professionals to become teachers (Berry, 2001). These programs are increasing in response to current teacher shortages in many subjects in both urban and rural school districts (Hussar, 2001). They range

[31] Chapman claimed this was true of 26 states in 1982, and we were unable to find more-recent data. The Arts Education Partnership's Arts Education State Policy Survey collects information on requirements for licensure in each arts discipline but does not indicate whether these requirements are aligned with state standards (Arts Education Partnership, "Licensure for Arts Teachers," n.d.).

[32] In a review of the status of elementary art education from 1997 to 2004, Chapman (2005, p. 130) points to survey results (U.S. Department of Education, National Center for Education Statistics, 2002, pp. 80–81) showing that 71 percent of classroom teachers do not offer instruction aligned with the standards—and this is despite the fact that 90 percent of the teachers reported participating in standards-based professional development in the previous 12 months.

from emergency certification to well-designed professional programs that appeal to the growing number of people who already have college degrees, as well as a good deal of life experience, and want to become teachers.[33]

There are almost no reliable data on the number of programs preparing teachers in the various arts, the number of teachers receiving their certificates, the content of these programs, and the backgrounds of faculty teaching in those programs.[34] Information on the content of teacher preparation programs is also scarce. Most arts specialist candidates receive instruction from education faculty, arts education faculty (who in smaller colleges are often adjunct or part time), and faculty in the arts and sciences. A 1998 survey of 177 college programs for visual arts specialists in the United States and Canada found "fairly consistent" courses of study across master's programs, which comprised arts education theory and practice, research methods, aesthetics, psychology, general education, and studio course work, with studio courses still the center of the curriculum in most cases. The survey also found that despite a wide variety of emphases in these programs, the artist-teacher and discipline-based arts education orientations were the most dominant (Anderson, Eisner, and McRorie, 1998). Other studies suggest that studio practice is still by far the most prevalent component of most programs (Day, 1997; Galbraith, 1997; Willis-Fisher, 1993), and teachers are not receiving the broad-based preparation they need to teach to the arts standards.[35] There is some evidence that the one or two methods courses required for arts education degrees are incorporating art history, art criticism, and aesthetics, as well as the multiple methodological topics required (Champlin, 1997; Galbraith, 1995).

An emphasis on artistic performance also pervades music education programs. According to Colwell (2005, p. 27), it is commonly assumed that all music departments should resemble those of a conservatory, "with the quality of the programs judged by performances of the orchestra and chorus." Other observers have made the same point: The focus of many music education programs is not teaching ability or educational knowledge, but perceived level of performing expertise (Woodford, 2005; Detels, 1999; Colwell, 2005). Performance skills are highly developed in most music education programs, but there is little evidence that the prevailing curriculum is teach-

[33] Advertisements in music journals, for example, provide evidence of a growing number of options for obtaining teacher certification in music. In one ad, Arizona State University describes a new program to accommodate a greater number of applicants: They no longer have to have a B.A. in theater education but can become certified strictly through their master's program (Colwell, 2005, p. 27). There is also some evidence that alternative programs attract more minorities and more men into teaching and help fill positions in schools and areas with critical shortages of teachers (Mikulecky, Shkodriani, and Wilner, 2004).

[34] Galbraith and Grauer (2004) provide a useful overview of research on teacher education in the visual arts.

[35] Based on a representative survey of state-approved undergraduate education programs in the visual arts, Willis-Fisher (1993) found that students take 36 hours of studio course work, on average, compared to nine hours of art history. Other studies have found that a range of studio courses—in painting, ceramics, printmaking, and digital imagery, for example—form the mainstay of instruction (Rogers and Brogdon, 1990; Sevigny, 1987). Many of the smaller institutions awarding such degrees do not have expertise in aesthetics or art criticism.

ing skills in musical perception for the general music student, a situation Schwadron complained of in 1988 (p. 90).[36]

National teacher education standards have been created in the various artistic disciplines for use in state teacher licensing systems, and the latest revisions align with the national arts content standards. But as of 2001, only 11 states had revised their teacher certification for arts teachers to align with state standards specific to the arts (Council of Chief State School Officers, 2001).[37] National professional associations of teachers in the various arts have challenged campus leaders to become more engaged in improving the quality of teacher education (Consortium of National Arts Education Associations; International Council of Fine Arts Deans; Council of Arts Accrediting Associations, 2001). If comprehensive arts education is to be delivered equitably to public school students, there will have to be policy change on many fronts, including efforts to broaden the preparation of arts specialists.[38]

Other Roles of Higher Education

We have focused on the professional education of teachers for K–12 students, but some colleges and universities also work closely with the public schools in their communities to enhance arts education in other ways. The seven Claremont Colleges in southern California, for instance, have a partnership with all 12 schools in the Claremont Unified School District that

- provides staff development to the district's arts teachers
- allows teachers to take arts courses at the colleges at no cost
- permits high school students to take arts classes at the colleges at reduced cost
- sends college arts students to intern in elementary school classrooms
- invites students of all grade levels to attend art exhibits, musical performances, and theater productions at the colleges free of charge
- permits public school theater productions to be held at college theaters
- provides access to libraries, art collections, and other arts resources to all district teachers.

This example shows how higher education institutions are able to bolster the arts education capacity of the K–12 school districts in their communities. In the next chap-

[36] The overemphasis on specialization at the expense of comprehensiveness is, of course, hardly unique to teacher education programs in the arts.

[37] As of this writing, no newer data have been synthesized on this issue. The Arts Education Partnership State Policy Survey collects information from arts education personnel within state education agencies about state certification of arts specialists in all the arts disciplines, but it is not clear from this database what guidelines are used for revising requirements for licensure. For the latest survey results, see Arts Education Partnership, 2006–2007.

[38] For a useful discussion of what it would take to make this happen for visual arts teachers, see Day, 1997.

ter, we describe how these institutions also provide their own students with the most comprehensive arts education available. Communities such as Claremont, by tapping university resources for K–12 and after-school programs, have been able to surmount some of the weaknesses of the public school system.

Summary: Performance of the Infrastructure for Youth Arts Learning

Overall, the institutional infrastructure for supporting youth arts learning is weak. In the nation's elementary schools, education in music and art tends to be spotty, casual, and brief; and instruction in drama and dance is even more limited. There is on average one hour of instruction per week in music and visual arts, which does not compare favorably with the instruction time for other subjects. Although arts standards are in place, state, local, and district policies are not providing the resources or time in the school day to implement sequential arts instruction—nor are states holding schools accountable for demonstrating student progress with respect to the standards. Finally, in elementary schools, general classroom teachers cannot be expected to be the primary providers of standards-based arts instruction in all four arts disciplines, especially when they are supported by few published curricula or standards-based texts. These conditions do not support quality instruction.

Beyond elementary school, arts education has limited reach and scope. In high school, qualified arts specialists offer arts instruction but reach only the small proportion of students who choose to take arts classes. The best of these programs introduce students to creative performance and develop their appreciation of skilled masters in the art form. Some programs, however, focus narrowly on the development of technical skills. Very few courses in middle or high school offer comprehensive arts education or arts appreciation for students not interested in performance.

Other parts of the institutional support infrastructure offer important elements of arts learning that can supplement school-based programs but cannot be expected to offer comprehensive arts learning. The after-school component of the infrastructure, for example, is expanding rapidly and becoming an increasingly important delivery system for arts programming for children. One of the values of this component is that it reaches children not being exposed to the arts through their school or family. Because of the particular power of the arts to engage children regardless of their language skills or academic performance, public and private funders have long focused on the spread of after-school programs, which offer the opportunities for disadvantaged youth to find pleasure, learn self-discipline, and develop relationships with artist mentors and role models.

Community service organizations and community schools of the arts serve a similar function. Some go beyond the isolated and often short-term after-school program to offer more discipline-based, sequential arts study for students who want to achieve

greater mastery in creative practice. Because the programs of community schools of the arts are more rigorous and sustained than those of the many public schools that have neither the resources nor the time in the school day for sequential arts education programs, the benefits for the children are likely to be stronger and more long term.[39] These institutions also help democratize the arts by serving not only people of all ability levels, but also people who are unable to pay tuition.

Many arts institutions have partnered with schools over the past several decades, a trend encouraged by federal and state arts policy in response to the decline of formal arts instruction in the schools. Although the focus has been predominantly on providing arts experiences rather than arts learning, the most exemplary programs have embedded the arts encounter within an instructional program that gives school-age children tools for appreciating the work of art and encourages reflection and discourse afterward. Our analysis suggests that this shift in focus toward arts learning and away from isolated exposures to artworks—a shift that has been supported by both public and private funders—is more likely to develop the aesthetic capacity of the young.

On the subject of higher education's role in producing those who are to teach the arts to K–12 students, we see a sharp distinction between programs that prepare general classroom teachers and those that prepare arts specialists. Preparation of arts specialists is generally robust, if somewhat overspecialized, and the estimated 200,000 arts specialists across the country are among the most highly trained teachers in public schools. Preparation of general classroom teachers, however, is regarded by many as the weakest link in the K–12 education system. This is a problem that goes well beyond the scope of our study. Nonetheless, it underscores the disconnect between the expectations embodied in the state arts standards for elementary school instruction and the fact that few elementary school teachers are educated in the arts.

Twenty years ago, the NEA described K–12 arts education in this way (1988, p. 67):

> In general, arts education in America is characterized by imbalance, inconsistency, and inaccessibility. There is a curricular imbalance in the relationship between the study of art and the performance and creation of art. There is inconsistency in the arts education students receive in various parts of the country, in different school districts within states, in different schools within school systems, and even in classrooms within schools. Because of the pressures on the school day, a comprehensive and sequential arts education is inaccessible except to a very few and often only to those with talent or a special interest.

Nothing we found in this analysis suggests that this state of affairs has improved. The growth in community arts learning is new and promising, but it cannot compensate

[39] For analysis of the relationship between benefits and length of involvement in arts learning, see McCarthy et al., 2004.

for the weaknesses that exist in K–12 arts education—the only part of the infrastructure with the potential to draw large numbers of young people into engagement with the arts.

The Support Infrastructure for Adult Arts Learning

In this chapter, we describe the institutional infrastructure that supports arts learning for adults (individuals 18 and older). As we did in the previous chapter for youth arts learning, we identify the kinds of organizations with which the infrastructure is populated and characterize them, as much as possible, in terms of their quantitative and qualitative dimensions. Our objective is to understand the extent of their reach into the adult population and the nature of the arts instruction they provide.

We begin by acknowledging two important points about adult versus youth arts learning. The first is that there is no formal, compulsory system of education for adults. In contrast to elementary school children, who are required to participate in arts education programs provided by their schools, adults participate in arts learning programs voluntarily. In fact, adults usually have to pay to participate. Consequently, these programs typically attract adults who are interested in learning more about a particular art form, and typically do not attract adults who have decided they are not interested—or who have never thought about the matter either way.[1]

A second, related point is that because adult education is not compulsory, adult arts learning is subject to far less government involvement and oversight than is youth arts learning.[2] In fact, much arts learning for adults takes place informally, in organizations that do not see their role primarily as educators. As a result, adult arts learning is not tracked in any systematic way: Few data are collected on the number, type, content, and quality of the educational programs offered or the number of adults taking advantage of these programs. This lack of data makes it even more difficult to determine the extent to which arts learning programs are helping adult Americans better understand and appreciate the arts.

[1] College and university arts learning programs may be the exception to this pattern in that they frequently expose students to new and unfamiliar art forms.

[2] For example, Jefferson (1987) claims that in the late 1980s, most states had no licensing or certification requirements for adult educators in the visual arts, and no standards for evaluating either the quantity or quality of adult visual arts learning programs. As far as we know, no state requires certification of adult educators in the visual arts, music, theater, and dance. A number of private organizations do offer certification, however. See, for example, Music Teachers National Association, n.d.

In the sections that follow, we use the available information to provide an overview of the primary institutions that educate adults in the arts. As Figure 5.1 shows, these can be grouped into three main categories: institutions of higher education, community-based providers, and arts journalists and critics operating through the media. The first category comprises two- and four-year colleges and universities that offer courses for academic credit in arts creation, performance, and appreciation. The second group consists of a wide variety of arts-producing and -presenting organizations, as well as community service organizations, such as YMCAs, libraries, municipal parks and recreation departments, and senior centers. The third category comprises individuals and organizations that offer professional reviews of art exhibits, performances, and books and provide forums for discussing them.

Higher Education

Structural Characteristics

According to the U.S. Department of Education, National Center for Education Statistics (2007), the United States has approximately 6,600 post-secondary institutions, of which 40 percent are four-year institutions, 34 percent are two-year institutions, and the remaining 26 percent are less-than-two-year institutions.[3] Roughly 30 percent of them are public and subject to oversight by state government; these enroll almost 75 percent of college and university students.[4] Thirty percent are private nonprofit

Figure 5.1
Support Infrastructure for Adult Arts Learning

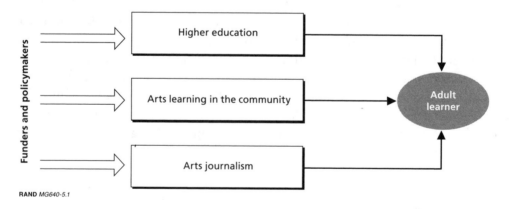

RAND MG640-5.1

[3] A number of other institutions offer post-secondary instruction of some type but do not choose to participate in federal student aid programs. The U.S. Department of Education does not collect data on these institutions.

[4] Forty-eight states have higher education boards (also called commissions or councils) responsible for governing or coordinating public four-year institutions. In some cases, these boards govern the entire public higher education sector (Berdahl, 2004).

institutions, typically governed by their own boards of trustees. For-profit institutions, which make up 40 percent of the total, represent the fastest-growing sector in higher education. They account for just 4 percent of total enrollment, however, and their primary offerings are vocational programs, typically regulated by the state (Eckel and King, 2006).

American higher education works differently than K–12 education. Because the subject matter is vast and there are myriad ways to approach it, and because of a long-standing belief in academic freedom, state governments have very minimal control over undergraduate general or advanced education.[5] Higher education institutions are typically responsible for their own specific curriculum and other academic decisions. However, there are broad agreements among institutions and programs about the goals for general and advanced education. Formalized in accreditation standards and in the statements of disciplinary associations, these agreements provide common frameworks for institutional and faculty decisions about course work. Thus, curriculum development across institutions is based on common principles but is not coordinated in the sense that every institution does everything in the same way. Within college and university dance, music, theater, and visual arts departments, many factors can influence the decisions of individual faculty members, including the institution's general requirements, the national consensus represented by the arts accreditation standards, reviews of course work developed at other institutions, and the availability of programming on campus or in the community. The landscape is characterized by consensus and similarity but not uniformity.[6]

Amount and Reach of Learning Programs

In fall 2005, higher education institutions enrolled approximately 17.5 million full- and part-time students, representing over 20 percent of the age 18 to 35 population (U.S. Department of Commerce, Bureau of the Census, 2006a). Almost one-quarter of the U.S. population age 25 and older held at least an associate's degree; 18 percent had a bachelor's or higher degree.[7] Of course, simply attending college does not guarantee that an individual will actively study or even be exposed to the arts. But students at American colleges and universities have many opportunities to learn about the arts through class work or as participants in campus-related arts events and activities.

A significant proportion of college students become arts majors. In 2003–2004, for example, approximately 5.5 percent of bachelor's degrees awarded by four-year insti-

[5] State governments are, however, actively involved in determining the curriculum for post-secondary vocational education programs.

[6] Many thanks to Samuel Hope for providing this account of curriculum development within higher education—almost verbatim.

[7] Authors' calculations based on data published in *Current Population Survey: 2006 Annual Social and Economic (ASEC) Supplement* (U.S. Department of Commerce, Bureau of the Census, 2006a).

tutions were in the visual and performing arts, and another 4 percent were in English language and literature.[8] At two-year, or community, colleges, 2.4 percent of associate's degrees in 2003–2004 were in the visual and performing arts.[9]

Additionally, large numbers of students who are not literature or fine arts majors participate in courses offered by college and university departments of English, visual arts, and performing arts departments. A national study of post-secondary transcripts found that three arts courses made it into the top 30 (in terms of percentage of earned academic credits): music performance (ranked 19th), introductory literature (21st), and American literature (22nd). Art history (the history of the visual arts) was one of the 30 most popular courses in the 1970s and 1980s but fell out of favor in the 1990s.[10] Data collected by the National Association of Schools of Music indicate that only about one in five students taking courses in music in 2006–2007 were pursuing degrees in music.[11] In dance and theater, the ratio of majors to non-majors taking classes was similarly skewed, at one in seven for dance and one in five for theater; in visual arts and design, it was less pronounced: approximately one-and-one-half times as many non-majors as majors.[12]

Although many non-majors take courses in the literary, visual, and performing arts purely out of interest, others do so as part of their college or university's general education requirements.[13] According to the U.S. Department of Education, U.S. Net-

[8] By way of comparison, the discipline boasting the largest number of bachelor's degrees was business, with 22 percent of the total. (Authors' calculations based on data published by the U.S. Department of Education, National Center for Education Statistics, 2006.) Literature is included in the arts (but not the fine arts) for the purposes of this discussion.

[9] The most popular associate's degrees were in "liberal arts and sciences, general studies, and humanities" (34 percent), followed by business (16 percent), and health professions (16 percent) (U.S. Department of Education, National Center for Education Statistics, 2006).

[10] This statement is based on surveys of transcripts of seniors in the high school classes of 1972, 1982, and 1992 who went on to earn bachelor's degrees. The 30 course categories that produced the highest percentage of earned credits accounted for roughly one-third of all credits earned; the top five courses taken by college students in the mid-1990s were English composition, general psychology, calculus, general chemistry, and general biology (Adelman, 2004).

[11] The data were collected from 589 members of the National Association of Schools of Music in fall 2006 and spring 2007. Note that "music majors" include students with various career objectives in music, including teaching, as well as students with non-music career objectives. We thank Samuel Hope for these data and this observation.

[12] The data for dance were collected by the National Association of Schools of Dance (61 institutions participating); for theater, the National Association of Schools of Theatre (160 institutions participating); for art and design, the National Association of Schools of Art and Design (274 institutions participating).

[13] General education requirements may be structured, going from most to least restrictive, as follows: individual courses that are mandatory for every student; single-subject clusters in which students may choose from a small number of courses within a given subject area; multisubject clusters in which students may choose from a small number of courses representing several different subject areas; and broad distribution requirements in which students must take at least one course within a specific subject area (National Association of Scholars, 1996).

work for Education Information (n.d.), "nearly every U.S. institution" of higher education has formulated general education requirements designed "to ensure that the student has an introductory understanding and basic competencies in some aspect of each broad academic area—the arts, humanities, social and behavioral sciences, physical sciences, languages, and mathematics and philosophy." Ratliffe et al. (2001, p. 6) comment that "general education is regarded as a central feature of preparation for professions as diverse as business, education, engineering, and nursing."

But general education requirements apparently are not what they once were. In a study of course catalogs from 50 "highly selective" four-year colleges and universities for the years 1914, 1939, 1964, and 1993, researchers at the National Association of Scholars concluded that "general education has become substantially devalued as an institutional objective" (1996, p. 61).[14] According to these researchers, general education requirements at top-ranked institutions became progressively less restrictive in the 1960s, 1970s, and 1980s, with a particularly marked diminution in the requirement for basic survey courses of history, literature, philosophy, etc. At the community-college level, Zeszotarski (1999) also found that just 68 percent of schools required that their non-transfer students—the students most likely to be pursuing occupational degrees—take courses in the arts and humanities. As Zeszotarski put it (p. 4), "This inconsistency, in conjunction with the emphasis on skills over knowledge, represents a degraded vision of general education for occupational degree students."

Nevertheless, it is at the college level that the general student has the opportunity—if not the requirement—to take broad-based courses on such topics as the history of film, traditional Asian art and aesthetics, cognitive science and the arts, and 20th century music—courses that offer an aesthetic and historical rather than production perspective on the arts. And it is not only traditional full-time students who can benefit from these types of offerings. In 2001, approximately half of all Americans age 16 and older participated in some type of formal learning activity, with roughly one-fifth doing so for personal development and enrichment (Kim et al., 2004).[15] The American Association of Community Colleges estimates that noncredit enrollment at community colleges may be as high as 5 million learners, on a par with 5.5 million enrollments in credit programs (Voorhees and Milam, 2005). However, the "hidden college" of noncredit extension and continuing education programs offered by higher education institutions is largely unmeasured, so it is impossible to know how many of its students are enrolled in courses in the arts.[16]

[14] According to one of our respondents, these findings may be biased because of the source's political nature.

[15] This figure does not include persons over 16 whose only participation was full-time enrollment in an academic or vocational degree program, and *formal* activities are defined as those with an instructor. See Kim et al., 2004.

[16] University extension schools, like all university departments, collect data on courses and numbers of participants. As far as we know, however, these data have not been aggregated to the national level.

Outside of course work, colleges and universities offer their students many opportunities to experience the arts through performances, exhibits, discussions, and events that take place on and around campus. In fact, as presenters and interpreters of the arts, higher education institutions provide an important public benefit that accrues from their role as sources of formal instruction. In rural areas, they often provide the only performance and exhibit venues for members of surrounding communities (Association of Performing Arts Presenters, 1995).[17]

Content of Learning Programs

Arts instruction in higher education serves the primary purpose of educating and training arts professionals—creators, performers, teachers, scholars, and administrators. For example, Higher Education Arts Data Services statistics show that of all undergraduates majoring in music in fall 2006, about one-third were enrolled in professional degree programs in performance and composition; one-third in professional degree programs in K–12 teacher preparation; and one-third in other programs, including history, theory, music therapy, music industry, sacred music, and liberal arts degrees in music.[18] In the preparation of professionals—especially professional artists and arts specialists—the elements of arts study associated with comprehensive education are all present, but instruction is usually weighted toward performance. In arts courses for non-majors, who (as described above) outnumber majors by large margins, the performance element is often omitted.

Other observers note, however, that college and university arts departments tend to focus their resources on the minority of students who have the potential to become professional artists (Detels, 1999; Johnson, 1997; RAND interviews). The non-majors who take the large introductory courses are not their first priority.[19] Detels (1999) argues, for example, that courses in college music departments rapidly become highly specialized, leaving only a few beyond the basic introductory level that emphasize aesthetics or historical context.[20] Johnson (1997, p. 6) states that "[m]any music depart-

[17] At 36 percent of the total, colleges and universities are the most common type of presenter within the membership of the Association of Performing Arts Presenters. An informal Web survey we conducted suggests that the majority of university extension programs also offer online programs of instruction.

[18] This distribution is not transferable to dance and theater, because most states do not offer separate certification of dance and theater arts specialists. Art is similar to music in that large numbers of undergraduates are in teacher preparation or art history. These differences arise from the varying natures of the art forms and the varied ways and places in which people work in the art forms. At some point in their lives, almost all arts professionals teach.

[19] This is true for most if not all academic departments. As stated by one of our respondents, "The institution that did not focus on majors would soon have no majors. Students would go elsewhere."

[20] Detels refers to upper-level music theory and composition courses as well as courses in performance. Of course, increased specialization within the major has also taken place in non-arts disciplines. See, for example, National Endowment for the Humanities, 1984; and National Association of Scholars, 1996.

ments have virtually abandoned, or never really developed, their roles in the general studies/liberal arts curriculum." To the extent this is true, music and other fine arts departments within institutions of higher education more properly belong on the supply rather than the demand side of the framework (see Chapter Two).

Hagood (2000) describes this phenomenon in the context of university dance departments. He points to a transition from "aesthetic" to "professional" values in the teaching of dance in the 1960s and early 1970s, a time when independent dance departments were being established at higher education institutions around the country.[21] By the 1980s, Hagood argues, some university dance departments were questioning whether they had gone too far in their focus on training professional dancers. One concern was that the narrowness of the dance curriculum made it inadequate for preparing future teachers.

There are signs, however, of a revived interest in boosting the general education requirements that encourage students to take courses in the humanities and the arts (Gaff, 2006; Ratliffe et al., 2001). For example, a survey of chief academic officers at four-year institutions revealed that almost two-thirds of them considered stronger general education programs a growing priority for their institutions (Ratliffe et al., 2001). If these thoughts are translated into action, we can expect to see more young adults signing up for courses in arts appreciation, thereby increasing the already significant importance of colleges and universities as venues for developing the capacity of young adults to engage with the arts.

Arts Learning in the Community

Structural Characteristics

Here, we look at the education programs offered by nonprofit arts-performing and -presenting organizations, community service organizations, and private instructors. Beyond the college or university campus, opportunities for adult arts learning in the community appear to be plentiful but fragmented and diverse. Information about these components of the demand infrastructure is sketchy and anecdotal, and there is no evidence of systematic cooperation among players, even within individual classes of arts education providers. Many arts organizations, for example, appear to develop their adult education programs in house, with little reference to the efforts of others within their discipline or within their geographic community.[22]

[21] Hagood also reports (2000, p. 223) that this was less true in the case of ballet, for which talented artists were often sent to professional schools at an early age, than it was in the case of modern dance, for which "the opportunity for students to refine their skills in performance, choreography, and teaching in a quality college dance program helped develop their survival skills outside the university."

[22] The approach to program development varies greatly by arts discipline. Art museums, for instance, have a long tradition of partnering with other organizations to provide arts learning opportunities to people of all

Amount and Reach of Learning Programs

Arts Organizations. Most of what we know about the adult learning opportunities provided by arts nonprofits comes from their national service organizations. Data collected by these organizations suggest that the education programs of arts nonprofits are primarily aimed at children, not adults. For example, in a 2005 survey of 107 theaters conducted by the Theatre Communications Group (the national service organization representing nonprofit theaters), roughly 80 percent of the education programs being offered targeted persons under age 18 (Renner, 2006). Similarly, a 2005 survey of 121 orchestras conducted by the American Symphony Orchestra League (2006) revealed that almost 75 percent of symphony orchestras' education programs were aimed at young people. Even in museums, which have a long history of adult education, "adult audiences are often given second priority, relative to children, in sharing the limited resources of museum education departments (Storr, 1995, p. 9).[23]

Nevertheless, most symphony orchestras, theater groups, dance troupes, opera companies, and art museums do offer some form of educational programming for adults.[24] In the performing arts, these typically consist of pre- and post-performance talks, membership newsletters, program notes, and the occasional lecture series and cooperative program with an educational institution. Some modern dance companies show videos before the performance and point to noteworthy details for spectators to attend to (Kriegsman, 1998). Museum offerings tend to be more extensive, including interpretive labels, lecture series, gallery talks, studio courses, film series, newsletters, detailed information sheets, and a variety of audiovisual aids (Pankratz, 1988).[25]

According to OPERA America, roughly 95 percent of opera companies offer pre- or post-performance lectures for their patrons, and OPERA America itself offers online courses on the historical background, musical style, literary source, and dramatic structure of selected operas.[26] The American Symphony Orchestra League estimates that more than 80 percent of symphony orchestras offer pre-concert programs to patrons.

ages, whereas linkages of this kind are much less commonly used by dance companies. See, for example, Wetterlund and Sayre, 2003; Levine, 1994.

[23] The emphasis on youth is also indicated by the fact that many arts nonprofits have separate administrative budgets and staffs for their youth arts learning programs but lump together adult learning, audience development, community outreach, and, occasionally, marketing. It is thus difficult to tell how much arts organizations spend on educating their audiences versus simply trying to sell them tickets.

[24] Our statement is based on published surveys of and email correspondence with the American Symphony Orchestra League, Dance/USA, OPERA America, TCG, and the Association of Art Museum Directors. We did not collect information on possible educational programs offered by organizations that produce and present other art forms, such as film and literature.

[25] Obviously, this source is dated. But we have no reason to believe that these offerings have changed all that much—with the exception of online educational offerings, which no doubt have increased considerably. See, for example, the short discussion of OPERA America's online offerings that follows in the text.

[26] OPERA America also offers online synopses, composer biographies, and audio clips for the top 20 operas most frequently performed by its members (OPERA America, n.d.).

Hager and Pollak (2002) found that about half of all organizations that present performing arts conduct some form of adult education and outreach, and 40 percent offer study guides and materials associated with the works they present. Dance companies may provide the least in the way of adult learning opportunities. Summarizing the findings of the 1996 National Task Force on Dance Audiences, Levine (1997, p. 32) reported: "More often than not the curtain goes up at show time, the performance unfolds, and the curtain goes down. Little personal contact transpires between artists and audience before or after the performance."

It needs to be noted, however, that most arts organizations that provide opportunities for adults to learn more about their art forms reach fairly few people with their programs. Whereas their youth arts learning programs frequently involve visits to schools (in the form of sponsored artists in residence or special performances at assemblies), their adult learning programs typically take place on their own premises and are centered on whatever performance or exhibit is ongoing (Storr, 1995). Accordingly, they tend to attract people who have already decided to attend the performance or exhibit and typically do not reach those not already interested in or familiar with the art form.[27]

In other words, arts organizations focus—perhaps appropriately—on deepening the experiences of their audiences. They cannot be expected to attract and educate those who have no inclination to seek the arts experiences they offer. Research suggests that traditional approaches to audience development—that is, efforts to reduce practical barriers to arts participation—will not be successful when perceptual barriers to participation exist (McCarthy and Jinnett, 2001). Strategies such as high-profile marketing campaigns, free performances, extended operating hours, and the establishment of satellite venues may increase the participation of people already inclined to participate—by promoting access—but they will not entice those not already inclined. It is unreasonable to expect arts organizations to undertake the financial and administrative burden associated with reaching members of the public who are not interested in their programs. For one thing, in contrast to children, adults have no places where they gather to be educated. But more important, the extent to which organizations whose mission is to perform and present the arts should also educate in the arts is not clear.

Community Service Organizations. A lack of comprehensive data means even less is known about the adult arts learning opportunities offered by community service organizations than by arts organizations. Nevertheless, there are scattered indications that these types of programs are expanding. According to the YMCA of the USA, for example, the nation's 2,617 YMCAs represent the largest nonprofit community service

[27] For example, a 10-year study of symphony orchestras funded by The John S. and James L. Knight Foundation found that "[t]raditional audience education efforts, designed to serve the uninitiated, are used primarily by those who are most knowledgeable and most involved with orchestras" (Wolf, 2006, p. 6). In the 15 communities surveyed in the study, those who regularly attended orchestras made up just 4 percent of the adult population.

organization in America, and arts and humanities programs are among the fastest-growing programs they offer. In 1998, the arts and humanities became a YMCA "core program area," and the YMCA of the USA "expects it will soon be one of the leading and most influential, if not largest, arts provider in the country for kids and adults" (YMCA of the USA, n.d.). Senior centers are another growing source of arts learning.[28] The U.S. Department of Health and Human Services' Administration on Aging estimates that there are between 10,000 and 16,000 senior centers in the United States, serving over 10 million older Americans. Many if not most of these offer programs in the arts, and their numbers are expanding (Barret, 1993; U.S. Department of Health and Human Services, Administration on Aging, 2004). Community schools of the arts have also recently expanded their outreach to older adults.[29]

Content of Learning Programs

Arts Organizations. As noted above, most arts organizations design their adult learning programs around current performances and exhibits: They do not have the resources to provide their patrons with generic, introductory information about their art forms, and basic arts education is in any case not their mission. But adult learners' widely disparate backgrounds in the arts can create difficulties for organizations that simply wish to enhance their audiences' experiences of a particular performance or exhibit. Education staff risk alienating one set of patrons when appealing to another.

For example, Hood (1983) argues that the qualities of a museum most highly valued by frequent visitors are not the same ones most highly valued by occasional or infrequent visitors. But because the interests of museum professionals tend to correspond to those of frequent visitors, museums tend to emphasize those qualities in their exhibits, thereby deterring occasional and infrequent visitors from visiting more often. Similarly, in a long-term study of the potential audiences for 15 symphony orchestras, the John S. and James L. Knight Foundation (2002) found that less-sophisticated listeners "want to be able to appreciate the music a little more and want help negotiating other aspects of the concert experience" (p. 15). But while these audience members thus would appreciate certain enhancements to program content and a less formal concert ambience, "some audience members would abhor such informalities" (p. 15).

A related issue is visitor familiarity with a particular exhibition or performance. With respect to museums, Storr (1995) comments on the fact that most adults visit any particular exhibit just once. Sequential education programs are difficult for museums to maintain because of the constant turnover of visitors. As a result, "many museum

[28] Senior centers are places where older adults can come together for nutrition, recreation, social and educational services, and comprehensive information on topics related to aging. Most senior centers are heavily subsidized by government and local nonprofit organizations (National Council on Aging, 2005).

[29] Correspondence with Jonathan Herman, Executive Director, National Guild of Community Schools of the Arts.

educators feel circumscribed in program planning by how little information can be shared, or how few concepts can be developed, within a single talk, tour, workshop, or activity" (p. 4). This problem is exacerbated for performing arts organizations because audience turnover is almost complete for every performance.

Finally, an important consideration for arts organizations seeking to enrich the arts experiences of their audiences is to understand what tools are necessary "for including the audience more effectively in the total arts experience" (Conner, 2004, p.15). One of the most effective ways to engage members of the public in observation and interpretation is conversation: In the case of museums, for example, educators who invite comments and questions from visitors as a way to engage them in participatory analysis and interpretation of a work of art will help create meaningful learning encounters. The current trend in museum education is toward such interactive participation (Lankford and Scheffer, 2004). This more interactive engagement is more likely to develop individual capacity for arts engagement than is a one-way transfer of information.

Community Service Organizations. Simple observation suggests that the arts programs offered by such organizations as YMCAs and senior centers are heavily weighted toward doing and making art rather than appreciating it. For example, the YMCA of the USA claims that its new arts and humanities initiative is turning local YMCAs into "places where kids and adults learn to paint, write, sing or act" (YMCA of the USA, n.d.). An examination of the Web sites for 20 YMCAs that have arts programs reveals that this description is largely correct: Of 47 different arts classes on offer, 44 involved instruction in dance, the visual arts and crafts, playing a musical instrument, acting, or writing. There were two book clubs and just one music appreciation course.[30] An examination of the Web sites for 20 senior centers in Los Angeles County indicated that they, too, mostly focus on creative expression: Of 45 different types of classes, just seven emphasized appreciation, this time of music, "American culture," and literature.

In those cases where community service organizations provide comprehensive arts learning opportunities to adults—that is, where programming contains all four elements of a comprehensive arts education, as defined in Chapter Three—they often do so in association with local universities or arts organizations. Perhaps the best example of this is Elderhostel, the nonprofit organization that provides travel and learning opportunities to older adults. In 2006, Elderhostel's arts-related programming entailed collaborations with art museums, university extension programs, folk festivals, opera companies, jazz bands, and other such entities.

[30] The 20 YMCAs were chosen by randomly selecting 20 zip codes and then determining the YMCAs closest to those zip codes that had arts programs.

Arts Journalism

Structural Characteristics

The key sources of public discourse about the arts are arts journalists, who provide adult arts learning through various media outlets, such as newspapers, radio, and the Internet. They inform the public by providing previews of arts events; news stories about arts institutions, artists, and the local arts scene; features on specific artists; think pieces on aspects of the arts; and reviews and criticism. Their commentary stimulates access to the arts by identifying what is worthy of attention, helping to get the right consumers and the right artworks together, and drawing the public's attention to emerging artists or little-known arts venues. It also supports local artists and arts institutions by recognizing their achievements and attracting the public to their performances, exhibitions, films, and books. And it stimulates demand through reviews and criticism that help readers appreciate what particular works of art have to offer.

Arts criticism elucidates works of art in a number of ways. First, arts critics describe the work in some detail, often articulating what is difficult to capture in words, such as the expressive effects of dance or music. Second, they analyze how the work fits together and achieves its effects. Third, they interpret what the work *means*, in a broad sense of the word: "[A] critic must often explain what's really going on in a new musical composition, what is meant by a new play, what a painter is implicitly saying in his new concatenation of images" (Beardsley, 1982, p. 152). Finally, critics often evaluate the work's merits, backed up with detailed observations, drawing on their understanding of other works and the genre as a whole and challenging informed readers to judge for themselves. In this way, criticism deepens appreciation of the best of the arts and manages to "do something against the merchants of the mediocre" (Ciment and Kardish, 2003, p. 15).

Amount and Reach of Arts Journalism

Despite dynamic growth in the supply of the arts in recent decades and what some observers see as an increased need for informed commentary, news on and critical coverage of the arts have been in decline for years. Newspapers, once the bastion of criticism and commentary related to local arts scenes, have been losing readers since the 1980s. In response, the industry has been consolidating, and newspapers have increasingly reduced their services, including their coverage of the arts. According to an analysis of 15 newspapers across the country, arts coverage declined significantly between 1998 and 2003 (National Arts Journalism Program, 2004). The number of articles about the arts is declining, the stories are getting shorter, and the space given over to listings is expanding. In short, "most papers dedicate less newsprint to the arts at a time when there is more art to write about" (p. 11).

Content of Cultural Coverage

The content of cultural coverage is becoming increasingly heterogeneous, with stories on television, movies, rock music, lifestyle, fashion, and design consuming greater space while coverage of the nonprofit fine arts and literature shrinks. Listings of arts and entertainment events now consume close to 50 percent of all coverage, squeezing the space for all arts journalism. Preview pieces (advance stories to arouse public interest in coming events), human interest features, and celebrity interviews are becoming more common (National Arts Journalism Program, 2004). The declining space for book reviews in major metropolitan newspapers has been spotlighted recently, and more book columnists are choosing voluntary buyouts (Nawotka, 2006).

Taken together, these trends reflect not only cutbacks caused by declining readership and advertising resources, but a shift in the targeted audience in response to the trends. Traditionally, arts coverage was for those readers who cared about the arts, a devoted niche audience. Often, there were separate critics for music, theater, dance, film, literature, and the visual arts. For example, for nearly 60 years (until 1993), the *San Francisco Chronicle*'s music and dance department had one dance and two music critics on staff. They put out a full-page think piece on Sundays, and a page-length music column and six or more other reviews of music and dance throughout the week. Besides these reviews, there were regular news stories, interviews, and other features about the arts. Today, the *Chronicle*'s single music critic has little to do: The paper has "not carried a classical music piece in many months, perhaps a year" (Commanday, 2006).

Other newspapers appear to have adopted a different model. Instead of appealing to multiple niche audiences, they are targeting more content to the mass audience, which is more interested in entertainment than the arts (Barringer, 1999; RAND interviews). "The reader that does not know anything is more valuable than the one that does," said one of our respondents. The result is a *"Consumer Reports"* approach to cultural topics rather than cultivation of intelligent discourse on the arts.[31]

This shift in editorial policy has led to many experienced journalists—film critics, theater critics, dance critics, visual art critics, and the like—retiring or moving to part-time status. Newspapers are turning increasingly to freelance contributors or wire-service stories for arts reporting (National Arts Journalism Program, 2004; Appelo, 2005). Most visual arts critics from the top 200 daily papers across the country receive less than half their income from their activity as critics, and nearly half of those still working full time suspect that their newspapers would not replace them if they left their jobs (National Arts Journalism Program, 2002).

[31] These trends do not appear to be caused by declining arts participation. In North Carolina, for example, the growth in almost every area of the arts from the early 1980s to the late 1990s was extraordinary, and surveys demonstrated that newspaper subscribers spent as much money on arts and entertainment as they did on sporting events. Yet the arts staff at *The Charlotte Observer* did not increase between 1993 and 1998 (National Arts Journalism Program, 1998).

There is evidence, however, that while the traditional outlets for arts journalism are closing, new programs are emerging to educate the next generation of arts writers. The Goldring Arts Journalism Program at Syracuse University is one of the nation's first graduate programs for arts critics. A one-year program that integrates journalism courses with studies in an artistic discipline, it is designed to help aspiring journalists develop the knowledge and analytic skills they need to make the arts more relevant, more compelling, and more accessible to their readers (Winzenried, 2005, p. 41). Programs are also opening at the City University of New York and at Columbia University, offering mid-career arts writers and editors a chance to improve their knowledge and skills. At the University of Southern California, the Annenberg/Getty Arts Journalism Program has been offering an annual three-week program for selected Fellows since 2002. And the NEA has sponsored a series of institutes in which arts critics from smaller papers are immersed in a comprehensive program of arts education.

The proliferation on the Web of arts blogs and literary blogs within the past two years suggests that the public discourse on the arts may be migrating to the Internet, but there is debate about whether the Web will serve as the voice for cultural communities—and whether the quality of the commentary can meet the standards of the best print journalism. Arts blogs often express bloggers' enthusiasms or disappointments and offer largely descriptive rather than critical writing (Appelo, 2005). According to Doug McLennan, editor of ArtsJournal.com, however, the distributed model and global reach of online discourse will reinvigorate the entire cultural sector (RAND interview; Appelo, 2005). Columbia's National Arts Journalism Program, which no longer offers year-long fellowships to arts journalists, is going virtual: It is now in the process of reconstituting itself as a virtual home for arts journalists, where they can create their own pages, share their work with other professionals, find information on best practices, and collectively build supports for the field.

Summary: Performance of the Infrastructure for Adult Arts Learning

Of all the institutions delivering arts instruction to learners of any age, colleges and universities are by far the most important source of comprehensive arts education—despite the fact that their resources are predominantly devoted to educating performing and visual artists and teachers. In contrast to most high schools, institutions of higher education offer a wide variety of arts courses designed to provide historical and cultural context for artworks as well as develop skills of aesthetic perception and interpretation of exemplary works of art. Trends over the past few decades, however, have deemphasized the arts and humanities as core courses required for a liberal arts degree. Given the importance of the college experience in generating demand for the arts, that single trend may be contributing to declines in demand. University exten-

sion programs—the "hidden college"—are an important, largely untapped, potential source for comprehensive arts education as a lifelong enterprise.

Viewed within the context of the larger infrastructure for arts learning, arts organizations have a limited reach and insufficient resources for taking on much of the responsibility for comprehensive arts education. Museums have the clearest mandate to help their visitors place the artworks they encounter into a context and appreciate their characteristics, and museums offer a wealth of information to the avid arts consumer. Performing arts organizations have stepped up to the task of offering educational programs in connection with their performances to satisfy their audience members' desire for deeper understanding of the artworks they encounter. These programs offer important single experiences for the consumer. They cannot, however, fill the need for ongoing skill development, and they cannot reach those who do not choose to come to their performances.

Public discourse about the arts has been contracting and has likely led to suppressed demand for the arts. If this discourse can be reconstituted on the Web, the effects of the transition will be temporary. But until there is a Web-based infrastructure that can offer careers to arts critics—and until the American public develops the habit of seeking its arts commentary from online sources—the breakdown in the traditional transmission of arts news and criticism is likely to weaken the entire cultural cycle.

The Role of State Arts Agencies

In the previous two chapters, we broadly described the institutional support infrastructures for youth and adult arts learning and identified areas having significant gaps. We also suggested that because of these gaps, many children and adults lack the tools they need to fully engage with works of art. In this chapter, we look at the role of SAAs in promoting arts learning. Using both quantitative and qualitative data, we assess the extent to which SAAs have sought to cultivate demand for the arts rather than to expand supply or improve access. We also point to recent initiatives by SAAs and the NEA that suggest the emergence of a new emphasis on demand.

SAA Grantmaking

We begin by looking at patterns and trends in SAA grantmaking. Historically, grants have been SAAs' primary means for achieving their goals, and they remain the most visible of SAAs' arts policy tools (National Research Center of the Arts, Inc., 1976; Lowell, 2004). The allocation of grants should therefore reflect SAAs' main priorities: For example, a high percentage of SAA grant dollars going to artists and arts organizations to create works of art could indicate that increasing supply is an SAA priority. Alternatively, a high percentage of SAA grant dollars going to school districts for curriculum development could suggest that SAAs have a strong demand orientation. We note, however, that even a high percentage of a relatively small amount is still a small amount. In 2004, the latest year for which we have data, total grantmaking by all 56 state and territorial arts agencies came to just $209 million.[1] In comparison, total expenditures by all U.S. public K–12 school systems in that year came to $472 billion (U.S. Department of Commerce, Bureau of the Census, 2006b).

[1] Except where indicated, the grantmaking data and analysis in this chapter are for the 56 U.S. arts agencies, which include agencies for the 50 states plus six special jurisdictions: American Samoa, the District of Columbia, Guam, Puerto Rico, the Northern Mariana Islands, and the Virgin Islands. Years are fiscal years unless noted otherwise.

SAAs have collected data on their grantees in every year since 1981 (digitized data from 1986 onward are available), when the National Standard for Arts Information Exchange (the National Standard) was first introduced.[2] For each grant they receive, SAA grantees are required to report—among other things—the name, address, disciplinary affiliation, and institutional type of the successful applicant; the type of activity funded; and the extent to which the activity funded involves arts education. The data within each category are aggregated by the National Assembly of State Arts Agencies to provide the number and value of SAA grants nationally within various categories. Our analysis focuses on the value of SAA grants by type of recipient, type of activity, and the extent to which the activity funded involves arts education as defined by the National Standard.

Categories of Recipients

Recipient data indicate which types of institutions have benefited most from SAA grantmaking. Beginning with the 52 types of grantee institutions identified in the National Standard, we group these data elements into five broad categories:[3]

1. artists and arts organizations
2. arts agencies
3. educational institutions
4. community organizations
5. other non-arts organizations.

The first category consists primarily of organizations and individuals responsible for the creation and presentation of works of art. It includes performing arts groups, museums and galleries, cultural centers, and artists, as well as the various organizations that provide funding and services for artists and arts organizations: arts service organizations, concert associations, symphony leagues, opera guilds, etc. It also includes institutions that train artists, such as arts schools and institutes. In 2004, performing groups received the largest chunk of SAA grant money within this category, accounting for almost 40 percent of the value of the total.

Local and regional arts agencies, plus fellow SAAs, form the second category of SAA grant recipients. The data do not distinguish among them, but the prevalence of

[2] The National Standard is a tool used by public arts agencies to organize and report information about their activities. National Standard codes and definitions are determined jointly by the National Assembly of State Arts Agencies and the NEA based on feedback from all SAAs, regional arts organizations, and other data users. The NEA requires state and regional arts organizations to follow these guidelines in their reporting. We thank the National Assembly of State Arts Agencies for providing this information.

[3] These groupings are modifications of the categories constructed by the National Assembly of State Arts Agencies and the NEA for their annual reports on SAA grantmaking. See Appendix B for a full listing. Data coded "none of the above" or "not reported" are not discussed; after 1986, they represent a very small fraction (1 percent in 2004) of the total value of grants.

large regranting programs among SAAs suggests that local arts agencies dominate this category of recipients.

The third category, educational institutions, comprises K–12 schools and school districts, two- and four-year colleges and universities, parent-teacher organizations, and childcare providers. In 2004, the biggest beneficiaries within this category were colleges and universities, at 51 percent of all SAA grants to educational institutions. K–12 schools and school districts were a close runner-up, at 48 percent.

Organizations that serve local communities make up the fourth category of SAA grant recipients. Parks and recreation departments, senior centers, health-care facilities, correctional institutions, religious organizations, and other community service and human welfare organizations are in this category, as are media organizations, such as magazines, newspapers, radio stations, and television stations. In 2004, almost 40 percent of the value of grants to recipients in this category went to television stations, presumably for arts programming.

The fifth category comprises individuals and organizations whose primary missions lie outside the arts but that occasionally or even frequently sponsor artists and arts organizations, serve as venues for performances and exhibits, partner with artists and arts organizations on projects, etc. Examples are non-art museums (such as history and science museums), businesses, historical societies, humanities councils, and various agencies of state and local government. Within this category, non-art museums were the biggest beneficiaries of SAA grants, receiving 37 percent of the total in 2004.

Patterns and Trends in Grantmaking by Type of Recipient

Figure 6.1 shows the distribution of SAA grants for 2004, the most recent year for which we have grantmaking data. As can be seen, artists and arts organizations were the largest recipients, with just over one-half of the total value of SAA grants, and the next largest category was arts agencies, with roughly one-quarter of the total. Grants to the categories of other non-arts organizations, educational institutions, and community service organizations were smaller.

How closely do the 2004 shares reflect past patterns in SAA grantmaking? Figure 6.2 shows the trends from 1987 to 2004. It can be seen that the percentage of grants devoted to artists and arts organizations has declined over the past 20 years, from almost 70 percent of the total in 1987 to close to one-half of the total in 2004. This decline has been roughly mirrored by an increase in the share of grants to local arts agencies, which rose from just over 10 percent of the total in 1987 to just under 25 percent in 2004. In contrast, the shares represented by educational institutions, community organizations, and other non-arts organizations have remained remarkably steady over time: Educational institutions, for example, received just 6 percent of the total value of SAA grants in both 1987 and 2004. Similarly, the share awarded to community organizations rose by just one percentage point over the period, from 5 to

Figure 6.1
Distribution of SAA Grants as a Share of Total Value of Grants, by Type of Recipient, 2004

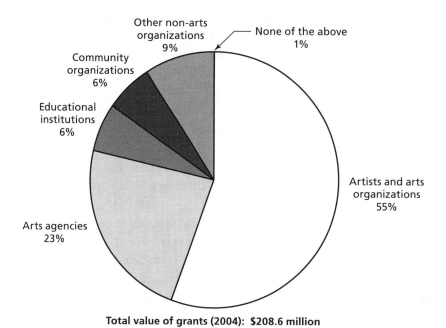

Total value of grants (2004): $208.6 million

SOURCE: Authors' calculations based on National Standard data.
RAND *MG640-6.1*

6 percent of the total, and the share for other non-arts organizations rose just two percentage points, from 7 to 9 percent.[4]

To the extent that SAA grants to artists and arts organizations are designed to encourage the production of artworks and their wider distribution among state residents, these trends point to a continued SAA focus on expanding supply and access. However, as discussed in Chapters Four and Five, the infrastructure of support for demand is diverse, containing many artists and arts organizations, as well as educational institutions and community service organizations. This means that some of the SAA grant monies directed to artists and arts organizations may be intended to support programs for cultivating demand.[5] To determine whether this is so, we looked at data on the types of activities funded by SAA grants.

[4] These patterns reflect the experience of most SAAs. In 2002 (date of available data), for example, four-fifths of SAAs devoted over 50 percent of their grantmaking dollars to artists and arts organizations. But there were, of course, exceptions—for example, 72 percent of the Wyoming Arts Council's 2002 budget went to local arts agencies, and the Maine Arts Commission devoted over one-third of its 2002 budget to educational institutions.

[5] Similarly, because educational institutions—and particularly institutions of higher education—are important both as presenters of artworks and trainers of artists, some grants to educational institutions may have been used to expand supply and promote access rather than to cultivate demand.

Figure 6.2
Trends in SAA Grants as a Share of Total Value of Grants, by Type of Recipient, 1987–2004

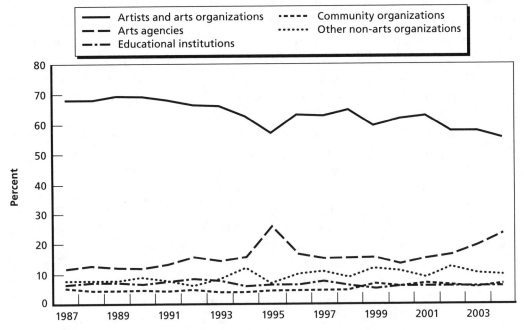

SOURCE: Authors' calculations based on National Standard data.
RAND *MG640-6.2*

Types of Activities Funded

The National Standard identifies 38 kinds of activities supported by SAAs, which we grouped into six broad categories:

1. creation, exhibition, and preservation of artworks
2. institutional support
3. arts learning
4. broadening of arts participation
5. regranting
6. other.

The first category covers grants for the commission or acquisition of new works of art; support for concerts, performances, exhibitions, and readings; artist fellowships; and conservation and preservation of existing works of art. These grants directly help to increase the quantity and quality of artworks (the supply objective) and may also increase opportunities for state residents to experience these artworks (the access objective). In 2004, support for concerts, performances, exhibitions, and readings represented almost 60 percent of the value of grants in this category.

The second category consists of grants designed to support organizations rather than particular projects or programs. Included in this category are grants for operational, administrative, artistic, and endowment support; to help establish new organizations; for facility construction, maintenance, and renovation; and for equipment purchase or rental. Whether these grants serve to expand supply, promote access, or cultivate demand depends on the receiving organization's mission. For example, a general operating support (GOS) grant to a local children's theater company may be more likely to cultivate demand than would a GOS grant to a cutting-edge art gallery. In 2004, GOS represented almost 80 percent of the value of grants in this category.

Grants in support of youth and adult arts learning make up the third category. Activities supported include artist residencies, arts instruction, assessment, curriculum development and implementation, identification and documentation of artworks, translation of written artworks and writing about art, and audience services. Together, arts instruction and artist residencies accounted for more than 80 percent of the value of grants in this category in 2004. Note that some arts instruction grants support the professional training of artists in conservatories and art schools, which is a supply-side activity in our framework. Also note that *learning* is very broadly defined here and includes many activities that might better be characterized as "exposure."

The fourth category is grants designed to broaden arts participation and increase public awareness of the arts (that is, to promote access). Included here are grants for fairs and festivals; marketing of artworks and arts events; recording, filming, and taping; publication of books and manuals; distribution of films, books, and prints; broadcasting; and public awareness campaigns.[6] In 2004, broadcasting accounted for 43 percent of the total value of grants in this category, followed by fairs and festivals at 40 percent.

The fifth category is regranting. SAAs do not collect information on how these grants are used, but the primary recipients are local arts agencies. According to Americans for the Arts (2001), 53 percent of local arts agencies provided GOS or special project support to local arts organizations in 2000, and 66 percent implemented arts education programs and activities. We do not know the relative importance of these forms of local arts agency support, however, because the value of grants in these categories is not reported. Nor do we know exactly what types of activities are classified as "arts education."

The sixth category covers grants given for a miscellany of activities not accounted for elsewhere, such as technical assistance to artists and arts organizations, professional development and training, conferences and seminars, and research and planning. This category also includes activities classified as "not reported" or "none of the above," which in some years were quite significant. In 2000, for example, such activities by themselves accounted for approximately 12 percent of the total value of SAA grants.

[6] Activities in the recording, filming, and taping category do not include the creation of media artworks.

Many of the grants classified as "not reported" represent legislative line item grants that were passed through SAA budgets but not awarded through SAA competitive panel processes.[7]

Trends in Grantmaking by Type of Activity

Figure 6.3 shows the distribution of SAA grants by activity type. In 2004, institutional support for organizations represented just over one-half of the total value of SAA grants, while support for the creation, exhibition, and preservation of the arts represented 17 percent. Percentages directed toward arts learning, regranting, and broadening of arts participation were much lower, even less than the percentage for "other" activities.

Figure 6.4 shows trends in SAA grantmaking by activity type from 1987 to 2004. Evident from the graph is that institutional support for organizations has dominated SAA grantmaking for many years. It has consistently represented the largest proportion by value, averaging 49 percent of the total over the period. Even at its lowest point,

Figure 6.3
Distribution of SAA Grants as a Share of Total Value of Grants, by Type of Activity, 2004

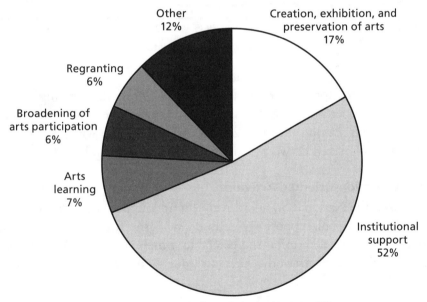

Total value of grants (2004): $208.6 million

SOURCE: Authors' calculations based on National Standard data.
RAND *MG640-6.3*

7 In 2002, for example, fully 40 percent of the California Arts Council's grants ($15.6 million) were classified as "not reported" under the National Standard. This corresponds exactly to $15.6 million in "legislative member requests" reported by the Council (California Arts Council, 2006).

Figure 6.4
Trends in SAA Grants as a Share of Total Value of Grants, by Type of Activity, 1987–2004

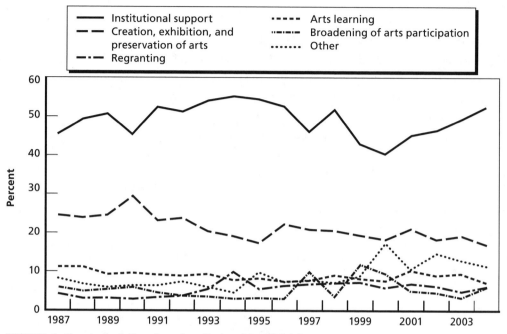

SOURCE: Authors' calculations based on National Standard data.
RAND *MG640-6.4*

in 2000, it accounted for more than 40 percent of the total; at its highest point, in 1994, it reached 55 percent. Over the same period, grants in support of arts creation, exhibition, and preservation averaged 21 percent of the total, while the various other activity categories hovered between 5 and 10 percent of the total.[8]

Funding of Education-Oriented Activities

As noted above, the National Standard recipient and activity data do not reveal what recipients of institutional support typically do with the funds they receive. Nor do these data allow us to determine the extent to which activities such as the presentation and exhibition of artworks have an educational dimension.[9] However, the

[8]　There is greater variance across states in grantmaking by activity than in grantmaking by recipient. In 2002, 19 out of 50 SAAs spent more than one-half of their grantmaking budgets on institutional support, while 35 spent more than one-third. SAAs in four states (Hawaii, Maine, Oklahoma, Vermont) spent less than 10 percent. Proportionately, the SAA that spent the most on arts learning was the Maine Arts Commission, at 42 percent of its grantmaking budget. The SAA that spent the least was the Georgia Council for the Arts, at less than one-tenth of 1 percent.

[9]　In fact, because of the wide range of possible arts education activities, and the degree to which such activities are embedded in many different kinds of grants and institutions, the National Assembly of State Arts Agen-

National Standard reports a third type of data that explicitly accounts for arts learning activities subsumed within other activity categories. Unfortunately, these "education-oriented activities" data underwent a definitional change in 1998 that effectively splits the sample in half—and some grantees are apparently rather casual about what they consider to be "educational."[10] But these data still shed important light on the extent to which grants that do not fall within our "arts learning" category have been funding arts learning activities.

A look at these data for 1987 through 1997 reveals that, on average, just over 6 percent of the total value of SAA institutional support grants and roughly 12 percent of the value of grants in support of arts creation, exhibition, and preservation were used in support of activities with a large educational component. In the 10 years from 1987 to 1997, the share of education-oriented grants overall rose from approximately 8 percent to 18 percent of the value of all SAA grants.

The 1998–2004 data indicate an even higher percentage of SAA grants supporting educational activities: By value, education-oriented grants accounted for almost one-quarter of all SAA grants over the period, including 17 percent of institutional support grants and 25 percent of grants supporting the creation, exhibition, and preservation of art.[11] Looked at another way, within the set of education-oriented grants, almost 40 percent consisted of institutional support grants, and another 18 percent supported arts creation, exhibition, and preservation. Slightly less than one-quarter of all the education-oriented grants made by SAAs fell within the activity category of "arts learning" defined above.[12]

These data reveal that much of the SAAs' education-oriented grantmaking goes to artists and arts organizations that view a large part of what they do, but by no means all of it, as educational. By comparison, much less is directed to activities specific to arts learning, such as curriculum development or writing about art. Even artist residencies,

cies feels strongly that the recipient and activity data do not provide an accurate proxy for the entirety of SAAs' education-oriented grantmaking.

[10] From 1986 to 1997, a single composite code identified grants that involved the presenting or touring of art as well as "any organized or systematic educational effort with the primary goal of increasing knowledge or skills in the arts [or using] the arts to teach non-arts subjects" (National Assembly of State Arts Agencies, n.d.). Beginning in 1998, the National Assembly of State Arts Agencies and the NEA replaced this code with a unique arts education code that identifies whether 50 percent or more of the activities supported by a grant are designed to "increase knowledge or skill in the arts with measurable outcomes" (National Assembly of State Arts Agencies, n.d.). Although the second set of data is more reliable than the first, a number of our respondents told us that their grantees still have difficulty deciding whether 50 percent or more of the activities supported by a particular grant should be classified as educational. This difficulty is more pronounced for institutional support grants than for other types of grants.

[11] We averaged over the 1998–2004 period. Note that the apparent jump in education-oriented grants between 1987 and 1997 and 1998 and 2004 may be misleading because of the definitional change in 1998.

[12] The state with the highest share of education-oriented grants in 2002 was Hawaii, at 59 percent; the state with the least was Tennessee, at 7 percent.

long the mainstay of SAAs' youth arts learning programs, accounted for less than 15 percent of the value of all grants identified as education oriented between 1998 and 2004.

How much and what kinds of educational programming do SAAs support through grants that are not specifically targeting arts learning? Unfortunately, as discussed in Chapters Four and Five, few data are available on community-based arts learning opportunities for youth or adults, including opportunities made possible through SAA grants. We do know that with respect to institutional support, about 30 percent of the SAAs offering GOS required applicants to provide some kind of educational programming.[13] However, SAA requirements typically did not specify what form these education programs should take. Certainly, no SAA that we know of required all of their GOS recipients' education programs to be standards based.[14] The limited information we have about such programs suggests that most still consist of visits to schools (assembly programs) and student field trips to off-campus performances and exhibits. They typically are not embedded in any sort of comprehensive, sequential arts learning.[15] Most would therefore be more correctly categorized as arts exposure rather than arts learning, which we would describe as increasing access to the arts.

SAA Programs That Target Youth Arts Learning

We can say somewhat more about SAA grant programs connected to the K–12 public schools, of which there are three main types: artist residency programs, professional development programs, and school-community partnerships.[16] Often developed in conjunction with the NEA, these programs are the focus of considerable SAA attention: On average, SAAs dedicate 1.5 full-time-equivalent employees to them, a significant commitment since few SAAs have more than 20 full-time-equivalent employees (National Assembly of State Arts Agencies and NEA, 2005; National Assembly of State Arts Agencies, 2005).

The artist residency has traditionally been the centerpiece of SAA demand-side grantmaking. SAAs in all 50 states either directly administer or fund programs that put artists in K–12 classrooms.[17] But the nature and purpose of artist residencies are changing. We discuss the evolution of artist residencies and what they imply for broader changes in SAA approaches to promoting arts learning below.

[13] This is based on a survey of 2007–2008 grant guidelines for SAAs in the 50 states.

[14] Our visits and conversations with SAA staff suggest that at most SAAs, staff that direct institutional support programs coordinate only loosely, if they coordinate at all, with staff that direct arts education programs.

[15] See, for example, Washington State Arts Commission, 2006; Rowe et al., 2004; and Myers, 2001.

[16] A few SAAs also support after-school arts learning programs, early childhood programs, and programs for pre-service teachers. See, for example, National Assembly of State Arts Agencies and NEA, 2005.

[17] Based on a review of individual SAA Web sites in February 2008 and data presented in National Assembly of State Arts Agencies and NEA, 2005.

In addition to funding residencies, a number of SAAs have instituted small programs to provide in-service training to educational professionals. One of the longest-running programs of this kind is the Nebraska Art Council's Prairie Visions Institute. Since 1988, Prairie Visions has provided two- to three-week summer workshops to classroom teachers, arts specialists, and school administrators in areas such as curriculum development (Fiske, 1997).[18] The goal of Prairie Visions is to help schools make the study of the visual arts integral to a Nebraska K–12 education. To date, over 2,500 Nebraska teachers and administrators have participated (Nebraska Arts Council, n.d.). According to a 2005 survey, 37 out of 50 SAAs now provide similar programs either as summer institutes or as workshops scattered throughout the school year (National Assembly of State Arts Agencies and NEA, 2005).

A more recent trend among SAAs has been to support youth arts learning through programs that promote arts education partnerships among local arts organizations, K–12 schools, individual artists, parent groups, and civic groups using the national and state arts standards as a common reference.[19] In the state of Washington, for example, the Community Consortium grants program of the Washington State Arts Commission (2008) funds arts education partnerships that meet the following criteria:

- have long-term, sustainable plans to expand and/or improve in-school arts education for all students
- are aligned with Washington state's arts standards
- feature active and committed community partnerships
- respond to local needs and opportunities and develop local resources
- have district-level support and participation
- demonstrate effective and sustainable arts education practices in areas including assessment of student learning in the arts, planning, evaluation, budgeting, and advocacy.

The Commission believes that strong community-based partners can help schools to develop and implement standards-based arts curricula, recognize and take advantage of arts resources available in their neighborhoods, and strengthen the support of parents and other community members for arts education. Schools will then be in a much better position to sustain arts education in the face of competing claims on their budgets and schedules (RAND interviews). As of November 2007, SAAs in 20 states had initiated arts education partnership programs, though most do not appear to be as comprehensive or as rigorous as Washington's.

[18] Prairie Visions was originally funded by the J. Paul Getty Trust as part of its Discipline-Based Arts Education initiative. The Nebraska Department of Education, the Nebraska Arts Council, nine state universities, two art museums, and the state art teachers' association were partners in the program.

[19] Integration into the school curriculum through adherence to the standards is a key characteristic distinguishing these arts education partnerships from the more ad hoc collaborations described in Rowe et al., 2004.

These kinds of efforts look promising, but they represent, as our analysis makes clear, a relatively small fraction of SAA grantmaking. Once again, only about 10 percent of the value of SAA grantmaking is specifically directed to arts learning, compared with one-half of all grantmaking dollars going to organizations in the form of general institutional support—mostly as GOS—and almost 20 percent going to support the creation, exhibition, and preservation of art.

Beyond Grantmaking?

Although very important, grantmaking is not the only policy tool available to SAAs. A number of SAAs have moved beyond the role of grantmaker in recent years, becoming providers of more-comprehensive services to the arts community and others within their states (Lowell, 2004; Lowell and Ondaatje, 2006). A review of SAA Web sites, which we have summarized in Table 6.1, reveals some of the ways in which SAAs are becoming information hubs as well as financial resources for their state arts communities.

As shown in the table, 80 percent of SAAs now compile rosters of artists available for teaching or touring, and roughly three-quarters publish or provide links to cultural calendars and arts-related job opportunities. Over half of all SAAs sponsor statewide conferences or workshops on arts-related topics, provide materials or links relevant to arts advocacy, provide links to arts content standards and/or curriculum guides, and showcase selected artists either in physical exhibition spaces or online. A smaller number provide presenter or venue listings and links to online business and career management materials, sponsor cultural tours or trails, direct artists to information about health insurance, and review or podcast local arts events.

Table 6.1
Selection of SAA Services Reported on SAA Web Sites, for 50 States, 2007

	SAA Web Sites Reporting Service	
Service	Number	Percentage
Statewide conferences or workshops	26	52
Advocacy information	29	58
K–12 curriculum guides/content standards	31	62
Business and career management	16	32
Teaching or touring artist registries	40	80
Job listings/calls to artists	37	74
Presenter/venue listings	21	42
Cultural calendars	37	74
Cultural tours or trails	13	26
Artist showcases	26	52
Artist health insurance information	16	32
Reviews/podcasts of arts events	5	10

SOURCE: Authors' review of Web sites, November 2007.

In the following sections, we explore the extent to which SAAs have used tools other than grantmaking to cultivate demand. Specifically, we consider the historical role of SAAs in supporting youth arts learning, from the genesis of the artist residency concept to more recent activities such as participation in governmental forums and convening of stakeholders. Our analysis draws on a survey of the literature on NEA and SAA education policy, as well as on interviews and discussions with individuals involved in the field.

Brief History of SAA Support for Youth Arts Learning

The first SAA forays into the field of youth arts learning came in 1969, a time when the vast majority of SAAs still depended heavily on the NEA for funding (Scott, 1970; Larson, 1983). In that year, the NEA expanded both the scope and the geographic reach of a small residency program for poets that it had piloted in a handful of states. This new Artists-in-Schools program was jointly supported by the NEA and the U.S. Office of Education and was administered by SAAs (Eisner, 1974; Biddle, 1988).

According to Biddle (1988), the declared purpose of the Artists-in-Schools program was to supplement the public school arts curriculum already provided by arts specialists and classroom teachers. The visiting artist was to get students excited about art, not provide them with a comprehensive arts education. The study of art, especially art history, was within the purview of the National Endowment for the Humanities, not the NEA.[20] Further, the U.S. Office of Education was responsible for federal programs addressing elementary schools, secondary schools, and teacher education. Thus, neither funding nor oversight of the arts education offered in K–12 public schools originally appeared to be a natural function for the NEA and its state-level satellites.[21]

Yet responsibility for youth arts education at the federal level soon devolved on the NEA—and by extension, the SAAs. Chapman (1992) claims this happened because "arts education was only one of many topics to be addressed" within the Office of Education and the National Endowment for the Humanities, whereas "[by] virtue of its title, the Arts Endowment seemed to have responsibility for all proposals dealing with the arts, including arts education" (p. 125).[22] Chapman also remarked that the

[20] See Biddle, 1988, and Chapman, 1992. The 1965 enabling legislation for the NEA makes no mention of arts education. It was not until the reauthorization of the NEA in 1990 that arts education was recognized explicitly as one of its responsibilities. In 1997, Congress required the NEA to raise arts education to a priority (U.S. Congress, 1997).

[21] It is important to keep in mind that the vast majority of public arts education flows through state and local education agencies and institutions.

[22] Myers and Brooks (2002) suggest that the NEA also became involved in arts education early on because it owed political favors to the arts education community, which had been helpful in gaining congressional support for its creation.

Office of Education was hampered by "several staff cutbacks and various reorganizations" (p. 124). In any case, by 1974, the NEA had adopted full fiscal responsibility for the Artists-in-Schools program, and all 50 SAAs were receiving funds for its operation. Chapman estimates that by 1982, this program—which in 1980 changed its name to Artists-in-Education—had become the largest federal arts program for K–12 children.[23]

The Artists-in-Schools/Artists-in-Education program provoked considerable criticism from arts educators and arts education theorists. The major complaint was that artist residencies were not an effective way to teach children about the arts—and that the NEA and SAAs had avoided and even quashed unbiased evaluations of the program for this reason. Related criticisms were that the program's primary function was to provide jobs for artists, that it contributed to the loss of jobs for arts specialists, that it reached very few students, and that the "deschooling" of arts education by introducing individuals from outside the school system marginalized the arts as subjects not requiring certified instructors (Eisner, 1974; Smith, 1977; Day, 1978; Chapman, 1982a).

Our interviews with SAA staff and our reading of the literature lead us to think there is some truth to these charges. Under the original structure of the Artists-in-Schools/Artists-in-Education program, ability to teach was not a main criteria in selecting artists.[24] Artists were not integrated into classrooms because their work was considered—by them and everyone else—to be entirely outside the curricular structure. Further, residencies have never reached more than a very small percentage of American children: Eisner (1974) reported that just 2 to 3 percent of U.S. public schools were supporting an artist in residence; and Bumgarner (1994a) estimated that only 7 percent of U.S. public school students in 1990 had access to a resident artist.[25]

There is also no question that one of the program's major purposes was to support artists. James Backas, executive director of the Maryland State Arts Council from 1972 to 1976 and 1986 to 2001, acknowledged this openly, stating that the Artists-in-Schools program had "two major purposes: (1) to introduce art to the young or to the uninitiated adult in a creative, participatory role through close personal contact with a professional artist; and (2) to provide meaningful employment for professional artists that will not interfere with their own creative work" (Backas, 1981, p. 13). The NEA, too, acknowledged this point in its influential 1988 *Toward Civilization: A Report on Arts Education.*

[23] The Artists-in-Education program expanded on Artists-in-Schools by including after-school programs.

[24] According to one of our respondents, most SAAs did screen residency artists in an attempt to avoid problems, but screening consisted mainly of ensuring that the person did not have a criminal record. See, for example, various quotations in Arts, Education, and Americans Panel, 1977.

[25] The name of the Artists-in-Education program changed to Arts in Education in 1988.

Less clear is whether the growth of artist residencies in schools—and by the mid-1980s, there probably was no growth—actually led to a decline in the employment of specialist and classroom teachers trained in the arts.[26] We found no national data on school employment of arts specialists over the period and no empirical studies of a possible relationship between artist residencies and arts specialist employment. However, in the late 1970s, there were large-scale layoffs of arts specialists in a number of urban schools districts and in California following passage of Proposition 13.[27] Additionally, declining enrollments in the late 1970s and early 1980s meant that schools across the country lost resources, forcing them to lay off (or simply not hire) classroom teachers as well as arts specialists (Arts, Education, and Americans Panel, 1977; Morisi, 1994).

By the mid-1980s, the sense that all was not well with American arts education was growing. In 1983, the National Commission on Excellence in Education's *A Nation at Risk: The Imperative for Educational Reform* was published, expressing concern about "a rising tide of mediocrity" in American public schools and spurring a "back to basics" reform movement. This report's failure to acknowledge the arts as one of those basics was highly unwelcome, if not necessarily a surprise, to members of both the arts community and the arts education community (Herbert, 2004). In 1989, President George H. W. Bush and the state governors announced national education goals that initially did not include the arts. At the same time, some leaders in the arts community, and particularly at the NEA, were expressing concerns about what they saw as the widespread problem of "cultural illiteracy" in America,[28] by which they meant the lack of a general appreciation for and understanding of the arts (Hodsoll, 1985). A first step to addressing the problem—and to making the arts basic—they believed, was to reintroduce the arts as core academic subjects in the schools. The NEA's 1988 *Toward Civilization: A Report on Arts Education* summarized its new approach to arts education based on this view.

To further the goal of advancing arts literacy, the NEA introduced a program in 1987 designed to encourage SAAs to work with their state departments of education and local school districts to develop a statewide, sequential arts curriculum. This program, called Artists-in-Schools Basic Education Grants (AISBEG), never accounted for more than one-quarter of the NEA's arts education budget and was maintained as

[26] Between 1986 and 2004, the annual average rate of growth in the total value of grants for artist residencies in schools was, at 1 percent, less than the rate of inflation.

[27] See, for example, Moskowitz, 2003, and Illinois Arts Alliance, 2006. California's Proposition 13, which passed in 1978, reduced property taxes by 57 percent, leading to major cutbacks in arts programs and layoffs of arts teachers.

[28] As indicated above, arts educators and their representative organizations had long been aware of the decline in arts literacy among American youth. According to one of our reviewers, they "pleaded with the NEA to change course" well before it actually did.

a separate program for only four years.[29] But it represents the first time that education, and not simply exposure, was acknowledged as the purpose of an NEA/SAA arts education program. Further, the AISBEG application guidelines were quite specific about what must be done to ensure that students receive an arts education: develop, establish, and realize (1) specific objectives and competencies for student accomplishment in the arts; (2) curricula and resources aimed at sequential achievement of those objectives and competencies; and (3) methods for evaluating student progress toward those objectives and competencies.[30]

AISBEG represented a major policy departure for most, if not all, SAAs.[31] Some SAAs were deeply unhappy with the new program, seeing it as a diversion from their focus on introducing children to the arts through direct contact with artists. Several feared that closer relations with their state departments of education, which without exception were (and still are) among the largest departments within state governments, could compromise their independence. These SAAs have largely returned to the pre-AISBEG emphasis on artist residencies as the primary tool for encouraging youth arts learning (Bumgarner, 1994b; RAND interviews).[32]

But for some SAAs, AISBEG proved to be a catalyst that transformed their approach to youth arts learning. Their collaboration with educators has brought a number of realizations, including (1) the stakeholders in youth arts learning (such as arts specialists, classroom teachers, arts policymakers, school administrators, artists, arts organizations, parents, and elected officials) are various, each with a different view of what the targeted objectives and competencies for student accomplishment in the arts should be; (2) representatives of these stakeholders are rarely in the same room together; (3) despite the differences, common ground can be found; (4) communities typically lack the information they need to help decide among competing priorities; and (5) inadequate arts education is, above all else, a political issue that cannot be resolved unless all stakeholders agree to work together.

[29] Authors' calculations based on data provided in NEA *Annual Report*, various years. In fiscal year 1992, AISBEG and the State Arts in Education grants program (a program funding artist residencies) merged to form a new program, Arts Education Partnership Grants.

[30] Paraphrase of Bumgarner (1994b, p. 13), who quotes the NEA's Arts in Education program guidelines for fiscal year 1990.

[31] In interviews with Arts in Education staff members at the NEA and at several SAAs, Bumgarner (1994b) found that no SAA had an "AISBEG-like" program prior to AISBEG itself. According to SAA staff, however, the genesis of their own AISBEG programs was the educational reform movement that began in the mid-1980s, not AISBEG per se.

[32] For example, SAAs now appear to put much greater emphasis on the teaching abilities of artists chosen for school-based residencies. These artists are now called "teaching artists," and our SAA respondents told us that the change is not merely semantic: In several states, artists known to be poor teachers have been removed from SAA teaching artist rosters.

In the following sections, we look at the experiences of two SAAs—the Rhode Island State Council on the Arts (RISCA) and the New Jersey State Council on the Arts (NJSCA)—that have worked closely with their state departments of education and with others to improve the condition and status of youth arts learning in their states. Although some aspects of these experiences are unique, we think they nonetheless echo what is occurring in other states where SAAs have become strong policy partners with other stakeholders in youth arts learning (RAND interviews). These experiences may offer lessons to SAAs still seeking to have a strong, positive influence on the amount and quality of arts education received by K–12 students in their states.

Rhode Island: A Systems Approach to Improving Youth Arts Learning

RISCA, like the vast majority of SAAs, is small relative to other units of state government. When the NEA introduced AISBEG in 1987, RISCA's total revenues—including both state appropriations and NEA grants—were just $1.1 million, or 0.04 percent of the state of Rhode Island's total revenues, which is an about-average percentage for SAAs.[33] Just under half of RISCA's revenues came from the NEA rather than the state legislature, a somewhat larger federal share than for most SAAs at that time (Lowell and Ondaatje, 2006). Twenty years later, in 2007, RISCA's total revenue was $4.4 million, putting it among the top five SAAs in its share of total state revenue and its total revenue per capita. Fourteen percent of its revenues represented grants from the NEA, which was just slightly above average for SAAs.

RISCA was among the first set of SAAs to apply for and receive a planning grant under AISBEG. According to RISCA's director of arts education, the position of arts coordinator at the Rhode Island Department of Elementary and Secondary Education (RIDE) has only been filled sporadically, so it was up to RISCA staff to find people they could work with there. They chose the Literacy Office for two very practical reasons. First, the issue of literacy was receiving a great deal of attention both statewide and nationally at the time, so the office had money as well as regulatory punch. Second, some Literary Office staff were interested in working with RISCA to explore the issue of arts literacy.

RISCA and RIDE worked closely together to develop Rhode Island's voluntary "Arts Framework" (including arts content standards), which was published in 1996. In 1999, after policy conversations initiated by the two agencies, then-governor Lincoln Almond asked them to administer a task force on literacy in the arts, which was charged with examining the relationship between education reform and the arts and making policy recommendations on how the arts can have a significant effect on

[33] Authors' calculations based on state legislative appropriations data for 1987 provided by the National Assembly of State Arts Agencies (2007), NEA grantmaking data published in the NEA's *Annual Report* for 1987, and U.S. Census Bureau data on state and local government finances (U.S. Department of Commerce, Bureau of the Census, 1990). Total revenues for RISCA were calculated as state legislative appropriations plus NEA grants; total state government revenues include federal transfers.

the educational agenda of Rhode Island.[34] To address this relationship, the task force reviewed a wide range of scholarly research and writing and held public dialogue sessions around the state. It also acquired information and baseline data through surveys collected from Rhode Island K–12 school districts, institutions of higher learning, arts educators, artists, and community organizations.

A key premise of the task force was that arts learning in home and community settings, as well as at school, is critical to providing a comprehensive arts education to all K–12 students. Organizations and individuals at home, in the community, and at school together form a system of arts learning providers that operates best when values, goals, and resources are aligned. This premise was based in part on research conducted by the Arts Education Partnership and the President's Committee on the Arts and Humanities (and reported in *Champions of Change: The Impact of the Arts on Learning* [Fiske, 1999]), which identified "the active involvement of influential segments of the community" as the single most important factor in shaping and implementing effective districtwide arts education policies and programs (p. 9). It also reflected stakeholder views expressed in surveys and in conversations with members of the task force.

What the task force found, however, is that arts learning in Rhode Island homes and communities is often disconnected from arts learning in the schools because the various providers are not coordinated sufficiently. Accordingly, the task force called for the development of action plans to

- map the arts resources available in Rhode Island cities and towns
- raise awareness of the national standards for arts education and the Rhode Island Arts Framework
- facilitate coordination among providers
- align public and private resources to that end.

The task force also called for a change in Rhode Island's high school arts graduation requirement to a "standards-based demonstration of proficiency and knowledge for all students, based on Rhode Island and national arts standards" (State of Rhode Island, Governor's Task Force, 2001, p. 32). To draw up and help implement the plans, a network consisting of all stakeholders was to be created and was to be administered by RISCA, RIDE, and the Rhode Island Office of Higher Education. Rhode Island's Arts Learning Network was born.

In 2003, the Arts Learning Network convinced the Rhode Island Board of Regents of Elementary and Secondary Education to pass a statewide, proficiency-based arts graduation requirement. Beginning in 2008, all graduating seniors must demonstrate proficiency in two of the three areas of creating, performing, and

[34] The task force was made up of 19 leaders broadly representing the stakeholders in youth arts education: arts educators, classroom teachers, school administrators, parent-teacher organizations, arts policymakers, and artists and arts organizations. All task force members were appointed by the governor (Galligan and Burgess, 2005).

responding. To help with the new requirement, RISCA offered planning grants to school districts and assisted in organizing and supporting four educator-artist-parent-student teams, one each in dance, music, theater, and the visual arts. These teams developed district-level guidelines on how to define and measure discipline-specific proficiency in the three areas. RISCA also helped to set up and fund Rhode Island's Arts Passport program, in which professional and university arts organizations provide free access to their events and exhibits to help high school students meet the graduation requirement (Galligan and Burgess, 2005).

The new graduation requirement has drawn considerable attention to arts education in Rhode Island from parents, students, teachers, and school administrators, and not all of it has been positive. There was a recent backlash by parents worried that their high school seniors might not graduate because of the requirement (RAND interviews). It seems that they had not taken the requirement seriously, which is exactly the point: Proficiency in the arts has been made a requirement for graduation, so students, teachers, and parents must all take arts learning seriously. According to our respondent, despite the backlash, the requirement still has the full support of Rhode Island's Education Commissioner.

New Jersey: Identifying Priorities, Raising Visibility

New Jersey is geographically one of the smaller states, although its land area is roughly seven times that of the smallest state, Rhode Island. NJSCA's budget is large relative to the budgets of most other SAAs. In 1987, it ranked third in the nation in total revenue per capita, at $14.0 million total revenue, and its share of state government revenue put it in the top five; in 2007, its $23.5 million in total revenue put it among the top ten SAAs, and its share of state government revenue put it in the top five. Less than 3 percent of its revenues derived from the NEA (National Assembly of State Arts Agencies, 2007).

But New Jersey has 611 school districts to serve its 8.7 million population, and each one is responsible for developing its own curriculum (RAND interviews).[35] Accordingly, the process of developing and implementing statewide policies to encourage comprehensive arts education throughout New Jersey has been long and challenging—and it is not over. The recently formed New Jersey Arts Education Partnership, however, with NJSCA playing a lead role, is an encouraging development.

The story of the New Jersey Arts Education Partnership parallels that of Rhode Island's Arts Learning Network in a number of ways.[36] As with RISCA, NJSCA first began to collaborate with the New Jersey Department of Education on curricular matters largely because of the money and encouragement provided through AISBEG. In

[35] Rhode Island's 36 districts serve a population of slightly over one million.

[36] This is not a coincidence. We were told by respondents in New Jersey and Rhode Island that the two SAAs have borrowed ideas from each other since at least the 1990s.

1987, NJSCA joined with the Alliance for Arts Education/New Jersey, the New Jersey Department of Education, the New Jersey School Boards Association, the New Jersey Education Association, and the New Jersey Department of State in a "literacy in the arts" task force that was established by the New Jersey legislature to "create a comprehensive plan for the appropriate development of arts education in the elementary and secondary schools of the state" (Literacy in the Arts Task Force, 1989, p. 47). Among this task force's specific assignments were the following:

- Conduct a survey of all arts education programs in the state.
- Develop a model curriculum with sequential instruction for grades K–12.
- Explore partnerships and financial resources for the support of arts education in New Jersey.

The task force found that New Jersey had in place a legal and regulatory framework reflecting a strong commitment to arts education. However, it also found that despite an arts graduation requirement mandated by the state, high school seniors in New Jersey could easily graduate without taking a single course in music, dance, theater, creative writing, or the visual arts. Further, the survey conducted by the task force indicated that performance too often drove the arts curriculum in the schools. Insufficient attention was paid to the history of artists and arts forms, and students received limited exposure to the "aesthetic, interpretive, and critical aspects of arts literacy" (Literacy in the Arts Task Force, 1989, p. 12). The task force concluded that without effective evaluation procedures, "the arts will never be embraced" by schools or—perhaps more important—parents (p. 13).

The work of the task force partners helped to establish New Jersey's visual and performing arts standards in 1996, plus a curricular framework designed to support those standards (New Jersey Department of Education, 1998). However, our respondents told us that because students' and schools' achievements in the arts were not assessed, many observers—including some members of the New Jersey State Board of Education—suspected that New Jersey's independent school districts were not taking the steps needed to ensure implementation of the new standards (such as providing professional development opportunities to teachers).[37]

To determine the status of arts education in New Jersey and to set a baseline for the recently adopted content standards, the task force partners, led by NJSCA and at this point including the Playwrights Theatre of New Jersey, embarked on a detailed information-mapping project. By the early 2000s, they had collected information on a large number of New Jersey schools. In 2002, however, the Alliance for Arts Education/New Jersey ceased operations. A state budget squeeze and personnel and policy

[37] The New Jersey State Board of Education is the governing body for the state's education department. It sets the rules needed to implement state education laws. See State of New Jersey, Department of Education, 2006.

changes diverted the attention of NJSCA and the education department, and the data from the mapping project were never adequately analyzed.

This situation persisted until 2004, when the budgetary threats to NJSCA and the education department were defused. NJSCA joined with a new set of partners to push forward the idea of mapping the status of arts education in New Jersey schools. The education department and the state board of education—which were once again confronting the issue of assessment—signed on, and the New Jersey Arts Education Census Project was created.[38] NJSCA, the New Jersey Department of Education, the Geraldine R. Dodge Foundation, Playwrights Theatre of New Jersey, and Music for All were the partners in this effort. Music for All, a newly formed national advocacy group then based in New Jersey and "committed to expanding the role of music and the arts in education" was the leader (RAND interviews; Music for All Foundation, n.d.). The Census Project partners also formed the core of a reimagined arts education advocacy entity, the New Jersey Arts Education Partnership.[39]

The New Jersey Department of Education required every New Jersey public school to respond to the online survey that is at the heart of the new "mapping project" and was met with a 98.5 percent response rate. According to our respondents, schools were not tempted to overstate their achievements, because the education department and the project partners stressed the importance of understanding the true status of arts education around the state in order to resolve any problems. The fact that the two most significant funders of arts education in the state—NJSCA and the Dodge Foundation—were also project partners gave schools an extra reason to respond honestly to the survey questionnaire.

Because of its high response rate, the New Jersey survey offers a comprehensive picture of which schools are complying with the state mandate to provide a well-rounded arts education.[40] More than that, the survey report, which was released in October 2007, is already proving an effective tool for raising awareness of arts education among parents, school administrators, and elected officials (RAND interviews).[41] The partners are now taking advantage of that heightened awareness to push for a

[38] Education policymakers in New Jersey were concerned about possible neglect of all core curriculum content standards areas not subject to statewide testing under NCLB. Their first data collection, in 2004, addressed the extent to which K–12 public school instruction in world languages was meeting state standards. See New Jersey Department of Education, 2005.

[39] The new partnership has many members, including Music for All, NJSCA, the New Jersey Department of Education, the New Jersey Music Educators Association, Art Educators of New Jersey, Young Audiences, the New Jersey PTA, the Geraldine R. Dodge Foundation, and Playwrights Theatre of New Jersey. See New Jersey Arts Education Census Project, 2007a.

[40] Comparisons have been facilitated by the creation of an "arts education index," an arithmetic combination of scores related to survey responses on the various components of arts education in each school.

[41] For example, in a November 2007 meeting of the state board of education, the first hour was devoted to discussing the survey results.

number of changes, including inclusion of per-pupil arts spending in New Jersey's Comparative Spending Guide for public schools, professional development for school and district administrators that emphasizes the importance of the visual and performing arts, the creation of a clearinghouse that will enable schools in need of certified arts specialists to find them quickly and easily, and greater support for collaborations between arts organizations and school districts.

Conclusion

Our examination of SAA grantmaking patterns and trends reveals that despite gaps in the support infrastructure for demand for the arts (as identified in Chapters Four and Five), SAAs primarily focus on expanding supply of the arts and promoting access to the arts. On average, 60 to 70 percent of the value of grants awarded by SAAs between 1987 and 2004 went to supporting arts organizations or the creation, exhibition, and preservation of art, and less than 10 percent was specifically directed to arts learning.

Although roughly one-quarter of the value of SAA grants in 2004 went in part to support activities that grantees considered educational, SAAs' promotion of arts learning through GOS and other types of grants not specific to arts learning appears to be more opportunistic than systematic. While encouraging these grantees to provide educational programming, most SAAs offer little guidance on what that programming should look like.[42] Anecdotally, much of it appears to be aimed at expanding access and exposure, rather than developing the skills and knowledge needed for long-term arts engagement. But there is not much we can say about this programming, because to our knowledge, no SAA keeps track of the cost or character of the educational programming it helps make possible through GOS or program and project support grants. And no SAA has a grant program specifically directed to adult arts learning.

What we can say is that whether SAAs' education-oriented grantmaking is broadly or narrowly defined, it is simply too small to reach more than a tiny fraction of their states' populations. In fact, even if SAAs were to devote their entire budgets to grants in aid of arts learning, the impact would be minimal: In 2007, SAA budgets represented approximately 0.05 percent of state general fund expenditures, or just over $1.25 per state citizen (National Assembly of State Arts Agencies, 2007).

But grantmaking dollars do not fully reflect the effects that SAAs can have on arts learning in their states. An increasing number of SAAs are relying on tools other than—and in addition to—grants to promote arts learning, particularly youth arts learning. For example, many SAAs now support summer institutes, workshops, and

[42] Based on a review of SAA grant guidelines for 2007–2008. There are, of course, exceptions: The Arizona Commission on the Arts, for example, requires each of its larger GOS recipients (organizations with total adjusted operating incomes in excess of $1 million) to have a board-approved plan for K–12 education that aligns with the Arizona arts standards.

other professional development opportunities designed to help educators navigate their states' new K–12 arts content standards. SAAs are also actively seeking to strengthen collaborations between arts organizations and schools by supporting those that are aligned with state and national arts standards, have a long-term outlook, involve parents, and enjoy district-level support and participation.

Perhaps most important is that a few SAAs—and their national association— are now forging very broad partnerships with stakeholders in youth arts learning at the state and even the national level. Through the National Assembly of State Arts Agencies, SAAs helped to found the Arts Education Partnership, the primary forum for advancing arts education in America. Among other things, the Arts Education Partnership has produced highly influential research documenting the factors that correlate with strong youth arts learning programs.[43] As illustrated by what has happened in Rhode Island and New Jersey, partnerships can take a long time to develop and can entail considerable effort. But RISCA and NJSCA can already point to the significant positive returns from this approach, and a number of states appear likely to follow.[44]

It is, of course, too soon to judge whether a few pioneering efforts represent a nationwide trend, but there is evidence that public and private arts policymakers at the federal level are paying increased attention to programs that combine educational and aesthetic experiences in order to cultivate demand. Over the past few years, the NEA has sponsored a number of nationwide initiatives designed to build the kinds of skills and knowledge that enable individuals to have engaging arts experiences. These programs include American Masterpieces, Poetry Out Loud, the NEA Arts Journalism Institutes, The Big Read, and Operation Homecoming: Writing the Wartime Experience (see NEA, n.d.). The foundation community is also making new commitments to furthering the field of arts education, including research (see, for example, Dana Foundation, 2003, and Wallace Foundation, 2008). In the next chapter, we suggest that the time is right for such policymakers and funders to join forces with others in the cultural, educational, business, and political communities to improve arts learning for all people, particularly the young.

[43] The Arts Education Partnership is co-managed by the National Assembly of State Arts Agencies and the Council of Chief State School Officers and was created by the U.S. Department of Education and the NEA.

[44] For example, according to a respondent, at least four SAAs have contacted New Jersey's Arts Education Partnership about conducting a census of arts education similar to New Jersey's.

Conclusions and Policy Implications

We have proposed that healthy demand for the arts is critical to a vibrant nonprofit arts sector, that demand is stimulated by a certain kind of arts learning, and that arts policies focused on supporting the supply of and access to works of art are not sufficient for developing demand for the arts. We have described what public schools and other institutions are doing to provide arts learning, as well as the strategies SAAs have adopted to support such learning. Overall, we found that despite some progress over the past 30 years, neither education policies nor arts policies have made the cultivation of demand for the arts a priority. Many people across the country—most importantly teachers, but also philanthropic funders, community and school leaders, and arts professionals—are deeply committed to providing more and better arts learning to the young, but their work is often carried out within an infrastructure offering no more than fragile financial support and little recognition. In particular, the critical role that arts learning plays in supporting the entire cultural sector is insufficiently understood. This chapter summarizes our main points and their implications for SAAs and other policymakers.

Key Points

Cultivating Demand Is a Necessary Focus of Arts Policy

The arts represent a unique form of communication that can occur between artists and the individuals who encounter their works. For this communication to provide its full benefits, those individuals need to experience the work in a way that engages their emotions, stimulates their senses, and challenges their minds to a process of discovery. In other words, the aesthetic experience requires works of art that can elicit such a response (supply), opportunities to encounter those works of art (access), and people who seek out such encounters and can find value in them (demand). It follows that arts policies should support all of these conditions.

Yet for various reasons, investment in demand, by which we mean developing the capacity of individuals to engage in aesthetic experiences, has been neglected in both arts and education policy over several decades. It is our view that without this investment, audiences for the arts will continue to diminish despite heavy investments in

supply and access. We propose that policies be balanced to support supply, access, and demand, and that the overarching goal of these policies be to increase the number and quality of aesthetic experiences. These experiences are a better measure of the cultural health of a nation than are the number and quality of its works of art.

The Knowledge and Skills That Enable Aesthetic Experiences Can Be Taught

Demand for the arts can be cultivated by teaching people of all ages how to enjoy and understand works of art. The best way to accomplish this, according to those who have addressed the issue, is to help individuals develop four types of knowledge and skills, preferably in combination:

1. the capacity for aesthetic perception, or the ability to see, hear, and feel what works of art have to offer
2. the ability to create artistically in an art form
3. historical and cultural knowledge that enriches the understanding of works of art
4. the ability to interpret works of art, discern what is valuable in them, and draw meaning from them through reflection and discussion with others.

National and state arts content standards that now define what students should learn in each arts discipline at every grade level embody just such a comprehensive approach.

Educational Support for This Kind of Learning Is Weak

We do not know how much arts learning—in terms of frequency of instruction and amount of time spent in arts study—is enough to attract people into long-term engagement with the arts. But a few studies have suggested that prolonged instruction has the greatest effects on behavior and level of involvement (Heath, Soep, and Roach, 1998; McCarthy et al., 2004; Hetland et al., 2007). To describe the arts instruction available today, we inventoried the institutional infrastructure for the support of arts learning: K–12 public schools, colleges and universities, and programs offered beyond the classroom by arts organizations, community organizations, and community schools of the arts.

What our inventory revealed about public schools is that most students are not provided enough time on task to learn the skills and knowledge associated with building their capacity for aesthetic experience. Arts content standards have been almost universally mandated by the states and are broadening teaching practices, but state, local, and district policies are not providing the resources or time in the school day to implement these standards, and states are not holding schools accountable for student progress in learning these skills.

Arts organizations, colleges, and other institutions have been developing promising programs that complement school-based arts education. Both museums and performing arts centers have programs that focus on developing an aesthetic response to their works of art in children of all ages and their teachers. Some colleges offer to support their local public schools by providing access to their own infrastructure. Public school teachers, for example, are given free access to arts classes, high school students have access to arts classes at reduced cost, and college arts students are interning in elementary school classrooms. Additionally, some after-school arts-based programs are drawing on local teaching talent and exceptional venues to provide youth arts learning that aligns with state arts standards. Many of these programs were developed to bolster the capacity of under-resourced public schools. Despite their growing contributions to the arts learning infrastructure, however, these programs cannot substitute for strong, sequential arts education in the schools.

What we found on adult arts learning is confined almost entirely to the formal arts education provided by colleges and universities, which offer the broadest range of arts courses, including professional education and training for artists, scholars, and teachers and numerous courses for general students, community residents (through extension divisions), and high school students in the vicinity. These courses are largely voluntary and thus tend to reach learners who are already inclined toward participation. What little we know about opportunities for adult arts learning beyond college and university comes from arts organizations, which offer very few programs targeted to adults. And another avenue for learning, the public discourse about the arts carried out by cultural journalists and critics, has been declining in most newspapers across the country.

State Arts Policy Has Emphasized Supply and Access, Not Demand

Historically, grantmaking has been the primary function of SAAs. Our analysis of data on SAA grant recipients reveals that arts grantmaking at the state level has been heavily weighted toward arts organizations for more than 20 years. During this time, education institutions have received only a fraction of the funding received by arts organizations, and this fraction has remained remarkably constant. In terms of types of activities funded, institutional support has accounted for almost one-half of the total value of SAA grants, whereas grants directly supporting youth and adult arts learning have accounted for less than 10 percent. The percentage devoted to arts learning rises when we account for all SAA grants that have an educational component, but the educational nature of the programming supported by such grants is questionable. In most states, they are not part of a systematic, comprehensive strategy to promote youth or adult arts learning, and the extent to which they serve to cultivate demand is unclear.

In fact, the youth education initiatives of the NEA and SAAs were historically at least as much about employing artists as about educating K–12 students, as acknowledged by a number of SAAs as well as the NEA. The NEA and SAAs initially focused

their attention on small-scale residency programs that reached relatively few students and contributed little to making the arts an essential part of the K–12 public school curriculum. They saw these programs as opportunities to provide enrichment to children and, at the same time, support artists and arts organizations. They neither sought nor were asked to take a bigger role in formal instruction in the arts, which was seen by all as the responsibility (if, in hindsight, not the priority) of the schools.

After 40 years of policy and action aligned with this assumption, however, arts participation has declined, arts instruction in the schools has lost ground, and some SAAs are devoting greater attention to cultivating demand. The most notable evidence of this comes from SAAs that have moved beyond grantmaking, leveraging their position at the nexus of state government and the arts community to influence arts education policy. Two examples of such SAAs—those in Rhode Island and New Jersey (see Chapter Six for details)—are helping to build and maintain collaborations among the various stakeholders in arts education: arts specialists, classroom teachers, school administrators, parent-teacher organizations, arts policymakers, elected officials, and artists and arts organizations. Their goal is to develop policies that support comprehensive and sequential arts education in the public schools and to build public support for those policies.

Policy Implications

State Arts Agencies

Our suggestion that public support of the arts has been too narrowly focused on supply and access is not meant to imply that SAAs should start balancing their grant funding equally among supply, access, and demand. As we have noted, even if SAAs were to devote all of their resources to cultivating demand, their modest budgets would prevent them from making much of an improvement in the K–12 school system that delivers arts education. Similarly, there is little that SAAs can do through grantmaking alone that will encourage adults to seek arts experiences.

Instead, we suggest that SAAs and other funders and policymakers take a broad view of the support infrastructure for arts learning to determine where and how they might have the most leverage in spurring improvements. As our two examples show, SAAs can very effectively use tools other than grantmaking to improve policy and practice. We recognize that SAA priorities for cultivating demand will differ because of variations across states in policy environments, cultural-sector capacities, and demographics. There are, however, specific questions, described next, that SAAs should consider in identifying and evaluating their policy options.

What Is the Status of Youth Arts Learning in the State? Before SAAs can begin to help remediate problems in youth arts learning, they must better understand the overall arts learning environment, including community providers as well as public

schools. How many hours per week are various art forms offered, and who are the instructors? Do classroom teachers have the arts training they need to teach to the national arts standards? Is there equitable provision of arts education? If not, where are the gaps? Thorough "censuses" of arts education have been conducted in a handful of states, and SAAs have played a lead role in these efforts. The data collected have allowed policymakers to answer the questions about the arts learning environment and to develop strategies for improvement.

In New Jersey, for example, the SAA and other policymakers used a statewide survey to collect data on arts education in the public schools. They constructed an arts education index that measures the adequacy of arts education in every school and school district across the state. The full dataset is available online, so parents and others can easily compare their school's performance to that of others. In this way, the information is not only helping to establish priorities for action among many state players, but is also promoting competition among schools and school districts to provide the best arts education.

What Can SAAs Do to Raise Public Awareness of the Need for More Intensive and More Comprehensive Arts Learning Within and Beyond the Schools? For time and money to be made available for arts education, state residents and their political leaders must be convinced that arts education should be a basic part of K–12 education. SAAs have a unique position within state government for advocating the benefits of arts engagement and the necessity of promoting arts engagement through education.[1] As shown by our examples, strategies for raising public awareness can entail much more than a public relations campaign. In New Jersey, the arts education index offers guidance on where to invest resources, and it also gets the attention of parents and school administrators. In Rhode Island, the statewide arts high school graduation requirement is encouraging students to take more arts courses, parents to examine school offerings in the arts more closely, and schools to ensure that their arts courses align with state and national content standards.

How Can SAAs Best Contribute to Policy Changes That Will Strengthen Arts Education in the Public School System? No one group of stakeholders has the resources or leverage to single-handedly bring about change in general education policy at the state level. SAAs are likely to be more effective in bringing about change at this level as influencers and conveners of stakeholders rather than as grantmakers. However, the following strategies also appear promising for SAAs:

- Support comprehensive standards-based programs in the schools.
- Encourage colleges to offer arts courses for high school students and lifelong learning for community residents.

[1] Note that there is a difference between broad-based advocacy and political lobbying. Advocacy in the public interest is not only a right but a responsibility of government agencies, but it can easily be hijacked by more-parochial concerns about agency budgets and benefits for specific constituents.

- Support the arts education programs of cultural and other community organizations that are the most likely to cultivate a community of individuals who value the arts.

How Can SAAs Best Contribute to Policy Changes That Will Strengthen Arts Learning in the Community? For youth arts learning, SAAs can work with arts organizations and others to ensure they understand what the state and national content standards in the arts imply for their programs. Many SAAs are beginning to condition their awards of artist residency grants on alignment with the content standards and integration into classroom arts curriculum. They could link grants awarded to organizations for educational purposes directly to support of the standards, and they could promote programs to increase information and discourse about the arts through multiple media. To the extent that SAAs are in a position to see the system of arts learning provision as a whole, they may also be able to advise artists, arts organizations, and other arts learning providers on gaps in the system—and to fund individuals and institutions able to fill those gaps.

How Can SAAs Identify and Promote Exemplary Programs That Are Likely to Build Long-Term Engagement in the Arts? SAAs are uniquely situated to recognize and publicize programs relating to arts learning that are considered exceptional by experts in the field, such as outstanding

- arts courses for children and young adults provided in schools or throughout school districts, after-school programs, and programs offered by arts institutions and community organizations
- teacher development programs, including aesthetic education for general classroom teachers and arts specialists
- teacher preparation programs in higher education
- community-based programs for adult learning in the arts
- local collaborative networks in support of multiple goals relating to arts learning.

By drawing attention to such programs, SAAs can help to simultaneously build capacity in the field and develop public awareness.

Other Policymakers

For other policymakers and funders, the key implication of our work is that greater attention must be directed to cultivating demand among Americans, especially the young. Since the benefits of the arts are created by compelling experiences with works of art, providing more individuals with the skills that enable them to have these experiences should be a key focus of cultural policy. Earlier studies have offered long lists of recommendations for improving arts education in the schools, recommendations

that are still relevant today.[2] Rather than repeating them here, we make four broad recommendations.

Support Research to Inform Policy. We have already described the importance of collecting data on the status of arts learning at the state and local levels. Beyond that, additional research on the relationship between arts learning and long-term arts involvement is needed. In the past 20 years, there have been hundreds of social science studies of the effects of arts learning on non-arts outcomes (such as academic performance and self-esteem); but there have been only a few empirical studies of the effects of arts learning on arts participation later in life—and they found a strong correlation. More research is needed to test what the conceptual literature (and personal observation) supports: that developing individuals' skills of aesthetic perception and interpretation, for example, can increase their satisfaction from encounters with works of art; and the higher their satisfaction, the more they demand such experiences. The resultant findings could possibly make the case for increasing resources for broad-based arts learning at all levels.

Support Collaborative Programs That Increase the Amount and Breadth of Arts Learning. We have offered a broad view of the support infrastructure for arts learning so that policymakers can determine where and how they could have the most leverage in spurring improvements. For the young, for example, we have highlighted critical gaps in arts learning opportunities and promising programs that are addressing these gaps, such as those offered by arts organizations and higher education institutions to complement school-based instruction. Institutional leaders, local and national foundations, and public agencies should identify and support these and other programs that increase and broaden arts learning opportunities and are likely to draw young people into engaging arts experiences.

Advocate for Change in State Education Policy to Bring Arts Education to All Students. Since the 1970s, increased time for arts instruction has been needed at all grade levels in the public schools, and this need cannot be met without significant changes being made in state education policy. Arts content standards now exist in nearly every state, but K–12 children will not be provided with more and better arts education until states follow through with an accountability system and ask districts to report on arts instruction provided and learning achieved. Until state boards of education require such results, arts standards and mandates will often be ignored. As many have pointed out, current political pressures have created an environment in which what is tested dictates what is taught (Center on Education Policy, 2007). If the arts are to join the ranks of tested subjects, standards-based assessments consistent with the content and nature of the arts and arts education will have to be developed and funded at the state and district levels (Woodworth et al., 2007, p. 18). Including a year of

2 See NEA, 1988, for instance.

arts study as a requirement for high school graduation and college entrance is another important policy step, one that a number of states have already taken.

Build a Coalition for Arts Learning That Represents the Entire Infrastructure for Supply and Demand. Achieving change in state education policy, however, will require diverse communities to reach out to one another and forge a common agenda. The key players will be the arts policy community (including the NEA and SAAs), leaders in the arts community (such as directors of major arts organizations and the business leaders on their boards), and the professional organizations that represent thousands of arts educators. Only by working together can they persuade the general education community—and the American public—of the importance of arts learning as a means of drawing more Americans into engagement with the culture around them. These key players have often worked at cross-purposes (Hope, 1992, 2004), but they have also collaborated successfully in recent years, developing arts content standards at both the national and state levels. They can build on this success.

The more these communities understand their interdependency, the more their collaboration will evolve and strengthen. We have emphasized that arts learning plays a more critical role in the cultural sector than is generally realized. Those who function largely on the supply side in our supply/demand framework have long been aware that their financial survival depends on the existence of adequate demand but may not fully recognize the role of arts learning in cultivating that demand. Arts educators and the faculty who train them often focus on developing future artists and may not understand the extent to which they could help create future audiences. Arts policymakers have focused so successfully on stimulating production that they may be contributing to an imbalance between supply and demand that hobbles the entire sector. If the arts are to thrive and evolve in the future, all these communities need to recognize and respect the contributions of arts educators to the cultivation of ongoing demand and advocate for state policies that support comprehensive arts learning for all children.

The main beneficiaries of these actions will be future generations of Americans. In particular, stronger state policies in support of arts education will help expand public engagement in the arts and spread the benefits of such engagement more equitably. As Gee (2004, p. 131) puts it, the purpose of arts education is the "democratizing of the opportunity to get what art offers." Unless a united coalition of influential stakeholders succeeds in this purpose, Americans may have to abandon the ideal of democratized arts and acknowledge that the arts are going to become, like literacy in an earlier age, largely the province of the educated elite.

Interviewees

The following individuals provided data and background information for this report through telephone and in-person individual interviews, focus groups, and email exchanges. Affiliations identified here for these individuals were current at the time of contact.

Anawalt, Sasha	USC Annenberg/Getty Arts Journalism Program
Barsdate, Kelly	National Assembly of State Arts Agencies
Baskin, Laurie	Theatre Communications Group
Brown, Sherilyn	Rhode Island State Council on the Arts
Campbell-Zopf, Mary	Ohio Arts Council
Carriuolo, Nancy	Rhode Island Office of Higher Education
Cohn, Shelley	Arizona Commission on the Arts
Combs, Gerri	Southern Arts Federation
Cunningham, Sarah	NEA
Daugherty, Nancy	NEA
Deasy, Richard	Arts Education Partnership
Doughty, Heather	Pennsylvania Council on the Arts
Faison, Michael	Idaho Commission on the Arts
Galligan, Ann	Northeastern University and Rhode Island Arts Learning Network
Hedgepeth, Tim	Mississippi Arts Commission
Hope, Samuel	National Office for Arts Accreditation
Horn, Philip	Pennsylvania Council on the Arts
Jaret, Lisa	Washington State Arts Commission
Johnson, Andrea	OPERA America
Johnson, Muriel	California Arts Council
Kelley, Mary	Massachusetts Cultural Council
Lakin-Hayes, Mollie	Southern Arts Federation
Lawson, Wayne	Ohio Arts Council

Marshall, David	Massachusetts Cultural Council
Martin, Wayne	North Carolina Arts Council
McLennan, Douglas	ArtsJournal
Meadows, Lori	Kentucky Arts Council
Middleman, Robin	New Jersey State Council on the Arts
Miller, David	Foundation for New Jersey Public Broadcasting
Morrison, Bob	Music for All
Newman, Warren	Independent consultant, formerly NEA
Regan, Mary	North Carolina Arts Council
Rogers, Brian	Pennsylvania Council on the Arts
Runk, Steve	New Jersey State Council on the Arts
Skomal, Martin	Nebraska Arts Council
Slavkin, Mark	Music Center of Los Angeles
Smith, Ralph	University of Illinois at Urbana-Champaign
Steiner, David	Hunter College
Szanto, Andras	Columbia University
Taylor, Andrew	Bolz Center for Arts Administration, University of Wisconsin
Truxes, An Ming	Connecticut Commission on Culture and Tourism
Tsutakawa, Mayumi	Washington State Arts Commission
Tucker, Kris	Washington State Arts Commission
Vitiello, Vicki	North Carolina Arts Council
Wilson, Jan	American Symphony Orchestra League

Taxonomy of SAA Grants by Type of Recipient, National Standard Code, and RAND Category

National Standard Code	Type of Recipient	RAND Category
01	Individual artist	Artists and arts organizations
03	Performing group	
04	College or university performing group	
05	Community-based performing group	
06	Youth performing group	
07	Performance facility	
08	Art museum	
10	Gallery or exhibit space	
11	Cinema	
12	Independent press	
13	Literary magazine	
14	Fair or festival	
15	Arts center	
17	Arts service organization	
18	Union, guild, or association	
47	Cultural series organization	
48	School of the arts	
49	Arts camp or institute	
16	Arts council or agency	Arts agencies
27	Library	Community organizations
32	Community service organization	
33	Correctional institution	
34	Health care facility	
35	Religious organization	
36	Senior center	
37	Parks and recreation	
42	Media: periodical	
43	Media: daily paper	
44	Media: weekly paper	

National Standard Code	Type of Recipient	RAND Category
45	Media: radio	
46	Media: television	
50	Social service organization	
19	School district	Educational institutions
20	Parent-teacher organization	
21	Elementary school	
22	Middle school	
23	Secondary school	
24	Vocational or technical school	
25	Other school	
26	College or university	
51	Childcare provider	
02	Individual non-artist	Other non-arts organizations
09	Other museum	
28	Historical society	
29	Humanities council	
30	Foundation	
31	Corporation or other business	
38	Government: Executive	
39	Government: Judicial	
40	Government: House	
41	Government: Senate	
99	None of the above	None of the above / Not reported
−1	Not reported	

Taxonomy of SAA Grants by Type of Activity, National Standard Code, and RAND Category

National Standard Code	Type of Activity	RAND Category
01	Acquisition	Creation, exhibition, and preservation of art
03	Award or fellowship	
04	Creation of a work of art	
05	Concert, performance, or reading	
06	Exhibition	
18	Repair, restoration, and conservation	
25	Apprenticeship or internship	
07	Facility construction, maintenance, or renovation	Institutional support
10	Establishment of new organization	
11	General support for institution or organization	
14	Professional support: administrative	
15	Professional support: artistic	
23	Equipment purchase, lease, or rental	
32	Stabilization, endowment, or challenge support	
02	Audience services	Arts learning
09	Identification and documentation	
12	Arts instruction	
20	School residency	
21	Other residency	
27	Translation	
28	Writing about art	
30	Student assessment	
31	Curriculum development and implementation	
08	Fair or festival	Broadening participation
13	Marketing	
16	Recording, filming, and taping	
17	Publication	
24	Distribution of art	
33	Building public awareness	

National Standard Code	Type of Activity	RAND Category
35	Web site and Internet development	
36	Broadcasting	
26	Regranting	Regranting
19	Research and planning	Other
22	Seminar or conference	
29	Professional development and training	
34	Technical assistance	
99	None of the above	
−1	Not reported	

Bibliography

Adelman, Clifford, *The Empirical Curriculum: Changes in Postsecondary Course-Taking, 1972–2000*, Washington, D.C.: U.S. Department of Education, 2004.

American Symphony Orchestra League [now the League of American Orchestras], *Education/ Community Relations Survey: Detail Results of 2005 Survey*, New York: American Symphony Orchestra League, 2006. As of April 23, 2008, also available as pp. 3–11 of "Education/Community Relations Survey 2004–2005":
http://www.americanorchestras.org/knowledge_center/education_and_community_engagement_report.html

Americans for the Arts, *Local Arts Agency Facts: Fiscal Year 2000*, Washington, D.C.: Americans for the Arts, August 2001.

———, *The Future of Private Sector Giving to the Arts in America, A Report on the Proceedings of the 2006 National Arts Policy Roundtable* held at Sundance Preserve, Utah, October 26–28, 2006, Washington, D.C.: Americans for the Arts, 2007.

Anderson, Tom, Elliot W. Eisner, and Sally McRorie, "A Survey of Graduate Study in Art Education," *Studies in Art Education*, Vol. 40, No. 1, 1998, pp. 8–25.

Appalachian Education Initiative, *State of the Arts Survey: West Virginia Public Schools*, Morgantown, W.Va.: Appalachian Education Initiative, 2006.

Appelo, Tim, "Critical Condition: Arts Journalism Isn't Dead, It's Just Got a Serious Case of the Blogs," *Seattle Weekly*, June 15–21, 2005. As of February 27, 2008:
http://www.seattleweekly.com/features/0524/050615_arts_artblogs.php

Arostegui, Jose-Luis, "Much More Than Music: Music Education Instruction at the University of Illinois at Urbana-Champaign," in Jose-Luis Arostegui, ed., *The Social Context of Music Education*, Champaign, Ill.: Center for Instructional Research and Curriculum Evaluation, 2004, pp. 127–210.

Arts, Education, and Americans Panel, *Coming to Our Senses: The Significance of the Arts for American Education*, New York: McGraw-Hill, 1977.

Arts Education Partnership, "Arts Requirement for High School Graduation," *2006–2007 State Arts Education Policy Database*, n.d. As of March 28, 2008:
http://www.aep-arts.org/database/results.htm?select_category_id=4&search=Search%20%3C

———, "Licensure for Arts Teachers," *2006–2007 State Arts Education Policy Database*, n.d. As of March 28, 2008:
http://www.aep-arts.org/database/results.htm?select_category_id=6&search=Search

Association of Performing Arts Presenters, *1995 Profile of Member Organizations*, Washington, D.C.: Association of Performing Arts Presenters, 1995.

Augustine, Catherine H., Diana Epstein, and Mirka Vuolo, *Governing Urban School Districts: Efforts in Los Angeles to Effect Change*, TR-428-LA, Santa Monica, Calif.: RAND Corporation, 2006. As of February 27, 2008:
http://www.rand.org/pubs/technical_reports/TR428/

Backas, James J., *Public Arts Agencies: Toward National Public Policy*, a report based on the proceedings of the Policy Study Group on Federal-State Relationships held at Arlington, Va., July 11–12, 1981, Washington, D.C.: National Assembly of State Arts Agencies, August 1981.

Barret, Diane B., "Arts Programming for Older Adults: What's Out There?" *Studies in Art Education*, Vol. 34, No. 3, spring 1993, pp. 133–140.

Barrett, Terry M., *Criticizing Photographs: An Introduction to Understanding Images*, 3rd ed., Mountain View, Calif.: Mayfield, 2000.

———, *Interpreting Art: Reflecting, Wondering, and Responding*, Boston, Mass.: McGraw-Hill, 2003.

Barringer, Felicity, "Arts Coverage Falls Behind a Cultural Boom, Study Says," *New York Times*, November 16, 1999.

Barzun, Jacques, *The Use and Abuse of Art*, Princeton, N.J.: Princeton University Press, 1974.

———, *The Culture We Deserve*, Middletown, Conn.: Wesleyan University Press, 1989.

Bash, Sharon Rodning, *From Mission to Motivation: A Focused Approach to Increased Arts Participation*, St. Paul, Minn.: Metropolitan Regional Arts Council, 2003.

Baumol, William J., and William G. Bowen, *Performing Arts—The Economic Dilemma: A Study of Problems Common to Theater, Opera, Music, and Dance*, New York: Twentieth Century Fund, 1966.

Beardsley, Monroe C., "Aesthetic Welfare, Aesthetic Justice, and Educational Policy," *The Aesthetic Point of View: Selected Essays*, Ithaca, N.Y.: Cornell University Press, 1982, pp. 111–125.

Berdahl, Robert O., *Strong Governors and Higher Education: A Survey and Analysis*, June 2004. As of February 10, 2008:
http://www.sheeo.org/govern/gov-home.htm

Bergonzi, Louis, and Julia Smith, *Effects of Arts Education on Participation in the Arts*, NEA Research Report No. 36, Santa Ana, Calif.: Seven Locks Press, 1996.

Berry, B., "No Shortcuts to Preparing Good Teachers," *Educational Leadership*, Vol. 58, No. 8, 2001, pp. 32–36.

Beyond the Bell, Web site, n.d. As of February 17, 2008:
http://www.lausd.k12.ca.us/lausd/offices/btb/

Biddle, Livingston, *Our Government and the Arts: A Perspective from the Inside*, New York: American Council for the Arts, 1988.

Bodilly, Susan J., and Catherine H. Augustine, *Revitalizing Arts Education Through Community-Wide Coordination*, MG-702-WF, Santa Monica, Calif.: RAND Corporation, 2008. As of May 26, 2008:
http://www.rand.org/pubs/monographs/MG702/

Bodilly, Susan J., and Megan K. Beckett, *Making Out-of-School-Time Matter: Evidence for an Action Agenda*, MG-242-WF, Santa Monica, Calif.: RAND Corporation, 2005. As of February 27, 2008:
http://www.rand.org/pubs/monographs/MG242/

Boston After School and Beyond, Web site, n.d. As of February 17, 2008:
http://www.bostonbeyond.org/

Broudy, Harry S., *Enlightened Cherishing: An Essay on Aesthetic Education*, Urbana, Ill.: University of Illinois Press, 1972.

Brown, Alan S., *The Values Study: Rediscovering the Meaning and Value of Arts Participation,* Hartford, Conn.: Connecticut Commission on Culture and Tourism, 2004.

Bruner, Jerome, *Actual Minds, Possible Worlds,* Cambridge, Mass.: Harvard University Press, 1986.

Bumgarner, Constance M., "Artists in the Classrooms: The Impact and Consequences of the National Endowment for the Arts' Artist Residency Program on K–12 Arts Education (Part I)," *Arts Education Policy Review,* Vol. 95, January/February 1994a.

———, "Artists in the Classrooms: The Impact and Consequences of the National Endowment for the Arts' Artist Residency Program on K–12 Arts Education (Part II)," *Arts Education Policy Review,* Vol. 95, March/April 1994b.

California Arts Council, "California Arts Council's 10-Year State Appropriations History with Governor's Proposed 2006–07 Budget," January 2006. As of November 2007:
http://www.cac.ca.gov/

Carey, Nancy, Elizabeth Farris, Michael Sikes, and Rita Foy, *Arts Education in Public Elementary and Secondary Schools,* Statistical Analysis Report NCES 95-082, Washington, D.C.: National Center for Education Statistics, October 1995.

Carey, Nancy, Brian Kleiner, Rebecca Porch, and Elizabeth Farris, *Arts Education in Public Elementary and Secondary Schools: 1999–2000,* Statistical Analysis Report NCES 2002-131, Washington, D.C.: National Center for Education Statistics, June 2002.

Carroll, Noel, *Beyond Aesthetics: Philosophical Essays.* Cambridge, United Kingdom: Cambridge University Press, 2001.

Caterall, James S., and Emily Brizendine, *Proposition 13: Effects on High School Curricula, 1979–1983,* Stanford, Calif.: Stanford University Institute for Research on Educational Finance and Governance, 1984.

Center on Education Policy, *Choices, Changes, and Challenges: Curriculum and Instruction in the NCLB Era,* Eugene, Ore.: Center on Education Policy, July 2007.

Champlin, Kellene N., "Effects of School Culture on Art Teaching Practices: Implications for Teacher Preparation," in M. D. Day, ed., *Preparing Teachers of Art,* Reston, Va.: National Art Education Association, 1997, pp. 117–138.

Chapman, Laura H., *Instant Art, Instant Culture: The Unspoken Policy for American Schools,* New York: Teachers College Press, 1982a.

———, "The Future and Museum Educators," *Museum News,* Vol. 60, No. 6, July/August 1982b, pp. 48–56.

———, "Arts Education as a Political Issue: The Federal Legacy" in R. A. Smith and R. Berman, eds., *Public Policy and the Aesthetic Interest: Critical Essays on Defining Cultural and Educational Relations,* Urbana, Ill.: University of Illinois Press, 1992, pp. 119–136.

———, "No Child Left Behind in Art?" *Arts Education Policy Review,* Vol. 106, No. 2, 2004, pp. 1–17.

———, "Status of Elementary Art Education: 1997–2004," *Studies in Art Education,* Vol. 46, No. 2, 2005, pp. 118–137.

Chronicle of Philanthropy, "Is Giving to Universities and Arts Groups Under Attack?" in Give and Take: A Roundup of Blogs About the Nonprofit World, on philanthropy.com Web site, October 3, 2007. As of February 26, 2008:
http://philanthropy.com/giveandtake/article/335/think-tank-sees-attack-on-charitable-tax-deduction

Ciment, Michel, and Laurence Kardish, *Positif 50 Years: Selections from the French Film Journal,* New York: Museum of Modern Art, 2003.

Clarke, Anthony, "The Recent Landscape of Teacher Education: Critical Points and Possible Conjectures," *Teaching and Teacher Education,* Vol. 17, No. 5, 2001, pp. 599–611.

Collaborative for Teaching and Learning, *Status of Arts Education in Kentucky Public Schools: A Comprehensive Survey Conducted for the Kentucky Arts Council,* Louisville, Ky.: Collaborative for Teaching and Learning, 2005. As of February 27, 2008: http://artscouncil.ky.gov/Education/Epubs.htm

Colwell, Richard, "Whither Programs and Arts Policy," *Arts Education Policy Review,* Vol. 106, No. 6, July/August 2005, pp. 19–29.

Colwell, Richard J., and Carol Richardson, eds., *The New Handbook of Research on Music Teaching and Learning: A Project of the Music Educators National Conference,* Oxford and New York: Oxford University Press, 2002.

Commanday, Robert P., "Come to the Aid of Music Journalism," *San Francisco Classical Voice,* October 17, 2006.

Congdon, Kristin G., Doug Blandy, and Paul E. Bolin, eds., *Histories of Community-Based Art Education,* Reston, Va.: National Art Education Association, 2001.

Connell, J., M. Gambone, and T. Smith, *Youth Development in Community Settings: Challenges to Our Field and Our Approach,* Toms River, N.J.: Community Action for Youth Project, 2000.

Conner, Lynne, "Who Gets to Tell the Meaning? Building Audience Enrichment," *GIA Reader,* Vol. 15, No. 1, Winter 2004, pp. 11–14.

———, "In and Out of the Dark: A Theory About Audience Behavior from Sophocles to Spoken Word," in Steven J. Tepper and Bill Ivey, eds., *Engaging Art: The Next Great Transformation of America's Cultural Life,* New York: Routledge, Taylor & Francis Group, 2008, pp. 103–127.

Consortium of National Arts Education Associations; International Council of Fine Arts Deans; Council of Arts Accrediting Associations, *To Move Forward: An Affirmation of Continuing Commitment to Arts Education,* Reston, Va.: National Art Education Association, 2001.

Council of Chief State School Officers, *Model Standards for Beginning Teacher Licensing and Development: A Resource for State Dialogue,* Washington, D.C.: Council for Chief State School Officers, 1992.

———, *Gaining the Arts Advantage: More Lessons from School Districts That Value Arts Education,* Washington, D.C.: Council of Chief State School Officers, 2001.

Dana Foundation, *Acts of Achievement: The Role of Performing Arts Centers in Education,* New York: Dana Press, 2003.

Danto, Arthur C., "The Artworld," *Journal of Philosophy,* Vol. 61, No. 19, October 1964.

———, *The Transfiguration of the Commonplace: A Philosophy of Art,* Cambridge, Mass.: Harvard University Press, 1981.

Davis, Jessica Hoffman, *Framing Education as Art: The Octopus Has a Good Day,* New York: Teachers College Press, Columbia University, 2005.

Davis, Jessica Hoffman, Elizabeth Soep, Sunaina Maira, Natania Remba, and Deborah Putnoi, *Safe Havens: Portraits of Educational Effectiveness in Community Art Centers That Focus on Education in Economically Disadvantaged Communities,* Cambridge, Mass.: Project Zero, Harvard Graduate School of Education, 1993.

Day, Michael D., "Point with Pride or View with Alarm? Notes on the Evaluation of the NEA's Artists-in-Schools Program," *Journal of Aesthetic Education*, Vol. 12, No. 1, 1978, pp. 63–70.

———, ed., *Preparing Teachers of Art*, Reston, Va.: National Art Education Association, 1997.

Detels, Claire, *Soft Boundaries: Re-Visioning the Arts and Aesthetics in American Education*, Westport, Conn.: Bergin and Garvey, 1999.

Dewey, John, *Art as Experience*, [1934], New York: Berkeley Publishing Company, Perigee Books, 1980.

DiBlasio, Margaret K., "Certification and Licensure Requirements for Art Education: Comparison of State Systems," in M. D. Day, ed., *Preparing Teachers of Art*, Reston, Va.: National Art Education Association, 1997, pp. 73–100.

DiMaggio, Paul J., and Michael Useem, "The Arts in Education and Cultural Participation: The Social Role of Aesthetic Education and the Arts," *Journal of Aesthetic Education*, Vol. 14, No. 4, Special Issue: The Government, Art, and Aesthetic Education, October, 1980, pp. 55–72.

DiMaggio, Paul J., and Toqir Mukhtar, "Arts Participation as Social Capital in the United States, 1982–2002: Signs of Decline," *Poetics*, Vol. 32, No. 2, April 2004, pp. 169–194.

Doyle, W., "Themes in Teacher Education," in W. R. Houston, ed., *Handbook of Research on Teacher Education*, New York: Macmillan, 1990, pp. 3–24.

Eaton, Marcia Muelder, and Ronald Moore, "Aesthetic Experience: Its Revival and Its Relevance to Aesthetic Education," *Journal of Aesthetic Education*, Vol. 36, No. 2, summer 2002, pp. 9–23.

Eckel, Peter D., and Jacqueline E. King, *An Overview of Higher Education in the United States: Diversity, Access, and the Role of the Marketplace*, Washington, D.C.: American Council on Education, 2006.

EdSource, "Standards and Curriculum Overview," Web page, 1996–2008. As of February 28, 2008: http://www.edsource.org/edu_sta.cfm

Education Commission of the States, "State Policies Regarding Arts in Education," *StateNotes: Arts in Education*, Denver, Colo.: Education Commission of the States, November 2005.

Eisner, Elliot W., *Educating Artistic Vision*, New York: Macmillan, 1972.

———, "Is the Artist in the School Program Effective?" *Art Education*, Vol. 27, No. 2, 1974, pp. 19–23.

———, *The Role of Discipline-Based Art Education in America's Schools*, Los Angeles, Calif.: Getty Center for Education in the Arts, 1988.

———, *The Enlightened Eye: Qualitative Inquiry and the Enhancement of Educational Practice*, New York: Macmillan, 1991.

Eisner, Elliot W., and Michael D. Day, eds., *Handbook of Research and Policy in Art Education*, Mahwah, N.J.: Lawrence Erlbaum Associates, Inc., 2004.

Elliott, David J., "Music as Culture: Toward a Multicultural Concept of Arts Education," in Ralph A. Smith, ed., *Cultural Literacy and Arts Education*, Urbana, Ill.: University of Illinois Press, 1991, pp. 147–166.

Ellis, Diane C., and John C. Beresford, *Trends in Artist Occupations, 1970–1990*, NEA Research Report No. 29, Washington, D.C.: National Endowment for the Arts, August 1994.

Evans, Richard, and Howard Klein, *Too Intrinsic for Renown: A Study of the Members of the National Guild of Community Schools of the Arts*, New York: Lila Wallace–Reader's Digest Fund, 1992.

Ferrero, David J., "W(h)ither Liberal Education? A Modest Defense of Humanistic Schooling in the Twenty-first Century," in C. E. Finn and D. Ravitch, eds., *Beyond the Basics: Achieving a Liberal Education for All Children*, Washington, D.C.: Thomas B. Fordham Institute, July 2007, pp. 25–44.

Finn, Chester E., Jr., and Diane Ravitch, "Why Liberal Learning," in C. E. Finn and D. Ravitch, eds., *Beyond the Basics: Achieving a Liberal Education for All Children*, Washington, D.C.: Thomas B. Fordham Institute, July 2007, pp. 1–10.

Fiske, Edward B., "Art on the Prairie," *American Educator*, fall 1997.

———, ed., *Champions of Change: The Impact of the Arts on Learning*, Washington, D.C.: The Arts Education Partnership and the President's Committee on the Arts and the Humanities, 1999. As of December 30, 2007:
http://artsedge.kennedy-center.org/champions/pdfs/ChampsReport.pdf

Fowler, Charles, "Toward a Democratic Art: A Reconstructionist View of Music Education," in J. Terry Gates, ed., *Music Education in the United States: Contemporary Issues*, Tuscaloosa, Ala.: University of Alabama Press, 1988, pp. 130–155.

———, *Strong Arts, Strong Schools: The Promising Potential and Shortsighted Disregard of the Arts in American Schooling*, New York: Oxford University Press, 1996.

Gaff, Jerry G., "Handout on Curriculum Trends," presentation before Faculty Senate at Washburn University, August 2006. As of April 23, 2008:
http://www.washburn.edu/admin/vpaa/Gaff-WashburnHandoutCurriculumTrends.rtf

Galbraith, Lynn, "Analyzing an Art Methods Course: Implications for Preparing Primary Student Teachers," *Journal of Art and Design Education*, Vol. 10, No. 3, 1991, pp. 329–342.

———, ed., *Preservice Art Education: Issues and Practice*, Reston, Va.: National Art Education Association, 1995.

———, "What Are Art Teachers Taught? An Analysis of Curriculum Components for Art Teacher Preparation Programs," in Michael D. Day, ed., *Preparing Teachers of Art*, Reston, Va.: National Art Education Association, 1997, pp. 45–72.

Galbraith, Lynn, and Kit Grauer, "State of the Field: Demographics and Art Teacher Education, in Elliot W. Eisner and Michael D. Day, eds., *Handbook of Research and Policy in Art Education*, London, United Kingdom: Lawrence Erlbaum Associates, Publishers, 2004, pp. 415–437.

Galligan, Ann M., and Chris N. Burgess, "Moving Rivers, Shifting Streams: Perspectives on the Existence of a Policy Window," *Art Education Policy Review*, Vol. 107, No. 2, November/December 2005.

Gardner, Howard, *Art Education and Human Development*, Los Angeles, Calif.: J. Paul Getty Center for Education in the Arts, 1990.

Gee, Constance Bumgarner, "Spirit, Mind, and Body: Arts Education the Redeemer," in Elliot W. Eisner and Michael D. Day, eds., *Handbook of Research and Policy in Art Education,* London, United Kingdom: Lawrence Erlbaum Associates, Publishers, 2004, pp. 115–134.

Gillespie, Patti P., "Theater Education and Hirsch's Contextualism: How Do We Get There, and Do We Want to Go?" in Ralph A. Smith, ed., *Cultural Literacy and Arts Education*, Urbana and Chicago, Ill.: University of Illinois Press, 1991, pp. 31–47.

Gioia, Dana, "Stemming Our Cultural Decline," article excerpted from his commencement address at Stanford University, June 17, 2007, reprinted in *The Voice of Chorus America*, fall 2007.

Goodman, Nelson, *Languages of Art: An Approach to a Theory of Symbols*, 2nd ed., Indianapolis, Ind.: Hackett, 1976.

Gray, Charles M., "Hope for the Future? Early Exposure to the Arts and Adult Visits to Art Museums," *Journal of Cultural Economics*, Vol. 22, 1998, pp. 87–90.

Greene, Maxine, *Variations on a Blue Guitar: The Lincoln Center Institute Lectures on Aesthetic Education*, New York: Teachers College Press, 2001.

Hager Mark A., and Thomas H. Pollak, *The Capacity of Performing Arts Presenting Organizations*, Washington, D.C.: Urban Institute, April 2002.

Hagood, Thomas K., *A History of Dance in American Higher Education*, Lewiston, N.Y.: Edwin Mellen Press, 2000.

Halpern, R., "A Different Kind of Child Development Institution: The History of After-School Programs for Low-Income Children," *Teachers College Record*, Vol. 104, No. 2, 2002, pp. 178–211.

Heath, Shirley Brice, Elizabeth Soep, and Adelma Roach, "Living the Arts Through Language Learning: A Report on Community-Based Youth Organizations," *Americans for the Arts Monographs*, Vol. 2, No. 7, November 1998, pp. 1–20.

Heilbrun, James, and Charles M. Gray, *The Economics of Art and Culture*, Cambridge, United Kingdom: Cambridge University Press, 1993.

Herbert, Douglas, "Finding the Will and the Way to Make the Arts a Core Subject: Thirty Years of Mixed Progress," *The State Education Standard*, Vol. 4, No. 4, Winter 2004, pp. 1–9.

Hessenius, Barry, "Thoughts on the Arts as Overbuilt," Barry's Arts Blog and Update, Update No. 7, June 23, 2005. As of February 28, 2008:
http://www.westaf.org/blog/archives/2005/06/index.php

Hetland, Lois, Ellen Winner, Shirley Veenema, and Kimberly M. Sheridan, *Studio Thinking: The Real Benefits of Visual Arts Education*, New York: Teachers College Press, 2007.

Hirzy, Ellen Cochrane, ed., *Excellence and Equity: Education and the Public Dimension of Museums*, Washington D.C.: American Association of Museums, 1992.

Hodsoll, Frank, "Some Thoughts on Arts Education," *Studies in Art Education*, Vol. 26, No. 4, Summer 1985, pp. 247–252.

Hood, Marilyn G., "Staying Away: Why People Choose Not to Visit Museums," *Museum News*, 1983, pp. 50–57.

Hope, Samuel, "An Overview of the Strategic Issues in American Arts Education," in Ralph A. Smith and Ronald Berman, eds., *Public Policy and the Aesthetic Interest: Critical Essays on Defining Cultural and Educational Relations*, Urbana and Chicago, Ill.: University of Illinois Press, 1992, pp. 254–270.

——, "Art Education in a World of Cross Purposes," in Elliot W. Eisner and Michael D. Day, eds., *Handbook of Research and Policy in Art Education*, Mahwah, N.J.: Lawrence Erlbaum Associates, Publishers, 2004, pp. 93–113.

——, "Mending Walls: Policy Patterns for an Era of Decentralization," *Arts Education Policy Review*, Vol. 97, No. 3, January–February 1996, pp. 2–11.

Housen, A., and L. Duke, "Responding to Alper: Representing the MoMA Studies on Visual Literacy and Aesthetic Development," *Visual Arts Research*, Vol. 24, No. 1, 1998, pp. 93–102.

Howell, William G., "Introduction," in William G. Howell, ed., *Besieged: School Boards and the Future of Education Politics*, Washington, D.C.: Brookings Institution Press, 2005.

Hussar, William J., *Predicting the Needs for Newly Hired Teachers in the United States to 2008–09*, Washington, D.C.: U.S. Department of Education, National Center for Education Statistics, 2001.

Illinois Arts Alliance, *Arts at the Core: Every Child, Every Student*, Illinois Creates—The Illinois Arts Education Initiative, Chicago, Ill.: Illinois Arts Alliance, 2006. As of February 26, 2008: http://www.artsalliance.org/docs/education/artsAtTheCore.pdf

J. Paul Getty Trust, *Beyond Creating: The Place for Arts in America's Schools*, Los Angeles, Calif.: J. Paul Getty Trust, 1985.

Jackson, Susan, *The Center for Arts Education: A Decade of Progress*, New York: Center for Arts Education, 2007.

James Irvine Foundation, "Critical Issues Facing the Arts in California," working paper by James Irvine Foundation and AEA Consulting, November 2006. As of April 22, 2008: http://www.irvine.org/publications/by_topic/arts.shtml

Jefferson, Marion F., "Essentials: Adult Education Programs in the Visual Arts," *Art Education*, July 1987.

Jenkins, Harry, and Vanessa Bertozzi, "Artistic Expression in the Age of Participatory Culture: How and Why Young People Create," in Steven J. Tepper and Bill Ivey, eds., *Engaging Art: The Next Great Transformation of America's Cultural Life*, New York: Routledge, 2008, pp. 171–195.

John S. and James L. Knight Foundation, *Classical Music Consumer Segmentation Study: How Americans Relate to Classical Music and Their Local Orchestras*, Southport, Conn.: Audience Insight LLC, 2002.

Johnson, Roger, "Better Late Than Never: Thoughts on the Music Curriculum in the Late 20th Century," *Journal of Popular Music Studies*, Vols. 9–10, No. 1, 1997, pp. 1–6.

Kelly, John R., *Freedom To Be: A New Sociology of Leisure*, New York: MacMillan Publishing Company, 1987.

Kelly, John R., and Valeria J. Freysinger, *21st Century Leisure: Current Issues*, Boston, Mass.: Allyn and Bacon, 2000.

Kerka, Sandra, "Adult Learning in and Through the Arts," ERIC Digest ED467239 2002-00-00, Washington, D.C.: U.S. Department of Education, 2002.

Kim, Kwang, Mary Hagedorn, Jennifer Williamson, and Christopher Chapman, *Participation in Adult Education and Lifelong Learning: 2000–02*, NCES 2004-050, Washington, D.C.: National Center for Education Statistics, 2004.

Kirby, Sheila Nataraj, Jennifer Sloan McCombs, Heather Barney, and Scott Naftel, *Reforming Teacher Education: Something Old, Something New*, MG-506-EDU, Santa Monica, Calif.: RAND Corporation, 2006. As of March 29, 2008: http://www.rand.org/pubs/monographs/MG506/

Kirchhoff, Craig, "The School and College Band," in J. T. Gates, ed., *Music Education in the United States*, Tuscaloosa, Ala.: University of Alabama Press, 1988, pp. 259–276.

Kowalchuk, E. A., and D. L. Stone, "Art Education for Elementary Teachers: What Really Happens?" *Visual Arts Research*, Vol. 26, No. 2, 2000, pp. 29–39.

Kracman, Kimberly, "The Effect of School-Based Arts Instruction on Attendance at Museums and the Performing Arts," *Poetics*, Vol. 24, 1996, pp. 203–218.

Kreidler, John, "Leverage Lost: The Non-Profit Arts in the Post-Ford Era," *Journal of Arts Management, Law, and Society*, Vol. 36, No. 2, 1996.

Kriegsman, Sali A., "Meeting Each Other Half Way," *Dance/USA Journal*, Vol. 9, 1998, pp. 13–15.

Lankford, E. Louis, and Kelly Scheffer, "Museum Education and Controversial Art: Living on a Fault Line," in Elliot W. Eisner and Michael D. Day, eds., *Handbook of Research and Policy in Art Education*, Mahwah, N.J.: Lawrence Erlbaum Associates, Publishers, 2004, pp. 201–223.

Larson, Gary O., *The Reluctant Patron: The United States Government and the Arts, 1943–65*, Philadelphia, Pa.: University of Pennsylvania Press, 1983.

LA's Best, Web site, n.d. As of February 17, 2008:
http://www.lasbest.org/

Levine, Mindy N., *Widening the Circle: Towards a New Vision for Dance Education*, a report of the National Task Force on Dance Education, Washington, D.C.: Dance/USA, 1994.

———, *Invitation to the Dance: A Report of the National Task Force on Dance Audiences*, Washington, D.C.: Dance/USA, 1997.

Levinson, Jerrold, "Musical Literacy," in Ralph A. Smith, ed., *Cultural Literacy and Arts Education*, Urbana and Chicago, Ill.: University of Illinois Press, 1991, pp. 17–30.

Literacy in the Arts Task Force, *Literacy in the Arts: An Imperative for New Jersey Schools*, Trenton, N.J.: Alliance for Arts Education, October 1989.

Lowell, Julia F., *State Arts Agencies 1965–2003: Whose Interests to Serve?* MG-121-WF, Santa Monica, Calif.: RAND Corporation, 2004. As of February 28, 2008:
http://www.rand.org/pubs/monographs/MG121/

Lowell, Julia F., and Elizabeth H. Ondaatje, *The Arts and State Governments: At Arm's Length or Arm in Arm?* MG-359-WF, Santa Monica, Calif.: RAND Corporation, 2006. As of February 28, 2008:
http://www.rand.org/pubs/monographs/MG359/

Lugaila, Terry, *A Child's Day: 2000 (Selected Indicators of Child Well-Being)*, Current Population Reports, Washington D.C.: U.S. Bureau of the Census, 2003.

Madeja, Stanley S., *The Artist in the School: A Report on the Artist-in-Residence Project*, Washington, D.C.: National Endowment for the Arts, 1970.

Madeja, Stanley S., and S. Onuska, *Through the Arts to the Aesthetic; The CEMREL Aesthetic Education Programs*, St. Louis, Mo.: Central Midwest Regional Educational Laboratory, 1977.

McCarthy, Kevin F., and Kimberly Jinnett, *A New Framework for Building Participation in the Arts*, MR-1323-WRDF, Santa Monica, Calif.: RAND Corporation, 2001. As of February 27, 2008:
http://www.rand.org/pubs/monograph_reports/MR1323/

McCarthy, Kevin F., Elizabeth H. Ondaatje, and Laura Zakaras, *Guide to the Literature on Participation in the Arts*, DRU-2308-WRDF, Santa Monica, Calif.: RAND Corporation, 2001. As of February 27, 2008:
http://www.rand.org/pubs/drafts/DRU2308/

McCarthy, Kevin F., Arthur C. Brooks, Julia Lowell, and Laura Zakaras, *The Performing Arts in a New Era*, MR-1367-PCT, Santa Monica, Calif.: RAND Corporation, 2001. As of February 27, 2008:
http://www.rand.org/pubs/monograph_reports/MR1367/

McCarthy, Kevin F., Elizabeth H. Ondaatje, Laura Zakaras, and Arthur C. Brooks, *Gifts of the Muse: Reframing the Debate About the Benefits of the Arts*, MG-218-WF, Santa Monica, Calif.: RAND Corporation, 2004. As of February 27, 2008:
http://www.rand.org/pubs/monographs/MG218/

McDaniel, Nello, and George Thorn, *Learning Audiences: Adult Arts Participation and the Learning Consciousness*, final report of the Adult Arts Education Project, Washington, D.C.: John F. Kennedy Center for the Performing Arts and the Association of Performing Arts Presenters, 1997.

Mikulecky, Marga, Gina Shkodriani, and Abby Wilner, "A Growing Trend to Address the Teacher Shortage," *Policy Brief: Alternative Certification*, Denver, Colo.: Education Commission of the States, December 2004. As of February 28, 2008:
http://www.ecs.org/clearinghouse/57/12/5712.pdf

Missouri Historical Society, "Katherine Dunham's Living Legacy," 2006. As of February 26, 2008:
http://www.mohistory.org/public_site_static/content/KatherineDunham/

Morisi, Teresa L., "Employment in Public Schools and the Student-to-Employee Ratio," *Monthly Labor Review*, July 1994.

Morton, Beth A., and Ben Dalton, "Changes in Instructional Hours in Four Subjects by Public School Teachers of Grades 1 Through 4," NCES 2007-305, Washington, D.C.: Institute for Education Sciences, National Center for Education Statistics, May 2007.

Moskowitz, Eva S., "A Picture Is Worth a Thousand Words: Arts Education in New York City Public Schools," New York: Council of the City of New York Education Committee, 2003.

Music for All Foundation, *The Sound of Silence: The Unprecedented Decline in Music Education in California Public Schools*, 2004. As of February 28, 2008:
http://www.music-for-all.org/sos.html

———, About Us Web page, n.d. As of February 28, 2008:
http://www.musicforall.org/default.aspx

Music Teachers National Association, MTNA Certification page, n.d. As of February 26, 2008:
http://www.mtnacertification.org

Musical Educators National Conference, *National Standards for Arts Education*, 1994.

Myers, David E., "Excellence in Arts Teaching and Learning: A Collaborative Responsibility of Maturing Partnerships," 2001 Fowler Colloquium Papers, University of Maryland, 2001. As of February 10, 2008:
http://www.lib.umd.edu/PAL/SCPA/fowlercolloq2001paper2.html

Myers, David E., and Arthur C. Brooks, "Policy Issues Connecting Music Education with Arts Education," in Richard J. Colwell and Carol P. Richardson, eds., *The New Handbook of Research on Music Teaching and Learning*, New York: Oxford University Press, 2002, pp. 909–930.

Nagel, Ineke, and Harry B. G. Ganzeboom, "Participation in Legitimate Culture: Family and School Effects from Adolescence to Adulthood," *The Netherlands' Journal of Social Sciences*, Vol. 38, No. 2, 2002, pp. 102–120.

Nagel, Ineke, Harry Ganzeboom, Folkert Haanstra, and Wil Oud, "Effects of Art Education in Secondary Schools on Cultural Participation in Later Life," *International Journal of Art and Design Education*, Vol. 16, No. 3, 1997, pp. 325–331.

National Art Education Association, *Standards for Art Teacher Preparation*, Reston, Va.: National Art Education Association, 1999.

———, *Art Teachers in Secondary Schools: A National Survey*, Reston, Va.: National Art Education Association, 2001.

National Arts Journalism Program, *Reporting the Arts: News Coverage of Arts and Culture in America*, New York: National Arts Journalism Program, Columbia University, 1998.

————, *The Visual Art Critic: A Survey of Art Critics at General-Interest News Publications in America*, New York: National Arts Journalism Program, Columbia University, 2002.

————, *Reporting the Arts II: News Coverage of Arts and Culture in America*, New York: National Arts Journalism Program, Columbia University, 2004.

National Assembly of State Arts Agencies, "Arts Education Codes and Definitions," unpublished codesheet available through National Assembly of State Arts Agencies, Washington, D.C., n.d.

————, *State Arts Agency Staffing Trends*, Washington, D.C.: National Assembly of State Arts Agencies, 2005.

————, *Legislative Appropriations Annual Survey Fiscal Year 2007*, Washington, D.C.: National Assembly of State Arts Agencies, January 2007.

National Assembly of State Arts Agencies and National Endowment for the Arts, *State Arts Agency Arts Education Profiles*, September 2005. As of February 10, 2008:
http://www.nasaa-arts.org/nasaanews/2005state-profiles.pdf

National Association for Music Education, *Summary Statement [for National Standards]: What Students Should Know and Be Able to Do in the Arts*, n.d. As of March 30, 2008:
http://menc.org/resources/view/summary-statement-what-students-should-know-and-be-able-to-do-in-the-arts

National Association of Scholars, *The Dissolution of General Education: 1914–1993*, Princeton, N.J.: National Association of Scholars, 1996.

National Association of Schools of Music, "Community Education and Music Programs in Higher Education," *Futureswork*, May 1991.

National Commission on Excellence in Education, *A Nation at Risk: The Imperative for Educational Reform*, Washington, D.C.: U.S. Department of Education and National Commission on Excellence in Education, 1983.

National Council for Accreditation of Teacher Education, *NCATE at 50: Continuous Growth, Renewal, and Reform*, Washington, D.C.: National Council for Accreditation of Teacher Education, 2004. As of February 26, 2008:
http://www.ncate.org/documents/15YearsofGrowth.pdf

National Council on Aging, "Fact Sheets: Senior Centers," Web page, October 2005. As of February 26, 2008:
http://www.ncoa.org/content.cfm?sectionID=103&detail=1177

National Endowment for the Arts, "National Initiatives," Web page, n.d. As of February 28, 2008:
http://www.arts.gov/national/index.html

————, *Annual Report*, Washington, D.C.: National Endowment for the Arts, various years.

————, *Toward Civilization: A Report on Arts Education*, Washington, D.C.: National Endowment for the Arts, 1988.

————, *1997 Survey of Public Participation in the Arts*, NEA Research Division Report No. 39, Washington, D.C.: National Endowment for the Arts, December 1998.

————, *2002 Survey of Public Participation in the Arts*, NEA Research Division Report No. 45, Washington, D.C.: National Endowment for the Arts, March 2004.

National Endowment for the Humanities, *To Reclaim A Legacy: A Report on the Humanities in Higher Education*, Washington, D.C.: National Endowment for the Humanities, 1984.

National Guild of Community Schools of the Arts, "About Community Schools of the Arts: Facts & Figures," n.d. As of March 30, 2008:
http://www.nationalguild.org/csas_facts.htm

National Research Center of the Arts, Inc., *Study of State Arts Agencies: A Comprehensive Report*, New York: National Research Center of the Arts, 1976.

Nawotka, Edward, "Reviewing the State of Book Review Coverage," *Publishers Weekly*, October 9, 2006.

NEA—see National Endowment for the Arts

Nebraska Arts Council, "About Prairie Visions," *Prairie Visions: A Partnership of Art and Education*, n.d. As of February 28, 2008:
http://www.arts.nebraska.gov/index_html?page=content/PROGRAMS/PrairieV/PV

Netzer, Dick, *The Subsidized Muse: Public Support for the Arts in the United States*, Cambridge, United Kingdom: Cambridge University Press, 1978.

New Jersey Arts Education Census Project, "New Jersey Arts Education Partnership Launched: Statewide Arts Education Advocacy Organization Formed as a Force for Arts Education," news release, Trenton, N.J.: New Jersey Arts Education Census Project, September 18, 2007a. As of March 29, 2008:
http://www.artsednj.org/njaep_release.shtml

———, *Within Our Power: The Progress, Plight and Promise of Arts Education for Every Child*, Trenton, N.J.: Music for All Foundation, September 18, 2007b. As of March 29, 2008:
http://www.artsednj.org/survey.asp

New Jersey Department of Education, *New Jersey Performing and Visual Arts Curriculum Framework*, Trenton, N.J.: New Jersey Department of Education, fall 1998.

———, *A Report on the State of World Languages Implementation in New Jersey*, Trenton, N.J.: New Jersey Department of Education, fall 2005.

Nichols, Bonnie, *Demographic Characteristics of Arts Attendance, 2002*, NEA Research Note No. 82, Washington, D.C.: National Endowment for the Arts, July 2003.

Oakeshott, Michael, and Timothy Fuller, *The Voice of Liberal Learning: Michael Oakeshott on Education*, New Haven, Conn.: Yale University Press, 1989.

OPERA America, Web site, n.d. As of March 31, 2008:
http://www.operaamerica.org/audiences/lifelong/index.html

Orend, Richard J., *Socialization and Participation in the Arts*, NEA Research Report No. 21, Washington, D.C.: National Endowment for the Arts, 1988.

Orend, Richard J., and Carol Keegan, *Education and Arts Participation: A Study of Arts Socialization and Current Arts-Related Activities Using 1982 and 1992 SPPA Data*, Washington, D.C.: National Endowment for the Arts, 1996.

Osborne, Harold, *The Art of Appreciation*, New York: Oxford University Press, 1970.

Ostrower, Francie, *Motivations Matter: Findings and Practical Implications of a National Survey of Arts Participation*, Washington, D.C.: Urban Institute, 2005a.

———, *The Diversity of Cultural Participation*, Washington, D.C.: Urban Institute, 2005b.

———, "Multiple Motives, Multiple Experiences," in Steven J. Tepper and Bill Ivey, eds., *Engaging Art: The Next Great Transformation of America's Cultural Life*, New York: Routledge, 2008, pp. 85–101.

Pankratz, David B., "Adults and Arts Education: A Literature Review," in J. Balfe and J. Cherbo Heine, eds., *Arts Education Beyond the Classroom*, New York: ACA Books, 1988.

Parsons, Michael J., *How We Understand Art: A Cognitive Developmental Account of Aesthetic Experience*, Cambridge, United Kingdom: Cambridge University Press, 1987.

———, "Cognition as Interpretation in Art Education," in Bennett Reimer and Ralph A. Smith, eds., *The Arts, Education, and Aesthetic Knowing: Ninety-First Yearbook of the National Society for the Study of Education*, Part II, Chicago, Ill.: University of Chicago Press, 1992, pp. 70–91.

Peterson, Richard A., Pamela C. Hull, and Roger M. Kern, *Age and Arts Participation, 1982–1997*, NEA Research Division Report No. 42, Santa Ana, Calif.: Seven Locks Press, 2002.

Pittman, K., M. Irby, and T. Ferber, *Unfinished Business: Further Reflections on a Decade of Promoting Youth Development*, Washington, D.C.: International Youth Foundation, 2000.

President's Committee on the Arts and the Humanities and Arts Education Partnership, *Gaining the Arts Advantage: Lessons from School Districts That Value Arts Education*, Washington, D.C.: President's Committee on the Arts and the Humanities and Arts Education Partnership, 1999.

Radich, Anthony, ed., *Re-envisioning State Arts Agencies*, proceedings of a symposium held by the Western States Arts Federation in Denver, Colorado, on October 17–19, 2003, Denver, Colo.: Western States Arts Federation, 2004.

Ratliffe, James L., D. Kent Johnson, Steven M. La Nasa, and Jerry G. Gaff, *The Status of General Education in the Year 2000: Summary of a National Survey*, Washington, D.C.: Association of American Colleges and Universities, 2001.

Reid, L. A., "Knowledge and Aesthetic Education," in Ralph A. Smith, ed., *Aesthetics and Problems of Education*, Urbana and Chicago, Ill., and London, United Kingdom: University of Illinois Press, 1971, pp. 162–171.

Reimer, Bennett, "Education and Aesthetic Knowing," in Bennett Reimer and Ralph A. Smith, eds., *The Arts, Education, and Aesthetic Knowing*, Chicago, Ill.: National Society for the Study of Education, 1992, pp. 20–50.

Reimer, Bennett, *A Philosophy of Music Education: Advancing the Vision*, 3rd ed., Upper Saddle River, N.J.: Prentice Hall, 2003.

Remer, Jane, *Building Effective Arts Partnerships with Schools and Your Community*, New York: ACA Books, American Council for the Arts, 1996.

Renner, Daniel, "Moving Forward: Education Survey 2005," *Centerpiece*, New York: Theatre Communications Group, July 2006.

Robinson, John P., *Arts Participation in America 1982–1992*, NEA Research Division Report No. 27, Washington, D.C.: National Endowment for the Arts, 1993.

Robinson, John P., Carol A. Keegan, Marcia Karth, and Timothy A. Triplett, *Public Participation in the Arts: Final Report on the 1982 Survey*, Washington, D.C.: National Endowment for the Arts, 1985.

Rogers, E. T., and R. Brogdon, "A Survey of NAEA Curriculum Standards in Art Teacher Preparation Programs," *Studies in Art Education*, Vol. 31, No. 3, 1990, pp. 168–173.

Rowe, Melissa K., Laura Werber Castaneda, Tessa Kaganoff, and Abby Robyn, *Arts Education Partnerships: Lessons Learned from One School District's Experience*, MG-222-EDU, Santa Monica, Calif.: RAND Corporation, 2004. As of March 29, 2008: http://www.rand.org/pubs/monographs/MG222/

Ruppert, Sandra S., and Andrew L. Nelson, *From Anecdote to Evidence: Assessing the Status and Condition of Arts Education at the State Level,* Arts Education Partnership Research and Policy Brief, 2006.

Sabol, F. Robert, "An Overview of Art Teacher Recruitment, Certification, and Retention," in Elliot W. Eisner and Michael D. Day, eds., *Handbook of Research and Policy in Art Education,* Mahwah, N.J.: Lawrence Erlbaum Associates, Publishers, 2004, pp. 523–551.

Schuster, J. Mark, *The Audience for American Art Museums,* NEA Research Division Report No. 23, Santa Ana, Calif.: Seven Locks Press, 1991.

Schwadron, Abraham A., "Of Conceptions, Misconceptions, and Aesthetic Commitment," in J. T. Gates, ed., *Music Education in the United States,* Tuscaloosa, Ala.: University of Alabama Press, 1988, pp. 85–110.

Schwarz, Samuel, and Mary G. Peters, *Growth of Arts and Cultural Organizations in the Decade of the 1970s,* NEA Research Division Final Report, Washington, D.C.: National Endowment for the Arts, December 1983.

Scott, Mel, "Government and the Arts: The Federal-State Partnership in the Arts," *Public Administration Review,* July–August 1970, pp. 376–386.

Seastrom, Marilyn McMillen, Kerry J. Gruber, Robin Henke, Daniel J. McGrath, and Benjamin A. Cohen, *Qualifications of the Public School Teacher Workforce: Prevalence of Out-of-Field Teaching 1987–88 to 1999–2000,* Statistical Analysis Report NCES-2002-603, Washington, D.C.: National Center for Education Statistics, 2002.

Seidel, Steve, Meredith Eppel, and Maria Martiniello, *Arts Survive: A Study of Sustainability in Arts Education Partnerships,* Cambridge, Mass.: The President and Fellows of Harvard College on Behalf of Project Zero, 2001.

Sevigny, M. J., "Discipline-Based Art Education and Teacher Education," *The Journal of Aesthetic Education,* Vol. 21, No. 2, 1987, pp. 95–128.

Short, Georgianna, "The High School Studio Curriculum and Art Understanding: An Examination," *Studies in Art Education,* Vol. 40, No. 1, 1998, pp. 46–65.

Shulman, L. S., "Teacher Education Does Not Exist," *Stanford Educator,* fall 2005.

Shusterman, Richard, *Pragmatic Aesthetics: Living Beauty, Rethinking Art,* 2nd ed., Lanham, Md.: Rowman and Littlefield Publishers, Inc., 2002.

Smith, Ralph A., "A Policy Analysis and Criticism of the Artist-in-Schools Program of the National Endowment for the Arts," *Art Education,* Vol. 30, No. 5, 1977, pp. 12–16, 18–19.

———, ed., *Cultural Literacy and Arts Education,* Urbana and Chicago, Ill.: University of Illinois Press, 1991.

———, *Excellence II: The Continuing Quest in Art Education,* Reston, Va.: National Art Education Association, 1995.

———, "Aesthetic Education: Questions and Issues," in Elliot W. Eisner and Michael D. Day, eds., *Handbook of Research and Policy in Art Education,* London, United Kingdom: Lawrence Erlbaum Associates, Publishers, 2004, pp. 163–186.

———, *Culture and the Arts in Education: Critical Essays on Shaping Human Experience,* New York: Teachers College, Columbia University, 2006.

Smith, Ralph A., and Ronald Berman, eds., *Public Policy and the Aesthetic Interest: Critical Essays on Defining Cultural and Educational Relations,* Urbana, Ill.: University of Illinois Press, 1992.

State of New Jersey, Department of Education, "New Jersey State Board of Education," Web page, 2006. As of March 29, 2008:
http://www.state.nj.us/education/sboe/

State of Rhode Island, Governor's Task Force, *Literacy in the Arts: A Framework for Action*, Providence, R.I.: Rhode Island State Council on the Arts and Rhode Island Department of Education, June 2001.

Stevens, Louise K., *The Performing Arts in California: Rebuilding, Repositioning, Re-emerging*, Bozeman, Mont.: ArtsMarket, March 2000.

Stevenson, L. M., and R. J. Deasy, *Third Space: When Learning Matters*, Washington, D.C.: Arts Education Partnership, 2005.

Stigler, George J., and Gary S. Becker, "DeGustibus Non Est Disputandum," *American Economic Review*, Vol. 67, No. 2, 1977, pp. 76–90.

Storr, Annie V., "Current Practice and Potential: Research and Adult Education in Museums," panel brief presented at the U.S. Department of Education conference titled *Public Libraries and Community-Based Education: Making the Connection for Lifelong Learning* in Washington, D.C., April 12–13, 1995. As of February 28, 2008:
http://www.ed.gov/pubs/PLLIConf95/pelavin.html

Taylor, Andrew, "Overbuilt?" *The Artful Manager*, an ArtsJournal Web log, October 14, 2004. As of February 28, 2008:
http://www.artsjournal.com/artfulmanager/main/000157.php

———, "Three Short Detours Back to Public Value," speech presented at the National Assembly of State Arts Agencies Leadership Institute, Anchorage, Alaska, September 19, 2006. As of April 28, 2008:
http://www.artsjournal.com/artfulmanager/thoughtbucket/009101.php.

Tepper, Steven J., and Bill Ivey, eds., *Engaging Art: The Next Great Transformation of America's Cultural Life*, New York: Routledge, 2008.

U.S. Congress, *Arts and Humanities Amendments of 1997: Report Together with Minority Views to Accompany S. 1020*, Senate Committee on Labor and Public Welfare, 105th Congress, 1st Session, Washington, D.C., September 24, 1997.

U.S. Department of Commerce, Bureau of the Census, *1982 Census of Service Industries*, Geographic Area Series, United States, Washington, D.C.: U.S. Census Bureau, 1984.

———, "Section 9: State and Local Government Finances and Employment," *Statistical Abstract of the United States 1990*, 110th ed., Washington, D.C.: U.S. Census Bureau, 1990.

———, "Section 8: State and Local Government Finances and Employment," *Statistical Abstract of the United States 2006*, 125th ed., Washington, D.C.: U.S. Census Bureau, 2005a.

———, *2002 Economic Census: Arts, Entertainment, and Recreation*, Geographic Area Series, United States, Washington, D.C.: U.S. Department of Commerce, August 2005b.

———, *Current Population Survey: 2006 Annual Social and Economic (ASEC) Supplement*, Washington, D.C.: U.S. Census Bureau, 2006a. As of February 26, 2008:
http://www.census.gov/apsd/techdoc/cps/cpsmar06.pdf

———, *Public Education Finances 2004*, Washington, D.C.: U.S. Census Bureau, March 2006b.

U.S. Department of Education, *Goals 2000: Education America Act*, Washington, D.C.: U.S. Government Printing Office, 1994.

———, *State and Local Implementation of the No Child Left Behind Act, Vol. III: Accountability Under NCLB: Interim Report*, Jessup, Md.: U.S. Department of Education, 2007.

U.S. Department of Education, National Center for Education Statistics, "Frequency of Arts Instruction for Students," *NAEP Facts*, Vol. 4, No. 3, December 1999.

———, *Arts Education in Public Elementary and Secondary Schools, 1999–2000*, NCES-131-2002, Washington, D.C.: U.S. Department of Education, 2002.

———, *Digest of Education Statistics: 2005*, Washington, D.C.: National Center for Education Statistics, 2006.

———, *Postsecondary Institutions in the United States: Fall 2005 and Other Degrees and Awards Conferred 2004–2005*, NCES 2007-167, Washington, D.C.: National Center for Education Statistics, 2007.

U.S. Department of Education, U.S. Network for Education Information, "General Information," Web page, n.d. As of February 28, 2008:
http://www.ed.gov/about/offices/list/ous/international/usnei/us/edlite-underposted-geninfo.html

U.S. Department of Health and Human Services, Administration on Aging, "Aging Internet Information Notes: Senior Centers," September 2004. As of February 10, 2008:
http://www.aoa.gov/prof/notes/notes_senior_centers.asp

U.S. Department of Labor, Bureau of Labor Statistics, "Artists and Related Workers," *Occupational Outlook Handbook,* 2008–2009 ed., Washington, D.C.: U.S. Bureau of Labor Statistics, 2008. As of March 2008:
http://www.bls.gov/oco/ocos092.htm

Visual Understanding in Education, "Visual Thinking Strategies: Learning to Think and Communicate through Art," 2001. As of March 30, 2008:
http://www.vue.org/whoisvue.html

von Zastrow, Claus, and Helen Janc, *Academic Atrophy: The Condition of the Liberal Arts in America's Public Schools*, Washington, D.C.: Council for Basic Education, March 2004.

Voorhees, Richard A., and John H. Milam, "The Hidden College: Noncredit Education in the United States," Littleton, Colo.: Voorhees Group LLC, May 31, 2005. As of February 10, 2008:
http://www.voorheesgroup.org/Projects.html

Walker, Chris, and Stephanie Scott-Melnyk, *From Reggae to Rachmaninoff: How and Why People Participate in Arts and Culture*, Washington, D.C.: Urban Institute, November 2002.

Wallace Foundation, "Grants and Programs: Building Appreciation and Demand for the Arts," 2008. As of February 2008:
http://www.wallacefoundation.org/GrantsPrograms/FocusAreasPrograms/Building+Appreciation/

Washington State Arts Commission, "Where We Are Now: The State of Arts Education in Washington State," *Arts for Every Student Arts Education Resources Initiative*, Web page, n.d. As of February 26, 2008:
http://www.arts.wa.gov/education/AERI/where%20are%20we%20now.html

———, *Arts Education Resources Initiative: The State of Arts Education in the State*, Olympia, Wash.: Washington State Arts Commission, April 15, 2005.

———, *Arts for Every Student Arts Education Resources Initiative*, Olympia, Wash.: Washington State Arts Commission, January 2006. As of February 26, 2008:
http://www.arts.wa.gov/education/AERI/Arts-Education-Resources-Initative-Booklet.pdf

————, *Arts in Education Program: Community Consortium Grant Guidelines and Application Forms for Fiscal Year 2009*, Olympia, Wash.: Washington State Arts Commission, January 2008.

Weitz, Judith H., *Coming Up Taller: Arts and Humanities Programs for Children and Youth at Risk*, Washington, D.C.: President's Committee on the Arts and the Humanities, 1996.

Wetterlund, Kris, and Scott Sayre, *2003 Art Museum Education Programs Survey*, online report, Museum-Ed, 2003. As of February 26, 2008:
http://www.museum-ed.org/joomla/content/blogsection/6/53/

Willis-Fisher, L., *Aesthetics, Art Criticism, Art History, and Art Production in Art Teacher Preparation Programs*, National Art Education Association Advisory, Reston, Va.: National Art Education Association, 1993.

Wilson, Brent, *The Quiet Evolution: Changing the Face of Arts Education*, Los Angeles, Calif.: Getty Center for Education in the Arts, 1997.

Wilson, Suzanne, Robert Floden, and Joan Ferrini-Mundy, *Teacher Preparation Research: Current Knowledge, Gaps, and Recommendations*, Seattle, Wash.: Center for the Study of Teaching and Policy, 2001.

Winzenried, Rebecca, "Preemptive Strike: Taking Action to Educate the Next Generation of Arts Journalists—and Secure the Future of Classical Music Criticism," *Symphony*, January–February 2005, pp. 38–45.

Wolf, Thomas, *The Search for Shining Eyes: Audiences, Leadership and Change in the Symphony Orchestra Field*, Miami, Fla.: John S. and James L. Knight Foundation, September 2006. As of March 30, 2008:
http://www.knightfoundation.org/research_publications/detail.dot?id=178219

Woodford, Paul G., *Democracy and Music Education: Liberalism, Ethics, and the Politics of Practice*, Bloomington, Ind.: Indiana University Press, 2005.

Woodworth, Katrina R., H. Alix Gallagher, Roneeta Guha, Ashley Z. Campbell, Alejandra M. Lopez-Torkos, and Debbie Kim, *An Unfinished Canvas. Arts Education in California: Taking Stock of Policies and Practices, Summary Report*, Menlo Park, Calif.: SRI International, 2007. As of February 28, 2008:
http://policyweb.sri.com/cep/publications/publications.jsp

Wynn, J. R., "The Role of Local Intermediary Organizations in the Youth Development Field," discussion paper prepared for the Edna McConnell Clark Foundation, University of Chicago, Chicago, Ill.: Chapin Hall Center for Children, 2000.

YMCA of the USA, YMCA Programs for Arts Web page, n.d. As of February 28, 2008:
http://www.ymca.net/programs/programs_for_arts.html

Zeszotarski, Paula, "Dimensions of General Education Requirements," in *New Directions for Community Colleges*, No. 108, winter 1999, pp. 39–48.